WORLD WAR I
IN
40 POSTERS

Ann P. Linder

STACKPOLE
BOOKS

For my mother, Jean Austin Planutis

Copyright © 2016 by Ann P. Linder

Published by
STACKPOLE BOOKS
An imprint of Rowman & Littlefield
Distributed by National Book Network

All rights reserved, including the right to reproduce this book or portions thereof in any form or by any means, electronic or mechanical, including photocopying, recording, or by any information storage and retrieval system, without permission in writing from the publisher.

Printed in the United States of America

10 9 8 7 6 5 4 3 2 1

First edition

Cover design by Caroline M. Stover and Wendy A. Reynolds

Cataloging-in-Publication data is on file at the Library of Congress

CONTENTS

INTRODUCTION

In deepest France, where the Vézère flows into the Dordogne, the village of Limeuil climbs the hill above the confluence in a tangle of medieval houses, crested by the remains of a castle and the village church. In the churchyard, as in so many churchyards, squares, and crossroads in France, stands the *monument aux morts*—the monument to the dead of the Great War. In this tiny village of some 350 souls, the memorial plaque in the church bears 24 names, more than 6 percent of the population, higher than the 3.4 percent of the total population France lost in the First World War. Wherever I travel in the former belligerent countries of that war, I look at the war memorials because they tell me a great deal about the experience of a war that has left a broader legacy than the much more destructive war that followed it a generation later. For Europeans, it truly was the Great War.

My interest in the First World War as the most consequential event of the twentieth century dates to my university studies, but coalesced in the 1970s. Since then, the war has been the center of my scholarly interest and research. As I read and wrote, taught and published, I became increasingly enthralled by the propaganda posters of the war, and by the windows they open into understanding the reality, myth, and legacy of a war that is still, one hundred years on, what John Keegan has called "a mystery."[1]

My purpose is to explore that mystery through the posters that governments and charities issued in the thousands through some four years and three months of war. This book is essentially a cultural history of the war years as seen through visual propaganda. It is not meant to be an exhaustive survey of poster production during the war—many such books already exist.[2] Nor is it a book shaped by currently fashionable ideologies and accessible only to specialist scholars. My aim is to look at what the official posters of the combatant countries can tell us about the events, the societies, and the cultures of the Great War. The posters serve as openings into a vanished world, allowing us to scrutinize assumptions, attitudes, prejudices, fears, hopes, hatreds, wishes, and values on a national level, even unarticulated or concealed ones. In a period often viewed as the apogee of European nationalism, the posters, with their vibrant imagery and patriotic language, encapsulate national identities and visions of friend and foe.

To that end, I have chosen forty posters to examine in detail and to place within their specific historical and cultural context. My selection has been driven by several criteria. First, the poster must illuminate a broad range of ideas and attitudes characteristic of the period and the country. Second, the poster must also reveal its propagandistic goals and persuasive techniques, equally indicative of national values and objectives. Aesthetic concerns are important, but not in the sense of whether the poster is "pretty" or meets design-school standards of composition. Rather, the goal is to show how the style and design of the poster further its message in a manner typical of the nation involved. Finally, the poster must successfully embody a given propaganda theme: the themes are universal, the styles are not. Nor are language and lettering. Both are crucial to the poster's persuasive intent.

With the exception of the Austro-Hungarian Empire, I have limited the selection to the Western Front combatants for two reasons. First, the governments and general staffs were convinced that the key to victory or defeat was the Western Front. Second, persuasion works not through logic, but through emotional response. The interaction of image and language are integral to the

emotional appeal of propaganda. I have therefore chosen posters in English, French, and German (thus the Austrian posters), languages in which I am competent to judge and explain linguistic subtleties. In the end, every selection made by an individual and not a committee will be marked by taste as well as judgement, and in this case by what I consider most essential to understanding the period.

How, then, do we define propaganda in the context of the First World War, and why was the poster integral to its dissemination? In essence, propaganda is the attempt by an entity, be it public or private, to persuade people to think and behave in a certain way.[3] Propaganda occupies a public space and aims to convince a broad range of citizens of the truth of its message. What the country needs its citizens to do—enlist, contribute, buy war bonds, work, save—drives the propaganda campaigns. The manipulation of public opinion is the sole aim of propaganda. That is why cultural context is so important. What persuades in France may fall flat in Germany. Propaganda is not necessarily limited to government or its agencies, although most of the posters in this book are official posters. The Red Cross and other charities produced reams of posters. Picture postcards, circulated by the millions, are another treasure trove of propagandistic images. Moreover, the illustrated weeklies of the period (such as the *London Illustrated News* and *L'Illustration*) published vast numbers of patriotic images and stories, self-censoring along the way. It is worth remembering that one man's propaganda is another's information, and the difference depends on whether the material is produced by your side or the enemy's. Enemy propaganda is assumed to be deceptive; one's own is believed to be true. In the first total war, one that required the commitment of all citizens, propaganda was everywhere in print and visual sources.

Out of the proliferation of propaganda that marked the coming of the war, the poster emerged supreme. Nineteenth-century technological advances in chromolithography, lithography, and offset printing permitted the inexpensive mass production of images for books, magazines, and advertising posters. These developments coincided with the rise of industrial, urban societies, an increase in literacy thanks to public education mandated by nationalist governments, and modern mass consumption.[4] The advertising poster came into its own in the 1880s and 1890s with Jules Chéret, Henri de Toulouse-Lautrec, and Alphonse Mucha, to name only the most illustrious artists in what was truly the belle époque of the poster. In short, the advertising poster and the business of publicity (however despised by the educated elites) were ready to hand in 1914. In the period before radio, the poster was the most effective salesman around. Wide distribution and posting on walls, columns, and hoardings (walls built specifically to display posters, especially in railroad and subway stations and other public venues) ensured that a very high proportion of any given population would see them. The poster was already a visual commonplace of daily life; its persuasive power needed only to be redirected to a different object. If posters could sell cigarettes, they could also sell war bonds.

The less-than-respectable trades of advertising and publicity gained legitimacy through their contribution to the war effort and the sanitizing effect of cooperating with the government.[5] In Europe, where commercial hustling was generally looked down upon by the educated, the poster artists gained respectability and recognition. In the United States, where commercialism was more readily accepted, the quick alliance of government and artists in the Division of Pictorial Publicity of the Committee on Public Information (the official propaganda organ of the government during the war) ensured an unprecedented flow of posters for the war effort. But in both cases, the posters were created by cooperation between governments, artists, and printers. Some scholars have suggested that official government posters are less valuable historical artifacts because they present propaganda from above and therefore do not reflect the attitudes of the people. I hold the opposite view. The official posters are valuable because of their wide distribution and because through them one can see the needs, fears, and wishes of a government and a nation at war. The posters had to persuade the viewer, and to do that, they had to operate through the viewer's cultural memory—the cluster of attitudes, ideas, images, and memories that form the national mentality.

Posters are also important because they are the point of intersection between the needs of a government and the artist's translation of those needs into a visually persuasive argument. The government office tells the artist what it wants—say, a war loan poster emphasizing the protection of the family. But it is up to the artist to find images and words that will resonate with ordinary citizens and persuade them to sign up. The artist forms the connection between a government wish list and the

emotional response of its citizens. The text-only, information-heavy posters of the beginning of the war quickly gave way to vivid, image-focused posters because they drew more viewers and produced the response the government wanted.

Most of these posters are not aimed at soldiers, but rather at civilians. Their purpose is to convince civilians to respond to the needs of a nation at war. But what were those needs? What does a government need from its citizens to wage war? First, it needs soldiers. For countries with conscription, that was already taken care of. The government only needs to declare a general mobilization, and the men fall into line. But for nations without conscription, as was the case in Great Britain and its Dominions in 1914, and in the United States until May 1917, the recruitment of men was of primary importance. Raising and training an army is a long process, which helps to explain the urgency of recruiting posters.

Second, the nation needs money. All of the belligerents in World War I went into debt to sustain the war effort. Much of that borrowing was from the national community through war loans. War loan posters are by far the most common type of poster from 1914 to 1918, which is one of the reasons I have included so many of them. Since there are so many, they also provide fertile ground for examining varying propaganda techniques and appeals, and for making cross-cultural comparisons.

In addition to men and money, nations at war also need civilian labor to maintain production of armaments and food. With the men away, there was a twofold need for female labor: in the factories and on the land. Workers also needed to be encouraged to work efficiently and seriously to maintain high production. Governments also needed critical commodities: raw materials for war production and food for the army and for the civilian population. Conservation posters targeted mothers and children, encouraging both conservation and production. Britain and France were able to maintain food security for their populations throughout the war (largely due to female labor in the latter). Germans and Austro-Hungarians suffered real deprivation, and their posters reflect that.

Finally, governments needed their citizens to support charitable organizations such as the Red Cross, which cared for the wounded, prisoners of war, refugees, and orphans. Charities relieved the pressure on governments to provide such services, and were also a means of creating national community by including civilians in the war effort.

Obviously, all of these needs could be placed under the single rubric of supporting the war effort, which was precisely what citizens were expected to do. The theme of duty, specifically patriotic duty, runs through all of the propaganda posters. Persuading people to do their duty was a more complex matter, and relied on appeals to emotions and deeply held, often unarticulated cultural assumptions. However great the national differences, several themes are nearly universal and merge easily with a range of persuasive techniques.

The most prominent theme is probably that of the soldier. As combatants in a national cause, soldiers embody the values and aspirations of the nation. One's own soldiers are universally manly, courageous, heroic, courteous (in the chivalric sense), and self-sacrificing—in short, they are the ideals of young manhood. Enemy soldiers, correspondingly, are the incarnation of wickedness, often depicted as rapists, murders, and wanton destroyers of cultural treasures. Ultimately, the enemy is dehumanized, turned into a vicious animal by a particularly clear evocation of the "us versus them" mentality in which the enemy becomes totally "other."

The deification and vilification of soldiers merges easily into the themes of historical reference. The evocation of historical precedents forms part of the search for national origins so characteristic of European nationalist movements in the nineteenth century. For Britain, Germany, and Austria, that meant the resuscitation of all things medieval and chivalric, both in image and text. For the French Third Republic, which saw itself as the inheritor of Roman language and culture and the successor of the French Revolution, the default visual language was classicism. The United States, lacking ancient and medieval history, relied on evocations of the American Revolution and the Americanized classicism of the Founding Fathers. In all cases, the historical references legitimize the current endeavor.

The family as the core of the nation is a theme often clothed in those historical references. As the essential social unit, and one tasked with the creation and upbringing of the next generation, the family is invested with the responsibility for the future of the nation. The protection of the family thus emerges as a major propaganda theme throughout the war. It comes in many contexts, modern as well as historical, but invariably

equates the family and the nation. Closely allied and often intermingled with the glorification of the family is the equal sanctification of the land. Images of the land, usually rural images, serve to remind the viewer that the national land and people are sacred. This theme is most evident in France, because France had been invaded and felt a visceral threat to not only its culture, but also its very existence.

Underlying those themes is another that is never articulated, but always present—hope. The posters of the First World War are supremely hopeful. They trade on the citizen's beliefs and wishes: that soldiers will fight well and win, that if wounded they will be cared for and live, that hard times will pass, and that ultimately the victory will be won. This is not the meaningless universe embodied in the British poetry of the war, the "pity of war," to borrow Wilfred Owen's phrase.[6] Hopelessness does not sell war bonds. Optimism does. The unspoken optimism that informs these posters underlies even the overt fearmongering, and testifies to their psychological subtlety. Propaganda is often seen as obvious, crude, and blatant, but even those appeals work because of the skillful manipulation of fundamental emotional assumptions and cultural values.

These themes thread their way through the years of the war, taking on varying visual attributes based on nation and period, and being used in their turn in a whole range of propaganda techniques based on emotional manipulation. One of my goals is to follow the alterations in the appeals across time. That leads into military and political history, into art history, and into the social and cultural lives of the people who lived through it. For that reason I have organized the posters by year, combining 1914 and 1915 (as there was very limited production in 1914) and finishing with three posters from the immediate postwar period. Within each chapter, I have grouped the posters in a way that highlights the historical situation and allows for illuminating comparisons. Dating posters precisely is virtually impossible, so an arrangement based on considerations of purpose, theme, style, and technique seems most reasonable and enlightening.

Finally, the goal of this book is to see, as best we can with our twenty-first-century eyes, the world of the Great War. A hundred years of war, technological change, and social upheaval separate us from that world. Like the narrator of Marcel Proust's *Remembrance of Things Past*, we search for a world that is gone, but still shapes the world we live in. To better understand our world, we must find that one. For Proust's disillusioned, middle-aged narrator, the Bois de Boulogne, the world of Madame Swann that he loved as a boy has perished, and "the houses, roads, avenues are as fugitive, alas, as the years."[7] But for us, the houses and avenues are still there in the form of these posters. We only need to learn how to look.

1914–15

"Daddy, what did YOU do in the Great War?"

Savile Lumley
Great Britain (PRC 79), 1915

In the last days of July 1914, Europe went to war. The diplomacy that had kept the continent at peace since 1871 was unequal to the challenge of deflecting war in the Balkans.[1] One by one, beginning with Austria-Hungary on July 28, the great powers mobilized for war. Germany and Italy joined Austria-Hungary to form the Central Powers. France, allied with Russia in an entente cordiale since 1904, mobilized to support her ally. Like falling dominos, one mobilization triggered the next.[2]

On August 4, Great Britain fulfilled its commitment to protect Belgium and declared war on the Central Powers. Britain faced war with a professional standing army of around 400,000 men, half of whom were stationed overseas, garrisoning the far-flung posts of the British Empire. The men of the British Expeditionary Force (BEF), commanded by General Sir John French, were professional soldiers. They would later be called the "Old Contemptibles" after Kaiser Wilhelm II's order to his army to dispose of "General French's contemptible little army."[3] By the end of 1914, the BEF would be largely wiped out.

The standing army was not enough; Britain needed soldiers. Unlike the continental powers, Britain had never relied on conscription. The French had the revolutionary tradition of the *levée en masse*—with its origins in the mass uprising of 1792 to protect the young republic—and had been tinkering with conscription laws in the forty years since their trouncing by the Germans in 1870.[4] Trapped between admiration and revulsion of the German army, and unable to keep up with Germany's population growth,[5] the French military leaders struggled to improve the readiness and efficiency of their manpower systems. The German army had a complex and long-sighted system of conscription, initial service, and continuing reserve duties that ensured large reserves of trained manpower, ready to be mobilized and integrated into active forces as needed. So while there were always appeals for volunteers, the early propaganda posters on the continent focused on war loans and patriotic support for the troops, rather than on the headlong rush to recruit fresh manpower.

In Britain, the immediate need for men prompted a vigorous appeal for volunteers, issued by the new secretary of state for war, Field Marshal Horatio Herbert Kitchener (1st Earl Kitchener), on August 7. August and early September saw a surge in enlistments, 478,893 in total.[6] The famous photograph of the Central London Recruiting Depot, with a press of young men in boaters, bowlers, and flat caps eagerly but patiently waiting their turn to sign up, exemplifies the patriotic fervor and sense of duty of that moment. Not every man who enlisted did so from a sense of duty or loyalty to king and country; some surely enlisted for adventure or to escape a difficult or routine existence, but the general pressure to enlist animated the society from top to bottom.

Voluntary enlistment was managed by the Parliamentary Recruiting Committee (PRC), created in August 1914. The recruiting campaign lasted from October 1914 to September 1915.[7] After the first flush of enthusiasm in August and September, recruitment began falling by October.[8] Potential recruits were enjoined to participate in a "just" war against "an arrogant bully."[9] Local political organizations pushed

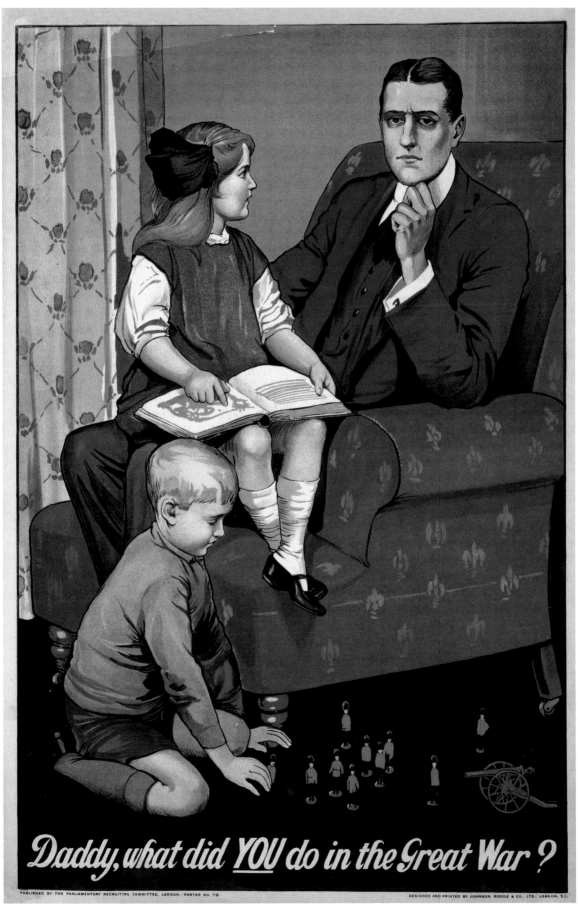

LIBRARY OF CONGRESS: LC-USZC4-10923

enlistment, but the main avenue of persuasion was the poster. The PRC commissioned a remarkable series of recruiting posters that deployed emotional appeals to patriotism, justice, fair play, and comradeship, frequently underlain by subtle shaming. The most famous poster of the early part of the campaign, Alfred Leete's image of Lord Kitchener with his pointing finger and the message "Your country needs you," used the intimidating figure of the hero of Omdurman, the possessive "your" to mandate responsibility, and the verb "needs" to imply inclusion and necessity. It did not appear in poster form until the end of September 1914, after enlistment had peaked. So its effectiveness as a tool of persuasion—something that is always difficult if not impossible to assess—was probably far less than myth would have it.[10]

Losses to the BEF mounted with the retreat from Mons and the battle of Le Cateau in late September. As recruitment slowed, the voices urging enlistment became more strident, and the appeals shifted from lighthearted calls to join one's mates in uniform to shame and insidious emotional blackmail. Of the many posters in this category, Savile Lumley's "Daddy, what did YOU do in the Great War" remains notorious. The Imperial War Museum even goes so far as to aver that Lumley, best known as an illustrator of children's books, disowned the poster after the war because the resentment against it was so great.[11]

The poster originated with an idea from Arthur Gunn of printers Johnson, Riddle and Co., one of the major printers for the PRC. After the war, his son Paul recounted the seminal incident.

> One night my father came home very worried about the war situation and discussed with my mother whether he should volunteer. He happened to come in where I was asleep and quite casually said to my mother, "If I don't join the forces whatever will I say to Paul if he turns round to me and says, 'What did you do in the Great War, Daddy?' He suddenly turned round to my mother and said that would make a marvellous [*sic*] slogan for a recruiting poster. He shot off to see one of his pet artists, Savile Lumley, had a sketch drawn straight away, based on the theme projected about five years hence, although by the time it had taken shape the questioner had become one of my sisters. To end the

story on a nice note, he joined the Westminster Volunteers a few days later![12]

Like the incident that engendered it, the finished poster exudes the idealized middle-class domesticity of the prewar period. Its message is aimed precisely at the family men of the middle and professional classes. The details are telling: The handsome but troubled young father is wearing a vested suit, tie, nice cufflinks, and a stiff collar—the uniform of the professional middle class. Like their father, the children are well-dressed—the boy in short pants and a pullover, the girl wearing a pinafore over her dress and an elaborate bow in her beautiful red hair. While the boy plays on the floor with nineteenth-century red-coated soldiers (not khaki-clad) and an equally archaic cannon, the little girl, seated on her father's lap, looks up from her book (a schoolbook, perhaps) to pose a question beginning with the homey and familiar "Daddy."

The decorative details tell the same story. The comfortable, overstuffed armchair with its turned legs and brass casters embodies middle-class comfort and security, and its presence visually anchors the father and daughter in the center of the frame. The discrete florals of the curtains and upholstery, correct for the period, imply taste and education. Lumley also used the subdued colors effectively. The soft bluish green of the chair is echoed in the border of the curtain, the girl's pinafore, and the boy's cannon, focusing the viewer's gaze on the girl and her father.

Then, into this tranquil family moment, whose only hint of war or discord is found in the boy's archaic toy soldiers, the girl, indicating a passage in her book, drops a bombshell question: "Daddy, what did YOU do in the Great War?" The text is in white schoolbook cursive against the dark green of the carpet, with the capitalized "you" nearly centered on the line to draw the viewer's attention. The question is aimed directly at the father, whose troubled visage clearly expresses his anguish at having to confess to his children that he didn't serve during the war. His failure to do so has cost him his honor and the respect of his children. This use of shame as a weapon is telling in a poster aimed at the middle class, where the traditional values of English manhood and of the British Empire were still alive and well in 1915.

The shaming of men into service was not unique to the Great War. A lingering echo of this poster appears in the 1970 film *Patton*, with George C. Scott in the

title role. As Patton harangues his men before a huge American flag in the opening sequence, he says, "Thirty years from now, when you're sitting around your fireside with your grandson on your knee and he asks you, 'What did you do in the great World War II?' you won't have to say, 'Well . . . I shoveled shit in Louisiana.'"[13]

But the egregious use of emotional intimidation in many recruiting posters and the commercialism of "selling war" took its toll.[14] Unlike France and Germany, where traditionally educated elites maintained control over style and content in visual propaganda, most of the British poster artists came from the fields of commercial art and advertising. It was in Britain, and later in America, that the unholy alliance of advertising and government propaganda was forged in the Great War. The huckstering style of the recruiting campaign alienated both the middle class and, more importantly, the working class, which was less likely to harbor traditional notions of honor and duty. The ill will created in the ranks was lasting and certainly contributed to general disillusionment among combatants, and to widespread distrust of government messages. The campaign gradually became less effective and Parliament introduced conscription in January 1916, just in time for the voluntary "Pals" battalions recruited in 1914 and 1915 to be decimated on July 1, 1916, on the Somme.

STEP INTO YOUR PLACE

Anonymous
Great Britain (PRC 104), 1915

As a part of its effort to raise "a mass army . . . by consent," to borrow Jay Winter's phrase,[15] the Parliamentary Recruiting Committee resorted to a wide range of appeals to the men of Britain. In the previous poster, the father is shamed by his failure to live up to expected standards of masculinity. As a persuasive tactic, shaming was widespread in posters ("Women of Britain say Go!") and in behavior. In the early weeks of the war, young women handed white feathers—a symbol of cowardice—to any young man not in uniform. As emotional blackmail, Lumley's poster can hardly be bettered, but its nastiness undermined its appeal.

"Step into Your Place," a slightly later poster from May 1915, is based on the same standards of appropriate male conduct, but the appeal to enlist is framed in the spirit of encouragement, inclusiveness, and male bonding. The cleverly designed poster depicts a *c*-shaped column of marching men; in the foreground are civilians of various classes and occupations, gradually changing into soldiers who disappear into the distance beneath the *c* in the word *place*. The curving diagonal of the marching column gives the image great dynamism and rams home the message: in wartime, we are all in this together—and a man's proper place is in the army.

Although the message is obvious, the details of the image bear closer scrutiny. By their attire, and especially their headgear, the men in the foreground embody the class divisions and stratifications of prewar British society. A gloved gentleman in a top hat, his briefcase and tightly furled umbrella in hand, precedes a businessman in a fedora, a ledger tucked under his arm. He is followed by a barrister in robe and wig, then a miner with a pickax and soft cap. In front of the top-hatted gent are a carpenter with his bag of tools, a farmer with a pitchfork, a delivery boy with basket and apron, and several men in straw boaters. Near the back on the right, a City of London man sports a bowler. A few men are bareheaded, and several wear workingmen's soft caps. The faces are scarcely differentiated, so the figures are clearly meant to be easily recognizable stereotypes from a broadly representative range of social stations and occupations.

The notion of being in one's rightful "place" was deeply embedded in the class system of prewar British society. Clothing, behavior, and accent pigeonholed nearly everyone. The "differently-dressed servants," as Philip Larkin describes them in his moving poem "MCMXIV,"[16] were especially encouraged to "know their place" and keep to it. Despite the implied social leveling, in reality social distinctions continued in the army. Officers and soldiers had different accommodations, discipline, and treatment, although to judge by photographs and firsthand descriptions, the living conditions at the front were universally miserable and had a democratizing effect among combat troops. When wounded or shell-shocked, troops and officers were cared for in separate hospitals. Craiglockhart, the hospital famous for its shell-shock treatment of Wilfred Owen and Siegfried Sassoon, was for officers only. Its "talking cure" was much gentler than the electric shock often administered to soldiers.[17]

But in the vision of this poster, distinctions of class and occupation vanish as civilians are metamorphosed into British soldiers. Visual distinction dissolves into unifying khaki. Before khaki (the word is Urdu for

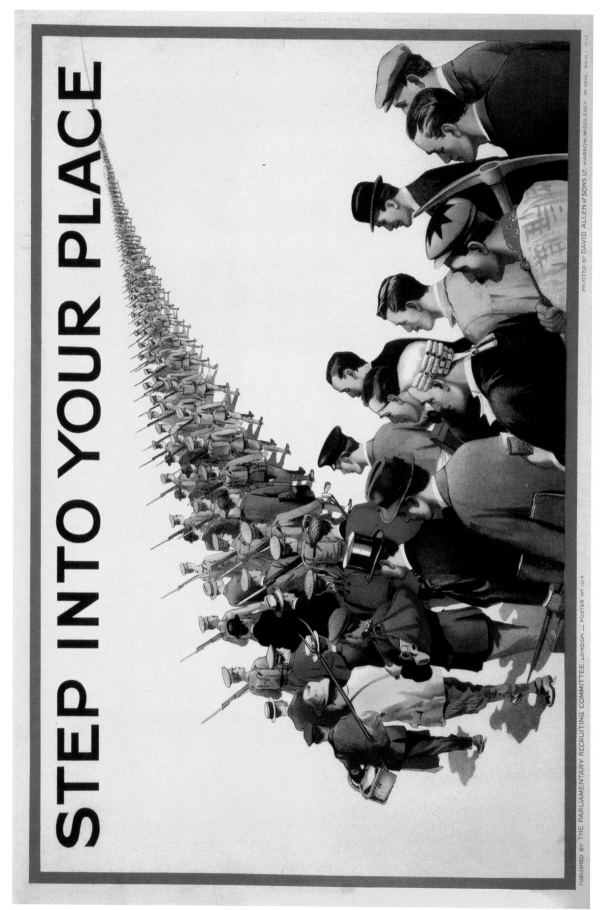

LIBRARY OF CONGRESS: LC-USZC4-11013

dust), nineteenth-century European uniforms were conspicuous in color and design. Toward the end of that century, most of the European nations moved toward uniforms that blended with the battlefield and made soldiers less obvious targets. Like the field gray (*Feldgrau*) of Germany, British khaki rendered troops less conspicuous. Khaki had been used in India in the 1857 Mutiny, but came into its own in the Boer War of 1899–1901, where troops wore a cotton khaki uniform (khaki drill). A wool serge version became standard service dress in 1902, and with a few modifications was used throughout the Great War. It became the badge of the trench soldier.[18]

The unity of the khaki marching column is further emphasized by the word *step* in the text, which implies dynamic movement and evokes the phrase to be "in step," as the marching soldiers are in step with the needs of the nation. In most Great War posters the soldier is either idealized (if he's yours) or vilified (if he's the enemy's). Stepping smartly into his designated place (note the possessive "your"), the soldier becomes the embodiment of the virtues of the nation, resolutely fulfilling his duty to king and country, but also to his fellow soldiers. It is a truism of military history that soldiers fight for their comrades rather than for abstractions such as monarch, nation, or homeland. In 1914, that was certainly the case for the regular soldiers of the British Expeditionary Force, for whom their regiment was their home. It was also true of German soldiers, for whom comradeship was the ultimate justification of their *Kriegserlebnis* (experience of war), a value that transcended rank, survived the war, and shaped interwar politics.[19]

The members of the Parliamentary Recruiting Committee realized early on that the desire to serve with one's friends, one's "mates" or "pals," could be a formidable inducement to enlist. A number of posters urge men to join "mates" who have already signed up. But the strongest inducement arrived in the form of the Earl of Derby's scheme for "Pals" battalions, units formed of men from similar areas, backgrounds, and occupations. In August 1914, Lord Derby, exercising his wealth and power in the north of England, called upon the men of Liverpool's business offices to form a battalion for the Kitchener (or New) Army, promising them that those who enlisted together would serve together. The numbers were raised at the first recruitment rally, with overflow forming two additional battalions. The idea moved like wildfire through the industrial Midlands, the Northeast, and South Wales.[20] Overall, almost 2.5 million men volunteered for the New Army.[21]

The recruits were badly needed. In the battles of 1914, the BEF had lost 30,000 of the 160,000 men sent to France at the outbreak of war. Over half of the original force had been wounded.[22] The BEF, thrown into the northern end of the French line to halt the German advance, had suffered heavy casualties at Mons on August 23, but held its ground. That night, General Sir John French, the BEF commander, learned that the French were withdrawing, and since his allies were falling back, he was forced to do the same. As the BEF retreated, the soldiers fought again at Le Cateau, losing 8,000 men killed, wounded, or missing, along with half the divisional artillery.[23] After the failure of the Schlieffen Plan on the Marne, the Race to the Sea and the first Battle of Ypres decimated the remains of the old army regulars, as the fighting settled into stalemate by the end of the year.[24]

The regulars of the British army had indeed stepped into their places. In time the men of the New Army would do the same, and they were bloodied and gassed at Neuve-Chapelle and Loos before 1915 drew to a close.[25] The poignancy of the Pals battalions is that the men who worked together and fought together also died together, and in large numbers. After Loos, and especially after the Somme in 1916, some streets in Midlands towns bore a black wreath on every door. The "lost generation" may be a cliché, but not in Britain. The profusion of names on village war memorials bears silent testimony to the unintended consequences of an effective recruiting campaign.

BRITAIN NEEDS YOU AT ONCE

Anonymous
Great Britain (PRC 108), 1915

We have looked at two of the propaganda techniques used by the PRC to encourage enlistment: shaming ("Daddy, what did YOU do in the Great War?") and inclusiveness ("Step into Your Place"). "Britain Needs You at Once" represents the third persuasive leg of the PRC's recruitment campaign: the appeal to myth, chivalry, and duty. Indeed, the sense of duty underlies all these appeals, as it does the ongoing exhortations to give, save, sacrifice, and work.

Duty is a universal theme in all the combatant nations. In Britain it takes on a specifically chivalric context that emerges from several intertwined nineteenth-century movements: medievalism (including chivalry), nationalism, and Victorian Christianity. National mythology, medieval chivalry, and Christian belief coincide in the striking design of this poster—so striking that it was borrowed for a 1917 Austrian war loan poster. The overall design draws on medieval precedents: the national myth of Saint George slaying the dragon is depicted in a rondel, very much like a medieval stained glass window. It is framed top and bottom by horizontal panels that bear the text; the spaces between the rondel and the panels are filled in with triangles. The dark green and black of the poster project a somber tone. The dragon rears against a flaming background as Saint George, his silver armor and white horse silhouetted against the beast's enormity, plunges his lance through the dragon's heart.

The origins of the legend of Saint George are obscure, probably some combination of an early Christian martyrdom and a popular legend of a town menaced by a dragon.[26] Whatever its genesis, two key components shape its use in British propaganda: first, Saint George is the patron saint of England, and thus a national symbol; second, he is a Christian knight who kills a dragon, the embodiment of evil, to protect a woman, usually a virgin. As a Christian David facing Goliath in the form of a dragon, Saint George incarnates courage against frightening odds. As patron saint of England, Saint George personifies the Victorian chivalric ideal, heroic masculinity in the service of a code of behavior that includes duty, and if necessary, self-sacrifice. In Saint George, English history and mythology converge. He is the patron of the oldest and most important order of knighthood in the kingdom, the Order of the Garter, founded by Edward III in 1348. His banner, a red cross on a white field, forms part of the Union Jack. "Saint George" was the battle cry of English armies for centuries, immortalized in Shakespeare's *Henry V*, where the king rallies his faltering soldiers with "Cry Harry for England and Saint George!"[27]

This poster would have resonated with contemporary viewers not only because Saint George was the protector of England, but because modernized chivalry, derived from the romantic rediscovery of the Middle Ages, had already permeated Britain in the early nineteenth century.[28] Sir Walter Scott's romantic novels kindled a mania for all things medieval. In an aesthetic retreat from modernity, the Houses of Parliament (destroyed by fire in 1834) were rebuilt in Gothic style; Augustus Pugin's Gothic designs for the interior of the new Parliament became all the rage; and the Pre-Raphaelites chose medieval subjects and styles for their paintings. Because the Middle Ages were seen as the

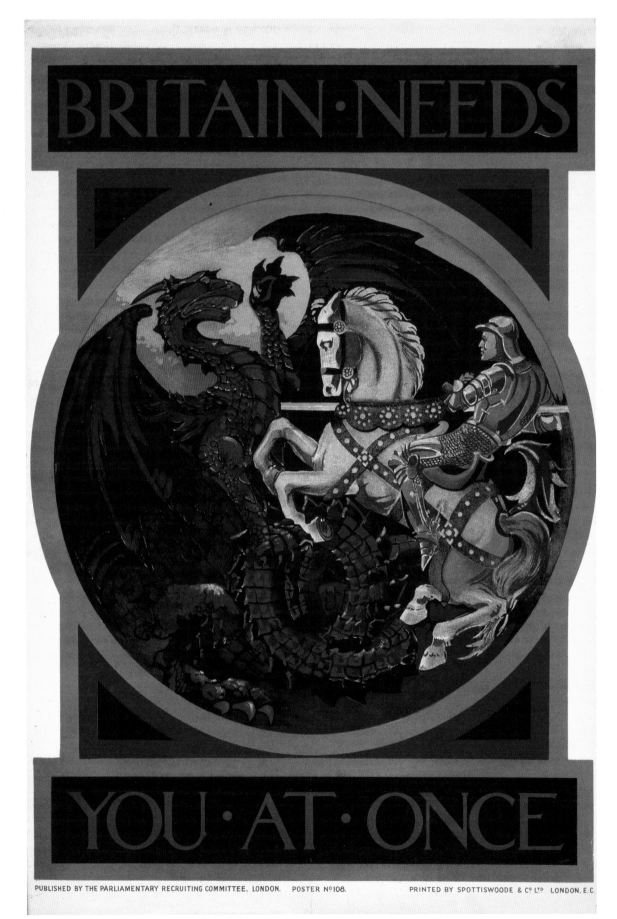

LIBRARY OF CONGRESS: LC-USZC4-11248

seminal period for national origins, medieval knights were national heroes, and somewhere along the line, Saint George became the paradigm of the English knight.

Decorations for valor are an often-overlooked link between medieval chivalry and modern armies. Most of the decorations for valor in the Western combatant nations in the First World War were crosses: the Victoria Cross, Distinguished Service Order, and Military Cross in Britain; the Légion d'Honneur and the Croix de Guerre in France; the Iron Cross in Germany. A significant majority of these decorations are in the form of the *croix pattée*, with four arms flaring from a narrow center, a style associated with the Templars and Hospitallers. These military decorations (most created in the eighteenth and nineteenth centuries) establish a direct link to the medieval Christian knight of the Crusades, sacrificing himself for his beliefs and his brothers-in-arms.[29]

By the middle of the nineteenth century notions of chivalry centered on "courage, duty, honor, fairness and faith."[30] Chivalry became the code of the gentleman and a means of training the young in behavior and citizenship.[31] Meeting such standards implied a daily struggle, and the metaphors of battle dominate the rhetoric. With such standards of conduct as the model, young men of most classes (these ideals especially permeated the elite public schools) were mentally primed for combat when it arrived.[32]

They were also primed for duty and self-sacrifice, implied by the image of a mortal battling something vastly larger and stronger than himself. The creator of this poster eschews the high rhetoric typical of nineteenth-century chivalry, but the elevated tone is there. The call is from the nation itself, which evokes the duty of the citizen to aid the nation in its moment of need. The use of the personal pronoun "you" makes the need personal, as does the "you" in the Kitchener poster. The "at once" command peremptorily demands immediate obedience and sacrifice of the self for the greater good, as a knight would follow the command of a king.

The elevated rhetoric of Victorian and Edwardian chivalry was, as Paul Fussell has pointed out, severely undermined by the grim realities of the war.[33] But the chivalric language of duty and sacrifice hung on into the commemorative language of the postwar period. The cemeteries built by the Imperial War Graves Commission, as well as the Cenotaph in London, rely on traditional elevated diction for the epitaphs. Early commemorative efforts offered the message that the losses had a meaning and that the "sacrifices were redemptive."[34] The War Graves Commission charged Rudyard Kipling, the poet of empire, with the task of providing appropriate epitaphs for the monuments. Kipling, who had lost his son in the war, supplied brief epitaphs in the traditional high language. For the Cenotaph, Kipling provided its only words: "The Glorious Dead." For the graves of unknown soldiers, "Known unto God." And for the Stone of Remembrance in the cemeteries, he chose a passage from Ecclesiasticus 44:14: "Their Name Liveth Forever." It would be difficult to find a more moving excursion into a noble language of meaning and faith.[35]

A final example of chivalric reference is the Sword of Sacrifice, designed by Sir Reginald Blomfield in 1918, and placed in all of the cemeteries built by the Commission. It consists of a stone Latin cross, with a bronze broadsword attached to one or both sides, the arms of the hilt aligned with the arms of the cross, the blade pointing down. What Kipling's epitaphs attempt in words, the sword—and this poster—achieve visually, uniting valor with faith, and sacrifice with redemption.

LE 178IÈME BATAILLON CANADIEN-FRANÇAIS

Anonymous
Canada, 1915

With the outbreak of war in August 1914, the Dominion of Canada, as part of the British Empire, also found itself at war. As in Britain, there was no conscription in Canada, and the Conservative government was opposed to its introduction. Prime Minister Robert Borden placed his faith in Canadian patriotism to raise the troops needed to support the motherland.

At the beginning, his faith was not misplaced. In a rush of patriotism and loyalty to Britain, thousands of men volunteered, and the first contingent of 33,000 troops sailed for Britain in October 1914. Two-thirds of them had been born in the British Isles and were part of the heavy wave of immigration in the first years of the century. Throughout the war, enlistment among the British-born remained much higher than among native-born Canadians.[36]

After the first flush of enlistments, Canadian recruiters were faced with a worrisome problem. They needed to encourage enlistment among the native-born, but a significant minority of those were French-speaking Canadians, who had a long, discordant history with the Anglophone majority. Of a total population of 8 million in 1914, 30 percent were French Canadians. After the departure of the first contingent of the Canadian Expeditionary Force (CEF), the task of recruitment fell to local militia units across the country, who designed and printed posters reflecting local conditions and the local population. The French Canadian recruiting posters provide a revealing look into the problems and tensions between English- and French-speaking Canadians.

This recruiting poster for the 178th French Canadian Battalion frames its appeal on duty and loyalty, while targeting a rural population. Unlike the British posters, it is very "busy" in design, including images, battalion insignia, and a great deal of text. The earliest recruiting posters from Britain and its Dominions were exclusively text, or contained only very simple images. Once the PRC took over production of recruiting posters, they quickly assumed early-twentieth-century advertising styles, prioritizing image over text for greater visual impact. Many of the Canadian posters, including the French Canadian ones, retain the older advertising style with large quantities of text.[37] That style is partly dictated by the local nature of the recruiting efforts—more information was required. In this example, the text is in a range of colors against a black background, beginning at the top with the number of the battalion, its area of origin (the Eastern Townships, located east of Montreal), and its nickname *les purs Canayens* (the pure Canadians) in French Canadian dialect. At the time, the last phrase would have referred to native-born Canadians, whether from the Eastern Townships or not. It draws a clear distinction between the native-born and recent immigrants, as the latter were mostly English-speaking.[38]

The image, which provides the focus of the poster, shows an idealized French Canadian farm. In the background are a tidy farmhouse and barn, while the haymaking goes forward in the fields. On the right, two girls in traditional caps and aprons wave at a passing company of soldiers. In the foreground, the white-bearded farmer, holding his scythe, gestures toward the marching column as he speaks to his son, who is dressed in his best and carrying his suitcase. The father says, "You have understood me, my son, it is

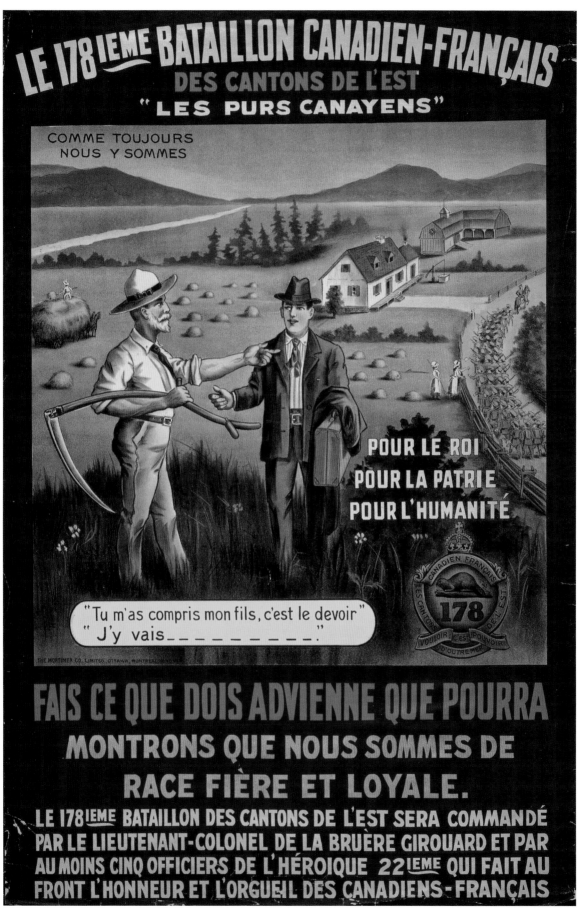

LIBRARY OF CONGRESS: LC-USZC4-12686

duty." "I'm going . . .," the son responds. On the surface, this is a simple patriotic image and message, the father urging his son to do his duty and defend his homeland. To the right of the young man are three reasons that he should fight: for the king (*le roi*), for the homeland (*la patrie*), and for humanity. The last is a legacy of the German "rape" of Belgium in 1914. The German execution of civilians and the burning of the medieval library of Louvain were used, and sometimes exaggerated, to paint the Germans as barbarians and to encourage outrage in Allied populations. The tactic was quite successful, leaving German propagandists to struggle, largely in vain, against the prevailing image of the "Hun" for the rest of the war.

The image includes two other elements: the battalion crest at the bottom right, and at the top left the phrase *comme toujours nous y sommes*. The phrase means "as always, we are there," implying a historical readiness to serve. But the text below the image highlights the tense relationship between French and English Canadians, especially in wartime. The line *Fais ce que dois advienne que poura* is a proverbial expression that means "do what you must whatever may come," couched in the typically antiquated language of aphorisms. It intensifies the call to follow duty whatever the consequences. The proverb clearly resonated with Francophone Canadians, as it continued to turn up in political slogans of the 1920s and 1930s.

The next sentence, however, reveals the degree of suspicion extant between the English Canadian–dominated government and army and French Canadians. The sentence reads, *Montrons que nous sommes de race fière and loyale*. The word *race* here indicates an ethnic group. Simply translated, it means, "Let us show that we are from a proud and loyal race," but the mere use of the word *loyal* raises the specter of accusations of disloyalty to the Crown and to the British Empire. English Canadian recruiting posters encourage men to do their duty, join their friends, and so on, but they do not call on men to demonstrate their loyalty by enlisting—it was assumed.

French Canadian hostility toward the British Empire had existed in some form since the conquest of New France in 1760 and the mass deportations of French Canadians from Acadia that followed. A more profound threat to the survival of French Canadian culture and language was Regulation 17, passed in 1912, which limited French-language schooling. Henri Bourassa, the guiding light of French Canadian nationalism, regarded the law as forced assimilation; he considered the English Canadians a greater threat to French culture than the Germans, and fought against the "Prussians of Ontario."[39] So while English Canadians suspected French Canadians, whose enlistments were low, of disloyalty and shirking, the French Canadians suspected the English speakers of trying to obliterate their cherished language and culture and, in effect, send them to their deaths. When conscription finally became law in January 1918, escalating demonstrations led to a serious riot in March in Québec City, in which conscript troops fired into a crowd, killing four demonstrators and wounding many others.

The final section of this poster states that the 178th will be commanded by Lieutenant-Colonel de la Bruère Girouard and at least five officers of the heroic 22nd Battalion, "which forms the honor and pride of French Canadians at the Front." The 22nd was the only well-established French-speaking battalion in the otherwise English-language CEF. Again the language in this passage, with its emphasis on pride, honor, and heroism, reinforces the notion that such qualities in French Canadians had to be proved to the army, the government, and to English Canada in general. Despite posters such as this one, low enlistments from French Canada stirred a nasty public debate over French Canada's contribution to the war that continued to influence political relationships for many years after the Armistice.

DRITTE KRIEGSANLEIHE

Erwin Puchinger
Austria-Hungary, 1915

Wars are hugely expensive enterprises. The unpleasant realities of war finance seem to have caught all the combatant nations unawares, partly because virtually everyone planned on a short war. The German Schlieffen Plan was aimed at just that: a quick (forty-two-day) knockout of France before turning east to face the Russian "steamroller." Sir Archibald Murray, chief of the general staff for the BEF, was sure the war would last "three months if everything goes well, and perhaps eight months if things do not go satisfactorily."[40] General Joseph Joffre, chief of the French general staff, in keeping with the vaunted French spirit of the offensive, planned an elaborate encirclement of the enemy in Alsace. Between his offensive and the rapid Russian invasion of East Prussia, he was convinced the Germans would quickly sue for peace.[41]

The stalemated front and heavy losses in early 1915 convinced the governments that the war was going to be much longer than anticipated, and that it would require far more money than anyone had foreseen. The Entente Powers (France, Russia, Great Britain) were in a more robust economic position than the Central Powers (Germany, Austria-Hungary, Ottoman Empire). Both Britain and France had vast colonial empires and the human and economic resources that went with them. The Entente had a combined national income 60 percent greater than that of the Central Powers,[42] but none of the countries involved was capable of financing the war from regular tax revenues. The Entente was in a better position to obtain external loans from Allied and neutral countries, namely the United States, because the Central Powers had been cut off from obtaining international loans at the outbreak of war. In the end, all the warring nations ran up huge national debts through domestic borrowing.[43]

Thus the combatant nations relied heavily on their own citizens to finance the war effort, resorting to repeated appeals and creating a superabundance of posters to advertise them. War loan posters form by far the largest category of Great War posters. War loans appealed to governments for several reasons: First, they kept the debt within the country and out of the hands of foreign lenders, who could be difficult about terms and repayment. Second, domestic loans took money out of circulation, reducing the potential rate of inflation and limiting the deleterious effect of black markets. On the negative side, they forced governments into reliance on the continued willingness of their citizens to support the war effort.

How, then, do you separate your citizens from their cash? On a prosaic level, most of the loans offered slightly higher interest than the current rate. They were also open to everyone, from large investors to small. Children were encouraged to participate, and loan campaigns were organized through the schools in France and Austria, while American children bought war savings stamps. On a deeper emotional and cultural level, the war loan campaigns appealed to patriotism, using symbols, themes, and artistic styles that resonated in the national psyche.

These symbols and themes animate Erwin Puchinger's poster for the Austro-Hungarian Third War Loan, floated in October 1915. Like the rest of the Central Powers, Austria-Hungary was cut off from foreign borrowing, and despite significant borrowing from Germany, resorted to war loans to raise the necessary

LIBRARY OF CONGRESS: LC-USZC4-11954

funds. In all, the Dual Monarchy issued eight war loans: the first in November 1914, then every six months thereafter, ending with the eighth in May 1918.

Puchinger's poster for the Third War Loan dramatically clothes themes of chivalry and protection in the artistic style of the Vienna Secession. The message is simple: subscribe to the Third War Loan at 5.5 percent. The verb (*Zeichnet*) is in the plural familiar imperative; the government addresses its citizens as part of the national family. The text itself is equally simple—a spare, somewhat angular lettering in beige, of the type favored by the Secession, set against a dark background. The image depicts a knight in chain mail and helmet, his broadsword drawn. Attacking lances break against his shield, which bears the Austro-Hungarian coat of arms. Behind him huddles a woman clutching a small child. In the background a castle is silhouetted against a red sky.

The theme of knightly prowess and self-sacrifice is one of the principal themes of World War I posters. It appears with particular frequency in Germany and Austria, where the national medieval past had been vividly resurrected in the nineteenth century. This image is different in tone from the British poster of Saint George, which is an abstract representation of courage sustained by faith. In that poster the dragon, always identified with Satan, is the incarnation of evil. Here the knight faces multiple national enemies, identified by the banners on the attacking lances—Italy, which had abandoned the Central Powers for the Allies in May 1915, above, and Russia below. The knight's strength comes from his duty to protect the woman and child behind him. In the iconography of this image, the knight is the protector of his nation and its people, incarnated in the helpless woman and child.

The details of the image enhance the message. The mother and child are depicted as vulnerable innocents. In Catholic Austria, the reference to the Madonna and Child would have been obvious. The child clutches its mother as her hand wraps protectively around it. Her bare toes peeping from beneath her skirt contrast with the knight's mailed feet, increasing her aura of vulnerability as she stares fearfully ahead at the approaching enemies. The knight, on the contrary, is invulnerable. He stands foursquare against the enemy lances that

shatter against his huge shield. He is ready to strike—the arm holding the great broadsword is drawn back, prepared to thrust.

This depiction is no more realistic than that of Saint George: it is a stylized, universalized rendering of the symbolic defense of the nation. The knight protecting land and people is a popular theme; what sets Puchinger's poster apart is its style. Puchinger, from a prominent family of officers and officials, studied graphic arts and painting in several Viennese art schools and became involved with the Vienna Secession (*Wiener Sezession*) movement around 1900.[44] This group of young artists rejected contemporary academic styles, creating modern art that integrated decorative surfaces into the design. In practice, Secession designs tended to be somewhat flat, linear, and geometric, lacking traditional perspective. In graphic design, lettering was often integrated into the composition and surfaces decorated with repeated geometric patterns in various combinations, or with fragmented, mosaic-like designs (particularly associated with Gustav Klimt).

These stylistic characteristics shape Puchinger's poster. The linear qualities of the sword, the lances, and the knight's stance place the knight at the center of the image. The typical geometric checkerboard patterning appears on the stylized design of the shield and is echoed on the woman's dress, her braided hair, and the knight's chain mail. Against the simplified background, the image is at once both static and dynamic.

Of the posters that employ chivalric imagery, Puchinger's is particularly significant for its rendering of a fundamentally traditionalist theme in a modern style. Unlike France, which favored its Beaux Arts academic realism, or Britain and the United States, which relied on established advertising and illustration styles, Austria-Hungary more readily accepted modernist styles for its posters. The traditional intellectual elites were often opposed to modern styles because they regarded them as insufficiently elevated and serious for use in wartime, but there are enough extant examples to infer that the general public, which had been seeing modern posters since the beginning of the century, readily accepted them. As a group, the modern posters are some of the most aesthetically powerful of all the Great War posters.

POUR LA FRANCE, VERSEZ VOTRE OR

Jules-Abel Faivre
France, 1915

From the beginning to the end of four and a half long years of war, one fact remained immutable for the French people: France had been invaded. The durability of the *union sacrée*, the sacred union of political parties and people, lay in "national indignation at German aggression."[45] By the end of 1914, eight departments of northeastern France were wholly or partly occupied by the German army. The French rarely referred to them as "occupied," which implied permanency, but as "invaded," a temporary state that would be corrected by French arms.[46] The occupied northeast was also France's second-most industrialized region, comprising half her coal capacity, two-thirds of her steel capacity, and 2.5 million of her citizens.[47] The loss of the northern departments, following the forfeit of Alsace-Lorraine to Germany in 1870, cemented the French determination to resist and pursue the war through to victory.

Moreover, the German atrocities of the invasion, both real and exaggerated, convinced the French that the war should be interpreted as a struggle of civilization against barbarism. The barbarian *Boche* threatened not only the nation, land, and families of France, but civilization and humanity itself.[48] Writers and artists consistently represented German soldiers as simian beasts and rampaging Huns.

In order to sustain the war effort, the French government, like the other combatant governments, resorted to war loans. France issued four war loans: November 1915, August 1916, December 1917, and October 1918, as well as victory and reconstruction loans in the 1920s. This is Jules-Abel Faivre's poster for the First War Loan. Faivre was one of the most popular poster artists of the war. Originally from Lyon, he began his art studies there and then completed his training in Paris. He was also well known as a caricaturist, a skill on display in this poster and many others.

Faivre's poster illustrates many of the general characteristics of French wartime posters. Unlike the modernist styles that one occasionally encounters in German and Austrian posters, the perceived threat to French culture elicited a retreat into the classical, realist, and academic traditions. French poster art of the war is representational, drawing on the traditions of the École des Beaux-Arts. There are intermittent whiffs of impressionism, but it is almost as if Postimpressionism, fauvism, and cubism had not existed. The choice of style is dictated not only by the need to assert French cultural superiority, but by the purpose of the work. Propaganda posters need to present a clear, easily understood message capable of persuading the widest possible range of viewers. Avant-garde art is rare in propaganda, a rule that is equally apparent in World War II posters and modern political advertisements.

The reliance on traditional draftsmanship—a skill emphasized in the academic tradition—often brings with it a fairly monochromatic color scheme. Many posters are simply black and white and rely on sophisticated drawing for their effect.[49] The use of Roman typeface represents a related classical tradition. A few posters utilize French handwriting, but the default type is Roman, which contrasts sharply with the German preference for *Fraktur* (the standard typeface of the nineteenth century) or other Gothic styles.

Faivre's poster exhibits most of these characteristics, and adds design elements that typify his inimitable flair.

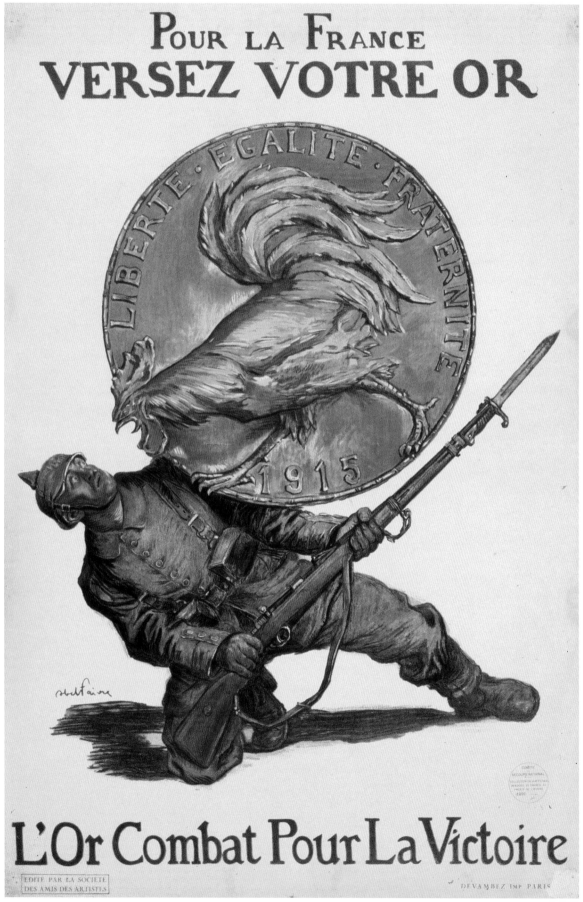

©2015 ARTISTS RIGHTS SOCIETY (ARS), NEW YORK/ADAGP, PARIS; LIBRARY OF CONGRESS: LC-USZC2-3865

The central image shows a German soldier under attack by a *coq gaulois*—the Gallic rooster, symbol of France—on a large gold coin. The German soldier, who looks both startled and frightened, wears the German field gray (*Feldgrau*) uniform. He is also wearing two items typical of French drawings of German soldiers: hobnailed boots and the German spiked helmet, the *Pickelhaube*. The boots suggest, at least in the Allied framework, the German desire to trample on the enemy, particularly on Belgian and French innocents. They figure largely in the wide range of caricatures that appeared after the initial invasion of Belgium, usually crushing women, children, and priests. The spiked helmet, here with its canvas field cover, was an object of French derision, and the most frequently used symbol for the *Boche* (German) soldier, especially in the early part of the war. As head protection the helmet was largely useless, and was replaced in 1916 with the iconic *Stahlhelm*, the steel helmet that became the most potent symbol of the German experience of the war. But for Allied propagandists, the spiked helmet reigned supreme throughout the war and well beyond it, reappearing in World War II images and even hanging on for the titles of the 1960s television show *Hogan's Heroes*.

Faivre's posters gain much of their dynamism from his use of diagonals. Here, there are two parallel diagonals: the rifle and the rooster. Soldiers are rarely depicted without their basic weapon, the rifle. In French posters, postcards, and magazine illustrations both German and French soldiers carry rifles with fixed bayonets, but with opposite meanings. In images of French soldiers, the bayonet represents élan and the cult of the offensive; in the hands of a German soldier, the bayonet, often dripping blood, symbolizes Hunnish brutality and barbarism. In this case, the rifle and its bayonet are useless. They are pointing away from the rooster, who has forced the soldier into a kneeling position of defeat and submission.

The Gallic cock, exploding from his coin to attack the enemy, provides the other diagonal. Animated animals as national symbols are everywhere in Great War propaganda; along with the French rooster, the German black eagle, the Austrian two-headed eagle, the English bulldog, and the Russian bear are the most widely used. As a symbol of France, the *coq gaulois* dates to the Roman occupation of Gaul, and probably has its roots in the similarity of the Latin word for rooster, *gallus*, and the word used to designate an inhabitant of Gaul.[50]

The clever cock Chantecler, who outwits the fox, originated in medieval French *fabliaux* (collections of animal fables) and was retold by Chaucer in the *Nuns' Priest's Tale*. The cock became more important in royal symbolism in the late Middle Ages and the Renaissance, emerging as a symbol of the nation under Louis XIV.[51] With the establishment of the Third Republic following the defeat of 1870, and its drive to rebuild the patriotic base of the nation, the cock, associated with "our ancestors the Gauls" (*nos ancêtres les Gaulois*), became not only a symbol of the nation, but also of "the people in arms and the vigilant state."[52] The cock is widely used in First World War propaganda, and is common on French monuments to the dead of the war.[53]

The *coq gaulois* first appeared on the coinage during the French Revolution in 1791, and remained there until 1914.[54] He is particularly prominent on the twenty-Franc gold piece, which is probably the model for the poster. The gold coin bears the motto of the French Republic, *Liberté, Égalité, Fraternité* (Liberty, Equality, Fraternity), around its border and the date of 1915. The date tells us that this is the First War Loan, although it is not stated on the poster. Unlike German and Austro-Hungarian posters, which generally state the number of the war loan, the French posters often omit the numbers or even, as here, any actual mention of a war loan. The text further clarifies the message of the belligerent golden cock, his beak open and feathers ruffled as he attacks. At the top it reads, "For France, Pour Out Your Gold." The possessives are forceful reminders that everyone must participate in order to save the country. The lower text reads, "Gold Fights for Victory," a double entendre already embodied in the victorious *coq gaulois*.

Humor is extremely rare in wartime propaganda posters (at least until the American posters come along), partly because posters were a major means of communication with the public, and because they fulfilled the serious public functions of promoting enlistment, donations, and support for the troops. In Germany and Austria especially, the posters partook of the high seriousness of wartime. But occasionally, in the French posters, there is a flash of the wit and satire so fundamental to French culture. This isn't the crude, often scatological humor found on all sides on postcards and in humor magazines. This poster is the visual incarnation of a witty French turn of phrase, the realization of ridicule.

THEY SERVE FRANCE

Anonymous
Canada, 1915

The maintenance of a strong interconnection between the fighting men and the people at home is a fundamental goal of propaganda in wartime, especially if the conflict is far away from the homeland, as it was in the case of Canada and later the United States. Positive morale on the home front, underpinned by belief in victory, was maintained by linking civilian and military service, however distant from the actual fighting. The obligation to serve, not limited to servicemen, but extended to all citizens (including women and children), totalizes the war effort by permeating the entire society.

As the soldiers serve by fighting, so must the people at home serve. The visual language of service winds its way through the propaganda of the Great War. It appears in the images of knights, wounded soldiers, industrial workers (male and female), nurses, and women doing agricultural work. The last of these is one of the enduring paradigms of the Great War. We denizens of the early twenty-first century recall with difficulty that the inhabitants of the early twentieth century lived in a far more rural world. In prewar France, for example, half the population lived on the land.[55] Even urban families often had relatives in the country.

National governments recognized both the actual and emotional aspects of an adequate food supply for the armies and the population. The European population was only a hundred years past subsistence farming and the shadow of famine. The bread riots of 1788 and 1789, and the revolution that followed, were part of the history and myth of the founding of the French republic. The starvation of the 1870–71 siege of Paris and the

Commune were recent events in the French consciousness. In Canada and America, those on recently settled land often lived close to the edge. The Central Powers introduced food rationing early in the war, no doubt in the hope of giving some appearance of evenhandedness to the process of food distribution, especially in the cities. Rationing was also designed to prevent hoarding, what the Germans evocatively called *hamstern* ("hamstering"), and black market activities. Their efforts met with varying success. In Germany, which also suffered from the British blockade of its trade, accounts of the latter part of the war are rife with hunger, black market trades, and city folk smuggling food in from country relatives. France and Britain, with relatively stable food supplies, only went to actual rationing late in the war.

The key crop in all of this was wheat, because bread really was the staff of life in most of the cultures, notably in France. Symbolically, bread was nourishment, and functioned as a kind of synecdoche for all food in posters and other propaganda. During the war, wheat production dropped by almost half in France and nearly half in Germany. In Austria, the loss was a whopping 88 percent.[56] For the Allies, much of that loss was made up by increased production in Canada and the United States. The centrality of grain production molds the propaganda images of agricultural work. The war began in August, coinciding with the harvest in northern Europe. With the sudden loss of male labor in France, old people, women, and children brought in the 1914 harvest, averting food shortages in the following winter.[57]

Images of women doing traditionally male farmwork recur frequently in propaganda posters, particularly

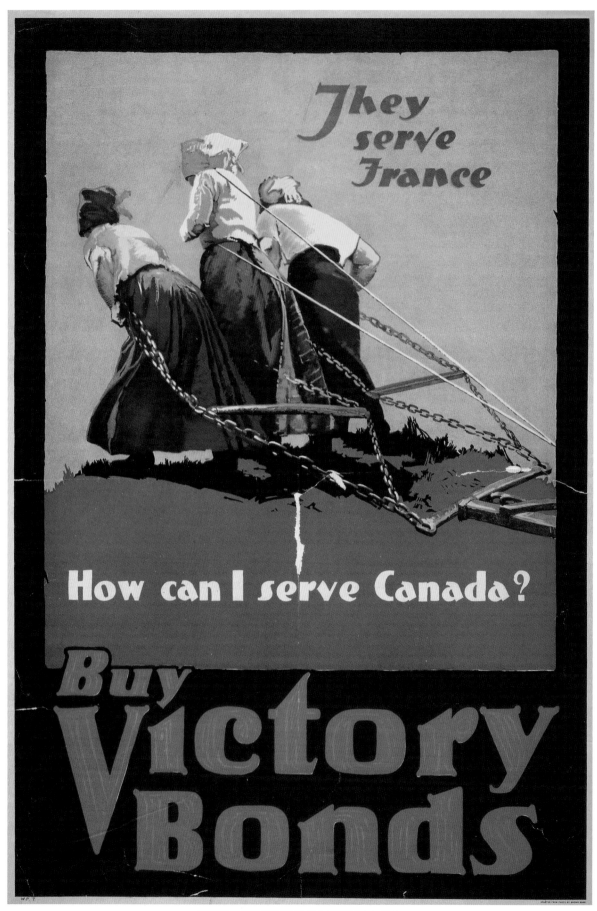

LIBRARY OF CONGRESS: LC-USZC4-12692

in France. This Canadian poster for victory bonds is based on a photograph from Brown Brothers, the stock photo supplier. It appeared in both English and French versions from 1915 to 1918. The image shows three women in rather drab traditional country dress, including caps, dragging a plow. They are bent forward with the effort as they drag the chains and ropes of the harness. Their faces are hidden, so they become, like the horses that have been requisitioned for the war, beasts of burden. They are not only doing men's work, but beasts' work. The diagonal lines of the ropes and harness echo the angles of their bent backs. As they struggle with the heavy plow, the women turn food production into a home front metaphor for combat. Their struggle is as acute and as essential as that of the men and animals they have replaced.

The English and French texts of this poster differ, and illuminate the differing appeals to English and French Canadians. The primary message, in large red letters that pick up the red of one woman's cap and another's skirt, is simple: Buy Victory Bonds (or in French, *Souscrivons à l'Emprunt de la Victoire*). Interestingly, the French uses the form of the imperative that means "Let's subscribe," creating a sense of inclusiveness not present in the direct English imperative. The text in the upper right, "They serve France" (*Elles servent France*), is identical. As noted earlier, the implication of obligation works through the word *serve*, and through the depiction of actual physical service, which is equated with the purchase of war bonds. Beneath the image the English text reads, "How can I serve Canada?" It is framed as a direct question, repeating the word *serve*, and invoking patriotism with its direct reference to Canada. The question is also very individualized, centering on the *I*. Faced with the image of women pulling a plow, the answer is provided by the exhortation to buy bonds. The English poster pulls together the obligation to serve one's country and the specifics of how to do that.

The French-language version strikes a slightly different tone. The text *Tout le monde peut servir* (Everyone can serve) omits the specific mention of Canada and avoids the direct question. It is a statement, not a personal call to action, although it implies that buying bonds is service. Despite the widespread perception that propaganda indulges in an in-your-face blatancy, it actually operates on very subtle linguistic and emotional levels. As mentioned earlier, French Canadians generally felt that neither Britain nor France was their mother country. They regarded the war as a British war, and thus had low enlistment rates compared to English Canadians and were generally less eager to participate in the war effort. They largely did not identify with France, so even attempts to play on historical cultural connections achieved little success. Henri Bourassa, the leader of the French nationalist movement, recognized the irony of the French expecting French Canadians to "offer the kinds of sacrifices for France which France never thought of troubling itself with to defend French Canada."[58] The French poster, like the English one, evokes sympathy for the laboring women by invoking the connection with France, but the plea to join them in their service is a muted one.

Both of these versions enlist the tried-and-true technique of eliciting guilt and shame in the viewer. Like the British recruiting posters, and modern pleas by humane societies and children's charities (however worthy the causes), they operate through emotional bullying. If the viewer fails to give, he or she is guilty of ignoring the suffering of others and should be ashamed. The unspoken message here is if women can pull a plow, you can buy a bond, and though the message could equally affect men and women, it seems to be aimed primarily at women. Like most posters involving food production and conservation, women were targeted because they controlled the household economy. Total war was waged at the kitchen table for the egg money.

ROTE KREUZ-SAMMLUNG 1914

Ludwig Hohlwein
Germany, 1914

Alongside the appeals for war loans, enlistment, and conservation, citizens were plied with entreaties from new and existing charitable organizations fulfilling a gamut of functions, from the relief of refugees, orphans, and animals to the care of wounded and disabled soldiers. By the support they provided, charities relieved the pressure on governments ill prepared to cope with the nasty realities of total war, of which the unexpected calamity of the Belgian refugee crisis was an object example.

As the German army swept through Belgium, its leadership was determined not to suffer again the depredations caused by *franc-tireurs* (guerrilla fighters) behind the German lines in 1870–71. In the course of August 1914, the German army killed at least 5,500 civilians and burned thousands of buildings, the most important of which was the great medieval library of Louvain. The atrocity stories—rape, cutting off the hands of children, using priests as clappers in their church bells—certainly grew better in the telling, but it seems clear that the Germans committed atrocities and killed significant numbers of civilians.[59] Panic engulfed the population, leading to a massive exodus into France and Holland and across the Channel to England. In Britain, the first welfare committees established were for relief of refugees and were welcomed by the British government.[60] Herbert Hoover first voluntarily arranged relief for 200,000 Americans trapped in Europe by the outbreak of war, then took over the Belgian relief effort as chairman of the Commission for Relief in Belgium.[61]

Governments had good reason to be grateful for the work of the charities and to encourage their activities, usually announced by posters. Not only did the raising of money and volunteers, especially female volunteers, spare money and manpower for the prosecution of the war, it provided civilians with an outlet for their generosity and a sense that they had a significant contribution to make. In short, the charities made civilians feel that they were "doing their bit." In the monarchies, charities often had a royal patron, providing female members of royal families with a visible role to play in the war effort. The part played by charities in the total national commitment to war is one of the reasons that the First World War is usually called the first "total war"—a war that mobilizes the entire population and all of its resources to defeat the enemy.

Of the established charities, none was more important than the Red Cross. It emerged from Jean-Henri Dunant's personal encounter with wounded men left to suffer on the battlefield following the battle of Solferino (1859). His memoir led to the creation of the first International Committee of the Red Cross in 1863, and the First Geneva Convention in 1864. That and subsequent conventions mandated the protection and neutrality of wounded soldiers and field medical personnel. Thus it was specifically focused on the care of the wounded, a focus that grew to include refugees and POWs. During World War I, the independent national Red Cross organizations were heavily involved in recruiting and training volunteer nurses, establishing hospitals, and providing medical care for the wounded.[62]

Not all Red Cross posters depict wounded soldiers, but many do. The goal of these posters, such as this one by Ludwig Hohlwein, was to evoke sympathy and encourage contributions from civilians. Such posters

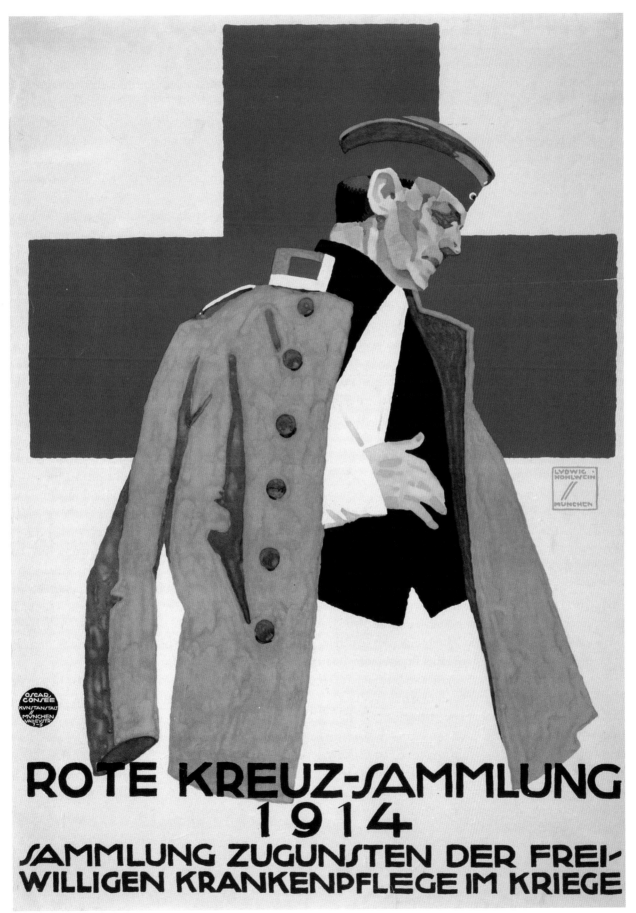

©2015 ARTISTS RIGHTS SOCIETY (ARS), NEW YORK/VG BILD-KUNST, BONN; LIBRARY OF CONGRESS: LC-USZC4-11639

utilize direct emotional appeals, with the wounded man as the focus of the image. The depiction of wounded soldiers posed special problems for those who commissioned and designed posters intended to raise money or enlist volunteers. The masters of the First World War battlefield—machine guns and high explosives with their shrapnel—wounded to an unprecedented and even unimagined degree. Men were simply torn apart or vaporized by high-explosive shells. Catastrophic wounds were common. French soldiers with devastating facial wounds, *les gueules cassées* (the broken faces), were numerous enough to form their own veterans organization. One need only look at the unsparing drawings of disabled soldiers by Georg Grosz and Otto Dix to grasp the extent of wounding.

However, Georg Grosz and Otto Dix didn't design Red Cross posters. They weren't trying to raise money. To create a wave of sympathy that would generate donations, the posters had to show men who were wounded "in a mentionable place," to borrow Sassoon's bitter phrase.[63] In short, the posters show men with relatively minor wounds, what British Tommies called a "blighty"—a wound bad enough to send you home but not bad enough to kill you or maim you permanently. The suffering of the wounded man is sanitized and modulated for civilian consumption. It raises concern, sympathy, and a desire to help, while avoiding the horror and repulsion that the depiction of severe wounds might elicit.

Hohlwein has met and exceeded all the requirements for a successful Red Cross poster, and done so in a modernist style. He began his artistic work as an architect, and then shifted to poster design in 1906. Like Lucian Bernhard in Berlin, Hohlwein, who settled in Munich, was influenced by the Beggarstaffs in England. They had developed a poster style relying on simplified images, bold lettering, and striking colors. Bernhard and Hohlwein became the leaders of the poster style called *Plakatstil* (poster style) or *Sachplakat* (object poster), after the monthly magazine *Das Plakat* that publicized the work of emerging German poster artists. With its simplicity (at least in contrast to the elaborate designs of art nouveau and its German version, *Jugendstil*) the *Plakatstil* of the early twentieth century accorded well with accelerating industrialization and the need for commercial advertising that sold products and could stand out from the welter of traditional posters on crowded hoardings and columns.[64] Hohlwein was already very successful by the beginning of the war, and went on to become one of the most important poster designers in Germany between the wars, eventually accepting commissions from the National Socialists.

This poster is typical of Hohlwein's style. The image of the wounded soldier, turned slightly to the side, forms a strong diagonal against the red cross on its white background. The bright white of the sling leads the viewer's eye to the soldier's face. The image is reduced to the minimum necessary to tell the story, most of it rendered in blocks of flat color in a limited palette of red, white, black, and tan. The soldier has his tunic draped around his shoulders and is wearing a soft garrison cap, not a helmet, signaling to the viewer that he is out of action. His face is the focus of attention. Hohlwein is justly admired for his subtle use of shading (probably based on photographs), which here conveys the muted and patient suffering of a noble soldier. With the slightly hunched shoulders and the empty sleeve of the jacket, Hohlwein economically turns the man into an object of immediate sympathy. The simple, squared-off letters of the text with the slanting *s's* are characteristic of Hohlwein's typography. The text announces that the Red Cross campaign of 1914 is for the benefit of volunteer nursing in wartime. Even without Hohlwein's iconic signature on the right—his name with two diagonal lines leading down to the name of his town, München (Munich)—his style is immediately recognizable.

As with the wartime Secession posters, this poster conveys its plea in the garb of the modern commercial poster. It is exceptionally handsome, as are a number of other posters Hohlwein made showing wounded soldiers, and it demonstrates the power of modern design to sell ideas, a power that would not be overlooked by Adolf Hitler.

IN DEO GRATIA

Fritz Boehle
Germany, 1915

At first glance this could almost be a late medieval engraving or a page from a book of hours: the crusader knight at prayer, the beautifully rendered warhorse, the Latin title in a Gothic script, the scrolling decorative borders. But the image is not from the German late Middle Ages. It is Fritz Boehle's 1915 poster *In Deo Gratia* (Thanks be to God). The poster is probably the Great War's best example of the conflation of two major nineteenth-century movements: medievalism and nationalism. And nowhere in Europe did those intellectual and political currents come together as spectacularly as in Germany.

The image of the soldier/warrior is fundamental in war propaganda. Because the soldier fights to protect his homeland, he becomes the embodiment of the virtues of the nation. In any country at war, "our" soldier is the ultimate "we." He incarnates everything that we believe ourselves to be. The enemy, equally, represents the opposite: the negation of "our" virtues and the embodiment of evil.

Knights and heroic warriors from the Middle Ages link the modern soldier to his illustrious forebears. The use of such themes in Great War images and texts is a logical efflorescence of the nineteenth-century obsession with all things medieval. Emerging from the romantic yearning for a pre-Renaissance, preindustrial world in which rationalism and materialism had not severed the links between God, man, and nature, the Middle Ages seemed to literate Europeans of the nineteenth century to incarnate everything that was missing from their own time, especially the chivalric ideals of prowess, devotion, duty, and sacrifice.[65] The urge to escape what they perceived as the straitjackets of neoclassicism and academic art drove the Nazarenes in Germany, the Pre-Raphaelites in England, and William Morris and his followers in the arts and crafts movement to revive the medieval ideals of honesty, spirituality, and craftsmanship.

As romantic artists and writers turned away from the ideals of classicism, regarded as ancient and universal, they equally turned toward the Middle Ages as the origin and source of their own specific national languages and identities. In Germany, the linguistic nationalism of Fichte encouraged romantic philosophers, philologists, and poets to steep themselves in the origins of the German language (the Grimm brothers) and the great epics of medieval Germany (the *Niebelungenlied*, *Parzifal*, and *Tristan und Isolde*).

The cultural politics of the rise of the unified German state in the mid-nineteenth century were deeply entwined with the glorification of the medieval German empire. The Holy Roman Empire of the German Nation (*das Heilige Römische Reich deutscher Nation*) was the First *Reich* (empire or kingdom); the empire of 1871–1918 the Second. Symbolic visual links between the empires shape the national monuments of the Second Empire. A striking example is the Kyffhäuser monument to Friedrich Barbarossa—built on the ruins of Barbarossa's castle, and centered on a monumental statue of the medieval emperor enthroned behind an equestrian statue of Wilhelm I, first emperor of the united Germany. The wildly popular *Wandervögel* movement of the beginning of the twentieth century—young men, mostly students, exploring the German countryside, living simply, singing folk songs, searching for folklore, and emulating medieval

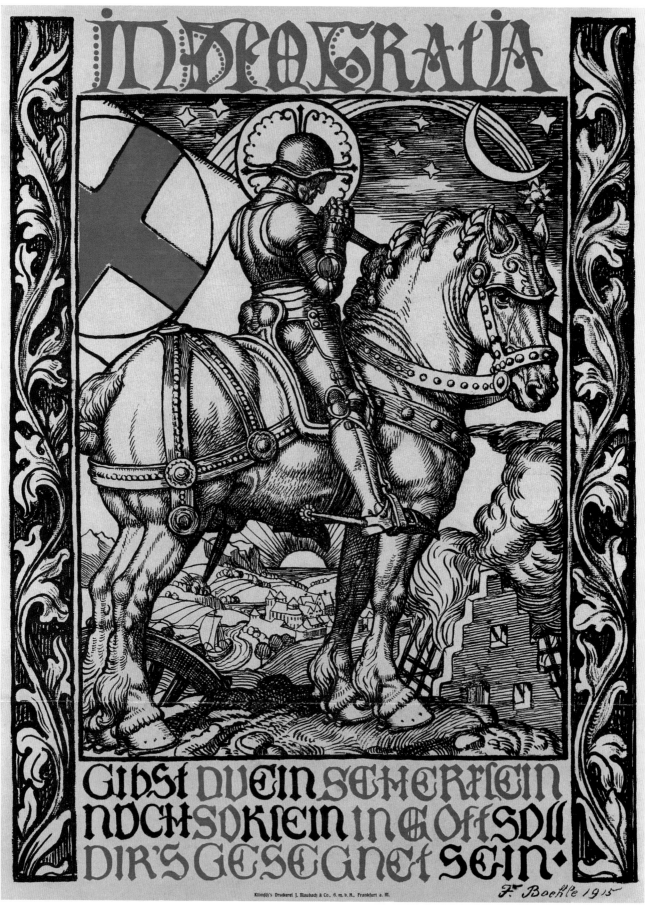

©IMPERIAL WAR MUSEUMS (ART.IWM PST 2660)

customs and titles—was deeply imbued with romantic nationalism.[66]

In a nation awash in romantic medievalism, the coming of war in 1914 offered many opportunities for artists and poster designers to exploit medieval images. In general, overtly medieval images and references to legendary figures from medieval literature (e.g, Siegfried), are far more common in Germany, and to some extent, Austria-Hungary, than in the other combatant nations. Thus Boehle's poster, although unique in some ways, is also part of a wider tendency to use medieval themes and motifs to emphasize the long history, and therefore authenticity and cultural superiority, of the German nation.

As an artistic realization, Boehle's poster is the ultimate wartime homage to the medieval German knight. The quintessential German late-medieval artist is Albrecht Dürer, whose engraving *Saint George and the Dragon* of 1508 (begun in 1505) is the historic model for the poster. Boehle had studied art in his home city of Frankfurt, where he focused on equine anatomy and created many images of knights; he also completed the obligatory student trip to Italy, and on his return became especially attached to medieval images and to the style of Dürer.[67] Absent the dragon, Boehle's lithograph is very closely based on Dürer's *Saint George*. Saint George was an all-purpose saint in the visual propaganda of the First World War. As the patron saint of England, his appearance is expected in British propaganda, but he shows up almost everywhere.[68] Since the dragon easily serves as a metaphor for evil and thus for the enemy, dragon slaying was an irresistible motif for propagandists.

But Boehle has done something unexpected with Dürer's image. Although obviously derivative, there are some significant differences. Dürer depicts the saint in his moment of triumph, the slain dragon lying at his feet. His halo is conspicuous, as is the indication of the cross of Saint George on his banner. He seems to exhibit a calm certainty in his prowess; his faith and the strength that comes from it have destroyed evil. He displays the same steadfast faith as the knight in Dürer's *Knight, Death and Devil* of 1513, stoically riding past death and evil.

Alone, astride his horse, Boehle's knight has taken a moment to pray. It is unclear whether the halo is meant to indicate sainthood (most educated Germans would have recognized the similarity to Dürer's engrav-

ing), or simply the profound devotion of an ideal knight. Similarly, the banner with its striking red cross could be the flag of Saint George, or that of a crusader. References to the Crusades were common during the Great War, since parallels to holy war and sacrifice for sacred values ennobled the modern war. (Even Gen. Dwight Eisenhower referred to the invasion of Europe in the Second World War as a "crusade.") Unlike its Dürer prototype, the horse in Boehle's poster is not looking straight ahead, but steadily regarding the viewer. Although the technique of direct eye contact with the viewer is fairly common in the advertising and propaganda posters of this period (the most famous example is the Lord Kitchener/Uncle Sam recruiting poster), here the horse's glance breaks the knight's solitude by drawing the viewer into the scene.

The background of Boehle's poster is a landscape in the medieval idiom. On the right-hand side, a northern German step-gabled house is on fire, its roof already burned down to the rafters, suggestive of the many woodcuts and engravings of the Thirty Years' War, and certainly meant as a symbol of destruction and loss. On the left side there appears to be a broken wheel, perhaps an allusion to the medieval Wheel of Fortune, symbolizing changing fortune from which death is the only escape. Between the horse's legs a peaceful river valley opens, with a rising sun in the

background, conventionally signaling hope. But above the heads of the knight and his horse is a night sky with the moon, stars, and a streaking comet. The simultaneous presence of the rising sun and the night sky is a reference to Altdorfer's *Battle of Alexander*, however glancing, but it may also imply the totality of God's creation, a creation that includes war.

The image is enclosed by text on the top and bottom, with decorative side borders faintly reminiscent of Dürer's borders for Emperor Maximillian's prayer book. The title, *In Deo Gratia* (Thanks be to God), is in red, as are the cross on the banner and selected words of the text at the bottom of the poster. The lettering is meant to look medieval although it is not the typical *Fraktur* common to many First World War German posters, nor does it seem to be a single historical style. It rather resembles Carolingian styles, including semi-uncial and rotunda, but is a combination of medieval styles, simplified for readability and rendered in all capitals.

The message *Gibst du ein Scherflein noch so klein in Gott Dir's gesegnet sein* (Give even the smallest mite, God will bless you for it) is an invitation to contribute, but the reason for the contribution is obscure. This may have been a poster for one of the nine war loans (*Kriegsanleihe*), as the Second War Loan was announced in March 1915 and is therefore close to the date of the poster, which is signed and dated in the lower right corner. The red cross in the knight's banner suggests that it might have been created for the Red Cross. Whatever the source of the solicitation, it is a very gentle request, quite unlike the vehement demands and commands of most war loan posters. Here, the giver is addressed by the familiar *du* and is told that he will be blessed for even the smallest contribution. The words picked out in red carry the weight of the message, and contribute to the medieval tone of the poster. In addition, the language, although not technically archaic, has a traditional tone, especially the word *Scherflein* (a mite) with its German diminutive ending.

Of World War I posters using chivalric imagery, Boehle's poster is an outlier. Virtually all the posters that use knightly images show the knight in action or reaction—slaying, thrusting, or defending. Whatever his action, he embodies the ideals of strength and prowess. Boehle's "parfit, gentil" knight embodies that other virtue of knighthood: dutiful service and devotion. This poster stands as an early example of a characteristically German type of poster, one with the exhortation to serve steadfastly to the end. Boehle's image is the visual correlative to the verb *durchleben* that appears frequently in the German literature of the war. The verb means to live through something, but as used in World War I, has the connotation of holding fast to the end, whatever that end may be. Steadfast service was a knightly virtue that would be much needed in Germany.

WEIHNACHTEN IM FELD!

Adolf Münzer
Germany, 1914

By December 1914 the early battles of the war—the Battles of the Frontiers and of the Marne, the Race to the Sea, First Ypres—were over; both sides had dug in, creating a line of trenches that stretched over four hundred miles from the English Channel to the Swiss border. On both sides the casualties had been enormous. The French had suffered most, losing 306,000 men in the first five months of war. Germany had lost 241,000 men, Belgium and Britain had each lost around 30,000, wiping out the "Old Contemptibles" of the BEF.[69] In 1914, the French army averaged 2,000 deaths per day.[70] As Christmas approached, the war settled into a stalemated front that would move scarcely at all for the next four years.

The war had not begun that way. For the German army, above all, it had been a war of rapid movement—not quite the Blitzkrieg of twenty-five years later, but nonetheless very fast for an army that still moved at the pace of marching infantry and horse-drawn vehicles. Speed was the key to resolving Germany's existential military problem: geographically Germany was trapped between two enemies, France and Russia, and faced a war on two fronts. By the beginning of the twentieth century, France was protected by a bastion of formidable forts on its eastern frontier; Russia, as always, was protected by its great distances. The Russian plain had swallowed many armies. How could the German army defeat both?

Enter Count Alfred von Schlieffen, chief of the Great General Staff from 1891 to his retirement in 1905. Obsessed by the double envelopment of Cannae, he was convinced that the only way to solve the strategic conundrum was to first engage and defeat France by sending the German army crashing through neutral Belgium and northern France in a great wheeling arc north and west of Paris, trapping and annihilating the French army within forty-two days of mobilization. The German army could then turn back to face the slow-mobilizing Russians.[71]

For German soldiers participating in the great invasion, the reality was exhaustion. Most of the accounts of this period, even the fictionalized ones, speak of the heat (it was the warmest August in years), the woolen uniforms, heavy packs, long marches, and blisters. Despite the soldiers' efforts and partly because of poor German generalship, the Schlieffen Plan disintegrated, allowing the French and British troops to stop the advance on the Marne and initiate the so-called Race to the Sea. The objective of the German army then became to flank the BEF, maneuver through the narrow, unprotected (so they thought) plain along the English Channel, and thus penetrate into France by the back door. Instead they met stiff resistance from the Belgian army, followed by King Albert's decision to open the sluices on the Yser River, creating an impassable flood zone north of Dixmunde.

The subsequent determination of the German command to break through along the Yprès salient led to one of the saddest and most mythologized episodes of the war. The units that launched a major attack against the BEF on October 30th were largely formed of students, the much-honored *Freiwillige* (volunteers) who had enlisted at the outbreak of war. Among them was Austrian Adolf Hitler, who had petitioned the King of Bavaria to be allowed to join the Bavarian army. These patriotic innocents received a couple of months of training and then were thrown into combat. They advanced in mass formations, providing excellent

LIBRARY OF CONGRESS: LC-USZC4-11708

targets for the disciplined fire of the British regulars, whose rate of fire was so rapid the Germans mistakenly took it to be machine-gun fire.[72] The legend of Langemarck (as the Germans call the battle) was that the young volunteers, overcome with patriotic fervor, charged into battle shouting "Hurray" and singing *Deutschland, Deutschland über alles*. That, at least, is the version presented by Hitler in *Mein Kampf*, and repeated in the 1932 official history of the 16th Bavarian Reserve Infantry Regiment. There is considerable evidence that German soldiers sang patriotic songs early in the war, but the song of choice was always *The Watch on the Rhine*, familiar to Americans as the song sung by the Germans in *Casablanca*.[73] By early November the offensive had failed at great cost, especially to the volunteer regiments. Over 130,000 German soldiers died in the fighting around Ypres between mid-October and the end of November, 41,000 of them volunteers.[74] It became known as the *Kindermord bei Ypern*, the Massacre of the Innocents at Ypres, and it raised in Germans, both at home and in the field, the awareness that the great gamble had failed, and that the boys wouldn't be home by Christmas.

Christmas was then, and remains, the most important of German holidays. And of all the symbols and traditions of Christmas, the Christmas tree is the most cherished. Probably originating in pagan Germanic practices, the act of bringing evergreen branches or a tree into the house at Christmas was already well established in Germany before Prince Albert introduced it to Britain in the 1840s. The custom also evokes the archetypal German forest, enshrined in myth, legend, and fairy tale. Adolf Münzer's choice of a Christmas tree for his *Weihnachten im Feld!* (Christmas in the Field) is calculated to arouse empathy and encourage generosity. The poster depicts a lighted fir tree in front of a red cross. The glowing candles, artfully arranged in inner and outer triangles, emphasize the shape of the tree against the red and white background. The text, in simple block letters, urges viewers to send gift parcels (*Liebesgaben*) for *unsere Krieger* (our warriors). As the image recalls Germanic forests, the word *warrior* evokes ancient Germanic warriors, who are the ancestors of "our" warriors. As is usually the case in propaganda, the possessive creates a connection between the civilian at home and the soldier at the front. The soldier-warrior is enshrined as the honor of the nation, heir to a long line of warriors stretching back into the mists of the Germanic past.

Münzer studied art in Munich and joined the artists' group *Die Scholle*, of which Fritz Erler was also a member. In 1915 he worked as a war artist at the front and enlisted in 1917, although he didn't serve.[75] The influence of *Die Scholle*, a group that wanted to create a specifically German art, and of *Jugendstil*, with its geometric shapes and simplified lines, are evident in Münzer's poster. But it is obvious that Münzer had also seen works in the German poster style of Lucian Bernhard and Ludwig Hohlwein. The simplified forms and areas of flat color strongly suggest modern German posters of the period.

Christmas 1914 was the first Christmas in the field for the armies. Indeed it was the first Christmas that the German army had been in the field since 1870–71. As the holiday approached, families sent gifts to their relatives in the trenches, as did organizations that raised subscriptions for the purpose (often with royal patronage). The now-famous Christmas truces of 1914 are part of the myth of the war, and myth and fact are difficult to disentangle. There are sufficient eyewitness accounts to suggest that some truces took place, particularly between German and British troops in Flanders. They seem to have involved the singing of Christmas carols, small lighted trees on the parapets, an informal cease-fire agreement, fraternization in no-man's-land, and the exchange of small gifts.[76] Most famous of all are the soccer matches between British and German troops. Needless to say, commanders frowned on the informal truces, and it was soon back to war as usual.

For historians of a romantic and idealistic turn of mind, the Christmas truces have been painted as a triumph of humanity over militarism—a brief interval of peace and goodwill in a maelstrom of blood and destruction. This Rousseauistic view has gained even more credibility in recent years with the film *Joyeux Noël* (2005). One point is overlooked in most analyses: the experience of the trenches irrevocably separated combat soldiers of all sides from the men who stayed behind the lines and the civilians who stayed at home. In Flanders and northern France one trench was pretty much as cold, wet, filthy, and miserable as another. The belief of the soldiers that the experience created an unbreakable kinship between them runs through French, German, and British literature. The truces marked an end point—the last point at which the front soldiers still felt free enough to openly express their kinship with one another.

ENLIST

Fred Spear
United States, 1915

A woman in white, her baby held close in her arms, drifts softly through green water to the seafloor. The bubbles of her last breath mingle with her floating hair. Two vicious fish circle while the strands of seaweed reach up for her. The enigmatic image is rendered more impenetrable by the single word *Enlist*. This is one of the most visually stunning of all World War I posters and one that perfectly illustrates two guiding rules of propaganda posters: without context the image, however moving, is meaningless; with context, the image tells the story. Joseph Pennell, one of the leading poster artists of the period, maintained that even people who could not read should be able to understand a poster "if the design is effective and explanatory."[77] In the Western world literacy had reached a high level by 1914, but he is nevertheless correct that in most posters, the image tells the story and therefore carries the weight of the message. That is why the text-only posters of the beginning of the war were quickly abandoned.

In the case of Fred Spear's poster, the context is the sinking of the British passenger liner *Lusitania* by a German submarine off the south coast of Ireland on May 7, 1915. In the forty years of peace that preceded 1914, the "freedom of the seas," the right of merchantmen of any nationality to transport and deliver cargoes where they pleased, unmolested, was enshrined in international maritime law. Since the world's goods moved by ship, shipping became a legitimate target of economic warfare in 1914. Geography provides the key to the combatants' problems. Landlocked Germany, with coastline only on the North Sea west of Denmark and on the Baltic Sea east of Denmark, was liable to blockade by the powerful British navy. Britain, an island nation, was totally dependent for its survival on import of foodstuffs and export of industrial goods.[78] As soon as war was declared, the Germans mined the east coast of England. The British replied by mining German North Sea routes.[79] By August 20, 1914, the British government had decided to blockade Germany to prevent both absolute contraband (arms and munitions) and conditional contraband (foodstuffs and commodities necessary for waging war) from reaching German shores.[80] Little by little, any products that would strengthen the Central Powers' forces and populations were cut off, including meat, metals, and oils.[81]

At the beginning of 1915, the German government decided to strike at British economic life by blockading Allied shipping. The weapon of choice was the submarine, which the Germans called an *Unterboot*, or U-boat. They quickly built up their U-boat fleet, and by the spring of 1915 were conducting operations in the Atlantic approaches to Britain.[82] The German submarines were conducting what is usually called "unrestricted" submarine warfare. International law concerning commerce raiding stipulated that an attacker had to give a merchant ship warning before sinking, allow crew and passengers to take to the lifeboats, provide them with food and water, and assist their passage to the nearest land.[83] In February 1915 the German government rejected that law and declared all the waters surrounding Great Britain and Ireland to be a war zone in which enemy ships would be attacked and destroyed. The statement also maintained that due to the "misuse" of neutral flags by British ships, neutral ships were also open to attack.[84]

©IMPERIAL WAR MUSEUMS (ART.IWM PST 3284)

The RMS *Lusitania* was one of the largest of the Cunard transatlantic fleet. It had flown a neutral flag during a January voyage due to reports of U-boats. Despite newspaper warnings of increased danger to neutral merchant shipping, in May the *Lusitania* sailed again, this time from New York bound for Liverpool. It was struck off Ireland with a single torpedo fired without warning, and sank in just over fifteen minutes, listing so quickly that only a few lifeboats could be lowered. Nearly 1,200 passengers lost their lives, 128 of whom were Americans.[85] Controversy over the contents of the *Lusitania*'s cargo hold, whether or not she had naval guns fitted (she had been constructed for conversion to a cruiser if necessary), and whether she represented a legitimate target for German submarines continues to this day.[86]

But in 1915, reaction on both sides of the Atlantic was shocked outrage. Spear's ethereal, impressionistic poster, published by the Boston Committee of Public Safety, apparently originated from a newspaper report describing bodies from the wreck that had washed ashore in Cork. According to the account, a woman tightly holding a baby had washed up, and "[N]o one has tried to separate them."[87] Spear's image actualizes the huge loss of life in a single loss—that of a mother and her child. The child appears to be naked, and the woman's bare feet and arms signal their vulnerability, implying that death has come upon them with no warning. The floating gown and hair elevate the drowning woman and her child to symbolic victims of German treachery. Her expression is serene, as if she has resigned herself to her fate. But the large, prowling fish suggest the prowling submarines, lurking beneath the surface, ready to deal out more death and destruction. Spear's anger is embodied in the single word *Enlist*. The appropriate response to barbarism is action.

The call to enlist was gaining traction in America, where the U.S. government lodged a strong protest sug-

gesting that the United States might intervene in the war against Germany. The German government, faced with a propaganda disaster and the action they most feared—American intervention on the Allied side—backed away from the policy of unrestricted submarine warfare. From mid-1915 until the beginning of 1917, Germany practiced restricted submarine warfare: all neutral merchantmen and passenger liners were exempt from attack.[88] Nevertheless, pressed by the tightening blockade and the losses sustained in the 1916 *Materialschlacht* (war of materiel), Germany resumed unrestricted submarine warfare in February 1917.

The sinking of the *Lusitania* proved to be an enormously expensive mistake for Germany, not merely because of the propaganda coup handed to the Allies, but because it initiated the gradual undermining of American neutrality. The intrusion of German barbarism into American life made the *Lusitania* as much of a cause célèbre as the *Maine*. In spite of neutrality, 26,000 American men enlisted in the French, British, and Canadian forces.[89] Voluntary officer training began in the summer of 1915, and the National Defense Act of 1916 initiated the tripling in size of the regular army.[90] American anger, temporarily tamped down by diplomacy and the cessation of unrestricted submarine warfare, was primed to explode with the resumption of unrestricted U-boat warfare and the revelation of the Zimmermann telegram in early 1917.

Ultimately, the German attempt to destroy Allied shipping and deal a knockout blow on the Western Front before the United States could mount a creditable force in France failed. Spear's poster, along with other early posters encouraging enlistment and training, played a role in turning public opinion against the Central Powers and preparing the American people for war.

1916

GOLD ZERSCHLÄGT EISEN

Julius Diez
Germany, 1916

Propaganda posters usually rely on a clearly stated, unambiguous message, but here we have the poster as paradox—one with roots in the nineteenth century and ultimately in the dim reaches of Germanic mythology. The paradox is posed by the title, *Gold zerschlägt Eisen* (Gold shatters iron), a statement that appears to be patently untrue. How can soft gold shatter hard iron? The answer, of course, is that gold donated to the war effort provides the means to shatter the iron weapons of the enemy, symbolized by the iron chain. So the poster urges the viewer *Bringt euer Gold zur Goldankaufstelle* (Bring your gold to the gold purchase authority). The paradox, both textual and visual, relies on the legendary qualities of the two metals and their historical uses in German culture.

Julius Diez was a member of the *Jugendstil* movement in Munich. Aesthetically this style emphasized bold lines and areas of flat color. Diez was known for his ability to mix archaic and modern elements, as he does here.[1] The image is dominated by the figure of a young woman in a golden gown (rendered in lines), with flowing golden hair surmounted by a crown bearing the word *PAX* (peace). She carries a stylized sheaf of wheat in her left hand and looks back at the dove of peace alighting on her right. She represents peace, plenty, and fertility, and is probably a reference to Freya, the goddess of love and fertility in Germanic mythology. The heavy iron chain that binds her to the large stone, a reference to the "iron" fetters of war, has been broken by the golden hammer. The hammer rests on top of an anvil-like stone, its handle striped in the black, white, and red colors of Imperial Germany. The flat black background is broken up by streaks of green lightning. The hammer and streaks of lightning are references to the hammer of Thor, *Mjöllnir*, an old Norse word meaning lightning. Mjöllnir was the greatest weapon of Asgard, the stronghold of the gods. When Thor, the god of physical strength, used it in battle, it flashed lightning, but it was also an instrument of protection and blessing.[2] Visually, the gold hammer frees the golden figure of Peace from the iron chains of war.

Iron and its symbolic associations reverberate across nineteenth-century Germany from the Wars of Liberation through the speeches of Bismarck and Wilhelm II and finally to the nail monuments of the First World War. The Iron Cross, the highest award for valor in Prussia and later Imperial Germany, originated during the Wars of Liberation from Napoleonic France in 1813. Karl Friedrich Schinkel, Berlin's greatest classical architect, collaborated with King Friedrich Wilhelm III on the design of the Iron Cross. It was modeled on the cross of the Teutonic order of knights, founded in 1198. Iron was chosen over precious metals because of its link to Germanic mythology and as a symbol of sacrifice to the fatherland. It thus unites Christian, chivalric, and nationalist imagery, which may account for its potency as a symbol for the nation.

In another form of sacrifice, the peculiarly German tradition of giving gold for iron was also born in 1813. In order to pay for the war to liberate Germany from French rule, the crown urged Prussian citizens to contribute gold jewelry, for which they received iron jewelry in exchange. The iron jewelry often bore the inscription *Gold gab ich für Eisen 1813* (I gave gold for iron 1813), and the iron jewelry became a popular emblem of patriotic sacrifice.[3]

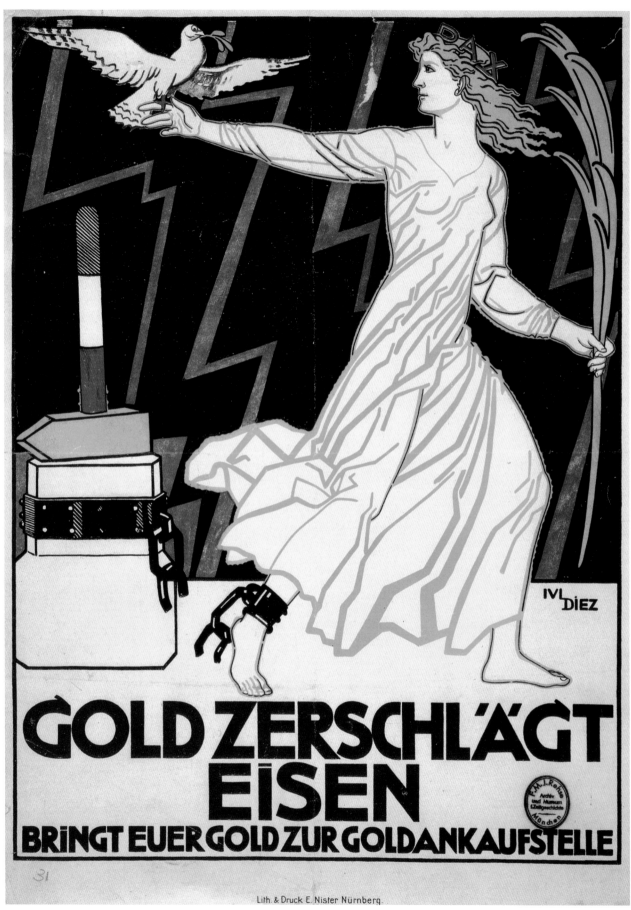

LIBRARY OF CONGRESS: LC-USZC4-11526

Iron as an emblem of patriotism also runs through speeches of Bismarck and Wilhelm II. The most resonant is the speech Bismarck delivered to the Budget Commission in September 1862 during a constitutional crisis. He famously stated that the great questions of the day would not be resolved by speeches and majority decisions—a clear dismissal of parliamentary rule—but by "blood and iron" (*Blut und Eisen*).[4] The speech solidifies the link between war and iron in the Prussian-led unification of the German states during the 1860s. Wilhelm II followed Bismarck by glorifying the "iron fist" (*eiserne Faust*) of Germany in an infamous speech on the German occupation of Tsingtao in 1897.[5] With its rich medieval associations and the implication of both strength and endurance, the "iron fist" or "mailed fist" was an idea fixed in German thought even before the war.

Those knightly qualities were embodied in 1915–16 in the so-called nailing monuments. Communities throughout Germany erected wooden monuments into which citizens of all walks of life were invited to hammer iron nails. Participants contributed to war charities for the privilege, and received a certificate in return. Knights were one of the most popular images, along with iron crosses. The significance of the nailing ritual rests in the symbolic link between the soldier—figured as a mailed knight, an iron warrior—and the civilian who thus displays commitment, however distantly, to the cause.[6]

In 1916, the imagery of iron as a symbol of strength and endurance became even more significant in the face of the *Materialschlacht* (war of materiel). The battles of Verdun and the Somme employed the new industrialized warfare of shells and machine guns to an unprecedented degree. Millions of shells rained down on French, German, and British troops during those battles, to say nothing of the lesser, but also costly, assaults of 1915 and 1916. The helplessness of soldiers under shellfire forms one of the most consistent themes in the literature of the war. The only moral quality of value was the inner strength to endure the terror of being shelled, the "iron will" to carry on in the full realization that golden peace was nowhere to be found in a storm of iron and steel.

ON LES AURA!

Jules-Abel Faivre

France, 1916

Abel Faivre's soldier, the incarnation of French élan, charges forward, shouting to his comrades to join him with *on les aura!* (we'll get them), the resounding slogan of the war and the embodiment of the offensive. In the years after the military debacle of 1870, the French nation and its army were forced to come to terms with a crushing defeat at the hands of the German army, the loss of the provinces of Alsace and Lorraine, and a generalized sense of national calamity. In the ensuing years of peace, the Third Republic gradually rebuilt the nation's sense of itself through relatively stable governments and extensive inculcation of republican patriotism in the newly created free public schools.

As it rebuilt, the French army faced two major problems: one sociopolitical, one demographic. The sociopolitical problem involved the conflict between the republican concept of a conscript citizen army (originating in the 1792 mass rising, the *levée en masse*) and the predominantly nationalist and Catholic professional officer corps. The latter did itself incalculable damage in the long course of the Dreyfus affair, when it closed ranks to cover up a patent miscarriage of justice. Alfred Dreyfus, a Jewish officer, was in 1894 falsely accused of espionage and treason, found guilty, and sent to Devil's Island. His conviction became a cause célèbre with Émile Zola and the liberal press, and dragged on for a dozen years until Dreyfus was cleared in 1906. The Dreyfus affair split France in two, and merely confirmed republican suspicions of the army, which led to a purge of Catholic and monarchist officers at the turn of the twentieth century. With the National Assembly's 1905 revocation of the 1805 concordat between France

and the Catholic Church, and the subsequent conclusive separation of church and state, Catholic officers (urged by the pope to resist the legislation) were forced to choose between faith and nation, bringing civil-military relations to an all-time low.[7]

The demographic problem was France's stagnant population of around 40 million. Germany's population, on the other hand, had increased from 41 million in 1871 to 65 million in 1911. Simply put, Germany had more men to mobilize than France did, and the Germans' system of conscription and integration of reserves allowed them to field a larger army. Along with actively encouraging a higher birth rate, French governments before 1913 had gradually reduced the term of service, but removed exemptions so the obligation to serve was more equally distributed over the male population. In 1913 a law requiring three years' active service finally passed, allowing for the draft of a higher percentage of men.[8]

The rebirth of French nationalism from the ashes of 1870, sustained by a new army permeated by republican values, also gave birth to military doctrine: the doctrine of the offensive to the limit, *l'offensive à l'outrance*. In the first years of the twentieth century, the doctrine of the offensive was based on two principles: first, that attack is always superior to defense, and second, that moral superiority trumps physical superiority. In short, an attack carried out by motivated, patriotic troops had to succeed. The war had to be carried to the enemy. The symbol of the offensive was the bayonet, and a bayonet attack—although such assaults scarcely ever occurred in the First World War—was glorified as the epitome of French élan.[9] It is difficult to find an image of a rifle

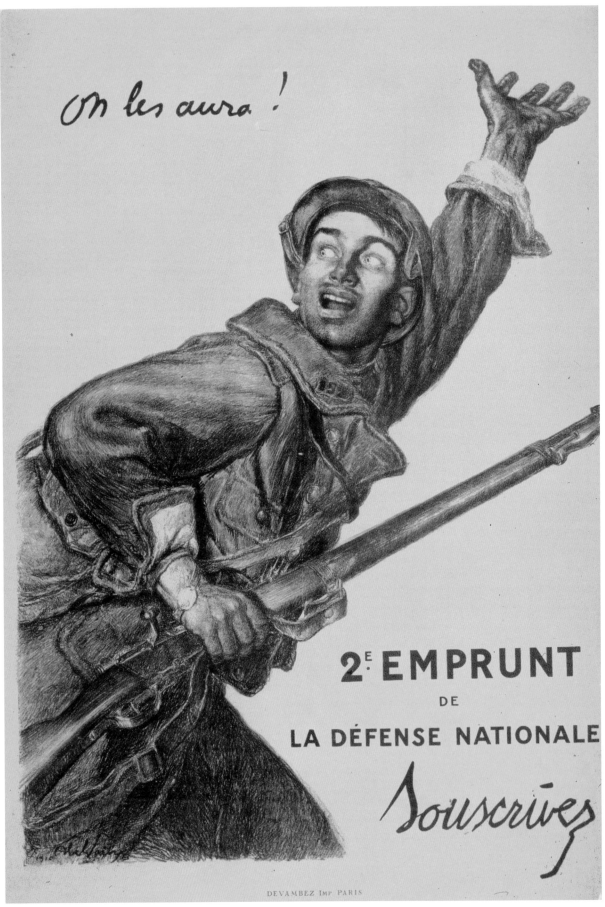

©2015 ARTISTS RIGHTS SOCIETY (ARS), NEW YORK/ADAGP, PARIS; LIBRARY OF CONGRESS: LC-USZC2-3863

without a bayonet attached. In the case of Faivre's poster, one must assume its unseen presence.

The doctrine of the offensive found its potential expression in the French war plan, Plan XVII, adopted in April 1913 under the auspices of Chief of Staff Joseph Joffre, who would also be in command of the French army in August 1914. A cornerstone of French nationalist thought was *revanche* (revenge)—a commitment to revenge 1870 by retaking the "lost" provinces of Alsace and Lorraine. Imbued with the doctrine of the offensive, Joffre mandated that in the event of war, his forces should attack the Germans immediately, which meant across the common border into Alsace-Lorraine. In practice, the attack eastward from Verdun went well for several days as the Germans executed a planned withdrawal. When they counterattacked, the French retreated and Plan XVII ended in a shambles.[10] With the great right wing of the German army cutting through Belgium and into northern France, the French were forced onto the defensive.

The largely defensive battles of 1914 did not disabuse the French leadership of the power of the offensive. In 1915, French units attacked fortified positions in Artois, most importantly Vimy Ridge, and in the Champagne. When the fighting petered out near the end of the year, little had been gained, and the French had suffered nearly 144,000 casualties. But even in 1916, Faivre's young soldier, clad in the horizon-blue uniform (*bleu horizon*) and the Adrian-pattern helmet, is on the offensive. French troops going to war in 1914 could have been mistaken for their grandfathers of 1870, still dressed as they were in red trousers (*pantalon garance*) and dark blue jackets and overcoats. Most of the combatant nations had abandoned colorful uniforms in the late nineteenth century, the British introducing khaki and the Germans field gray. In keeping with the polarized politics of Dreyfus-era France, left and right could come to no agreement about a new uniform for the French soldier. It was only in late August 1914, in the face of lengthening casualty lists, that a new uniform color was produced. Originally the fabric was to reflect the tricolor with red, blue, and white threads. To their dismay, the French authorities discovered that the red dye originated in Germany, so it was abandoned, leaving only the white and blue.[11]

Along with his horizon-blue uniform, the soldier wears the Adrian-pattern steel helmet, issued in mid-1915. Its design owes much to the helmets of French firemen, and it proved a successful design worn throughout the war.[12] (The kilometer stones of the *Voie sacrée* [sacred way], the supply road from Bar-le-Duc to Verdun, along which trucks and men moved ceaselessly from February to October 1916 to defend Verdun, are now marked by bronze Adrian helmets.) The appearance of Faivre's iconic *poilu* (First World War soldier) is completed with the standard-issue Lebel rifle. The 1886 model Lebel was the French infantryman's weapon throughout the war. With its bayonet attached, it became an essential symbol of the *poilu*.[13] The bayonet, nicknamed "Rosalie" by the press, was regarded as the ultimate offensive weapon, and glorified in poems and songs that did not overlook the phallic implications. The frontline troops detested the jingoism of the press, and even the name *poilu*, which actually means "hairy," although they may have appreciated the many French verbal associations between hair and virility.[14] The infantrymen, in journals and trench newspapers, called themselves *fantassins*, a word of unknown origin that simply means an infantryman.

Faivre's image, therefore, presents an idealized *poilu* for public consumption. He does have a mustache and a light growth of beard, but is not excessively dirty or disheveled. Indeed, his turned-back cuffs give him an air of energetic urgency as he charges forward. Other than the text, the poster is all diagonals, reflecting the dynamism of an offensive. The position of the figure is loosely based on Rude's sculpture of *La Marseillaise* on the Arc de Triomphe. The academic style invokes classical predecessors and republican traditions. Faivre's *poilu* is a soldier of the Third Republic, fighting for his land, his culture, and his traditions against a barbarian invader.

The text also calls on revolutionary traditions. The visual reference to Rude's sculpture in turn evokes the *Marseillaise*, written by Rouget de Lisle in 1792, part of the legend of the citizen army that rose in revolutionary France's darkest moment to defeat its aristocratic enemies at Valmy. *On les aura*—one of the two unavoidable slogans of the war, and a fundamentally belligerent one—comes from a line in a revolutionary song of 1790 by Ladré. *Ça ira* (It'll be fine) was apparently inspired by Benjamin Franklin, who when asked about the progress of the American Revolution, would answer "ça ira, ça ira." Toward the end of the original version of the song there are several lines dedicated to the martial spirit of the French:

Like the great, the small are soldiers in their souls
During war none shall betray
Every good Frenchman will fight with heart

. . .

The French will always win![15]

Later in the Revolution, a more bloodthirsty version of the song advocated hanging aristocrats and contains the line *"Quand on les aura tous pendus"* (when we've hanged them all). Thus, even though the meaning is slightly altered, *on les aura* still exudes not only revolutionary and martial prowess, but a strong whiff of revenge. Several postwar images take up this theme by transmuting the phrase from the future tense into the present: *on les a* (we've got them).

The doctrine of the offensive clung tenaciously to the thinking of the French high command. In 1916, the year of battles, French losses at Verdun were exacerbated by the French determination to retake lost forts and hills. The unshakeable conviction that an attack mounted with true élan could break through the trench lines and into open country added Nivelle's 1917 offensive in the Chemin des Dames to the long list of failures. The 1917 French mutinies were ultimately the result of a rigid obsession with offensive élan that cost ever more lives for little gain, and certainly no breakout. It would be the Germans, not the French, who would make a final—though abortive—breakout in 1918.

2EME EMPRUNT DE LA DÉFENSE NATIONALE

Hansi
France, 1916

War loan posters, are, on the whole, full of belligerent images. Knights, gallant soldiers rushing into battle, and aggressive national symbols (cocks and eagles) populate these posters, urging patriotic citizens to contribute to the war. But exceptions exist, and none better than this hopeful poster by Hansi.

Hansi, or Oncle Hansi, was born Jean-Jacques Waltz in Colmar, Alsace, in 1873, a mere two years after the annexation of Alsace-Lorraine by the German Empire. He began his career by designing pamphlets and post-cards, but in 1912 he turned to caricature and satire, expressing his anti-German sentiments in *Professor Knatschke* (the consonant-heavy name is part of the satire), in which he ridiculed German teachers and officials in image and text. German policemen and tourists were also favorite targets. He particularly liked to depict German tourists as poorly dressed—the opposite of the stylish French—and then show their doomed attempts to acquire style.

In the same year he published *L'Histoire d'Alsace*, a children's book full of drawings of Alsace and Alsatian children in the naïf storybook style that would become his trademark. *Professor Knatschke* became a bestseller in France, and Hansi a symbol of *revanche* to French nationalists such as Maurice Barrès. It also aroused the enmity of the German authorities—Hansi had already been arrested several times for disrespect—who finally accused him of treason. He was tried in Leipzig, found guilty, and sentenced to a year in prison in July 1914. The sentence caused outrage in France, making head-lines and provoking two articles by Clemenceau in his magazine *L'Homme libre*. In the end, Hansi did not serve his sentence. He escaped into France, although it is unclear how. One source says that he picked a lock, perhaps helped along by inattentive jailers. Once in France, he enlisted at the outbreak of war as a transla-tor with the rank of lieutenant.[16]

Hansi produced a number of posters during the war, including this one for the Second War Loan. The loan opened in July 1916, in the middle of the greatest French battle of the war, Verdun. At Christmas 1915, Gen. Erich von Falkenhayn, who had replaced Moltke as German chief of staff in September 1914, convinced the kaiser that France had reached its breaking point, and that a heavy offensive at a point the French were obliged to defend would lead to a collapse. The attack, he claimed, would force the French "to throw in every man they have" and "the forces of France will bleed to death."[17] The vital point Falkenhayn chose for the destruction of the French army was Verdun and its ring of forts. By attacking Verdun, Falkenhayn hoped to compel the French to funnel troops into a battle of attrition. If they gave up, they would lose Verdun; if they stood fast they would lose their army.[18] The Ger-man attack began on February 21 with a devastating bombardment. The fighting raged around the sur-rounding forts, especially Douaumont and Vaux, and the hills to the north, until mid-June, the forts chang-ing hands several times. A final German attempt to take Fort Souville failed in July, and the Germans went back on the defensive. In October, it was the turn of the French to go on the offensive, retaking Douaumont and much of the ground previously lost on the east bank of the Meuse.

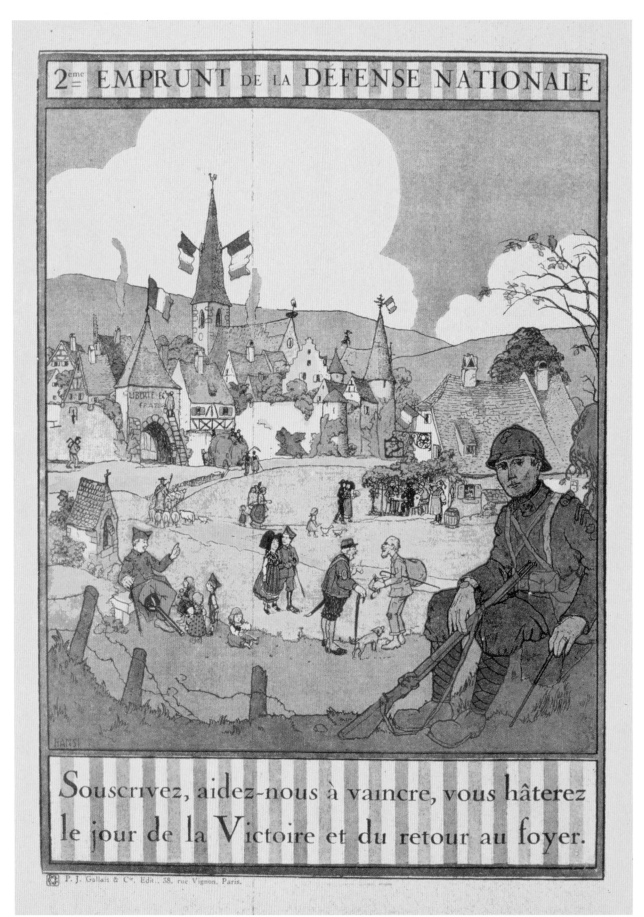

LIBRARY OF CONGRESS: LC-USZC2-3920

The defense of Verdun cost the French around 170,000 dead, only a little more than the German losses. The French army had 95 divisions; 70 of them rotated through the battle of Verdun.[19] Gritty *poilus* said that you didn't know what war was if you hadn't been at Verdun. For the French, it was, and remains, the defining, sacred battle for the survival of the nation.

Placed within the context of Verdun, this poster assumes a special poignancy. The picture of the Alsatian village is framed in the foreground by the barbed wire and destroyed earth of the battle zone, and by a sad soldier. He wears the horizon-blue uniform and elegantly wrapped puttees, the leg wrappings the French called *bandes molletières* (calf bandages), and which were characteristic of the First World War soldier.[20] The text, top and bottom, is backed by stripes in the colors of the French flag. The message below the image is in the imperative: *Souscrivez, aidez-nous à vaincre, vous hâterez le jour de la Victoire and du retour au foyer* (Subscribe, help us to win, you will hasten the day of victory and of the return home). By using both *vous* (you)—indicated by the form of the verbs—and *nous* (us), Hansi creates a community of common effort between soldiers and civilians. The language is elevated, using the verb *vaincre* (to vanquish), capitalizing *Victoire* (victory), and employing the rather old-fashioned phrase *retour au foyer* (return home). The word *foyer* actually means hearth, with the extended meaning of home, much like the English phrase "hearth and home." But in French it has a more profound connotation that views the home as a sacred spiritual space.[21]

In this case, home has a special significance, because the soldier's dream of home is of a liberated Alsatian village, now happily returned to France. This deeply revanchist image begins with a sunlit sky filled with puffy white clouds, the blue line of the Vosges Mountains in the distance. According to legend, prewar French officer cadets were taken up into the Vosges at night, so that they could look down into Alsace and remember that it was French. The ancient village with its church, walls, and jumble of buildings is bedecked with French flags. Above the gate into the town a workman on a ladder repaints the words *Liberté, Égalité, Fraternité*—the revolutionary motto of the French Republic. Even the stork, perched on his large nest on the church roof, appears to be happy. Storks are the much-revered symbols of Alsace and figure prominently in Hansi's drawings.

The joys of peace in a liberated Alsace occupy the center of the image. In the middle ground a soldier walks with his sweetheart, who wears the traditional Alsatian cap that in the decades after 1870 had become a shorthand reference to Alsace. A little further back, what appears to be a newly married couple—she is carrying a bouquet—enters the inn. On the right an officer, still in his uniform jacket and sword, speaks to a man wearing what looks like a tattered field-gray uniform. Nearly 400,000 Alsatian men served the German *Reich* during the war;[22] if the shabby figure does represent a demobilized German soldier returning to what is also *his* homeland, then the surface message of the poster—victory and the soldier's return home—deepens to include reconciliation.

To the left, in front of a wayside chapel, a soldier who has lost a leg and is still wearing his uniform coat and cap speaks to a group of children. One of the little boys is also wearing an army cap. On one level, this little scene is a reference to Oncle Hansi instructing the children in the history of Alsace. But the wounded soldier also reminds the viewer of the price that would be paid for the liberation of Alsace-Lorraine and the importance of acknowledging that price and the soldiers who paid it. The naive visual charm of the image doesn't quite succeed in diverting the viewer from its rather somber message of sacrifice, endurance, and perhaps ultimately, victory and reconciliation—a message entirely appropriate for 1916.

SAMMELT DIE OBSTKERNE

Julius Gipkins
Germany, 1916

In this first modern total war, the economic viability of the nation was fundamental to military operations. Economic warfare, with its goal of undermining enemy economies to the point that they would be unable to further prosecute the war, was nothing new. Both France and Britain had used blockades in the Napoleonic Wars.[23] From 1914 to 1918, the Allies and the Central Powers strove to inhibit commerce, starve industry of raw materials, and destroy the cohesiveness of the population by forcing shortages of food and fuel.[24] Prior to the outbreak of war, the general staffs of the European powers had given little thought to economic planning. They were focused on a quick war in which they would speed troops to the battlefields and rapidly defeat the enemy. The German generals in particular were convinced of a quick victory and saw no need to consider agricultural and industrial production. While aware of the possibility of blockade, a rapid victory, they believed, would limit its effect.[25]

However, the war quickly froze into a stalemate that forced all the combatants to husband and control resources of every kind, including agricultural and industrial production. The objective of economic controls was first and foremost to keep the army fighting in the field, and only secondly to maintain the civilian population and their support for the war. Economic controls were universally unpopular among farmers, industrialists, workers, and consumers. They created a viper's nest of conflicting interests, avoidance, and black markets. The propaganda campaigns aimed at convincing the general public to save food and fuel were nearly always couched in terms of reciprocal sacrifice: the soldier sacrifices himself to protect the nation, and the citizen sacrifices creature comforts so that the soldier can fulfill his duty. No right-minded patriotic citizen could fail to support the troops.

The situation in Germany was singularly unfavorable. As pointed out earlier, Germany's short coastline and landlocked position made it vulnerable to land and sea blockade. The British blockade, rapidly implemented by the Royal Navy, largely succeeded in cutting off contraband from entering Germany directly through its own ports or indirectly through bordering neutral countries.[26] Over the last three years of the war, the blockade gradually tightened to include any commodities that could contribute to the war, such as meat; metals; vegetable, animal, and mineral oils; cotton; and wool.[27] The success of the Allied blockade of the Central Powers is much debated among economic historians, but it seems clear that the deprivation it caused was widespread and exacerbated the disparities between classes and between urban and rural dwellers, hitting urban working-class families particularly hard.[28] Even soldiers, who enjoyed first priority for food, complained of being served bread cut with sawdust and other ersatz products; *Stacheldraht* (barbed wire), an unpalatable mixture of dried vegetables; and turnip marmalade.[29]

In 1916, increasing losses of men and materiel at the front and growing shortages of essential commodities at home contributed to the appointment of Field Marshal Paul von Hindenburg as chief of staff, with Gen. Erich Ludendorff, the great logistician, as his quartermaster general. Together they undermined the civil authorities, mobilized the economy for total war, and created what amounted to a military dictatorship that lasted until the end of the war.[30] That

LIBRARY OF CONGRESS: LC-USZC4-11556

mobilization led directly to hearth and home—that is, to women and children.

Beginning in 1916 and continuing through 1917, Julius Gipkins designed a series of posters encouraging German citizens, especially women, to collect fruit pits, which were crushed to obtain oil. Gipkins was a self-taught artist who established a graphics agency in Berlin and became a proponent of Bernhard's object posters.[31] His boldly colored posters are fine examples of the German modernist poster style.

This poster, created for the war office for oils and fats, directly exhorts women through its text, and children through its image. The black background behind the bright yellow text represents a blackboard. Above the heavy yellow line, the text urges the reader *Sammelt Obstkerne* (collect fruit pits), then in smaller lettering to "send them to school with your children, or to the nearest collection site." The message ends with an emphatic exclamation point. The text is in traditional German *Fraktur*, the standard typeface of the nineteenth century, evoking the authority and *Kultur* associated with the German public school system, which was the oldest in western Europe. It is, in short, a message that cannot be lightly disregarded.

The text presents another point of interest: both the verbs and the possessive *Eure Kinder* (your children) are in the familiar plural, the term of address used with family, children, and animals. While a certain edge of condescension may be assumed, the government is addressing its citizens as if they were family members. The German word *Gemeinschaft* (community) was much used in the First World War, and carries forceful connotations of German nationhood and unity. It was favored by conservative thinkers in the mid-nineteenth century, and was co-opted by the National Socialists for their propaganda. The message casts the collection of fruit pits as a national, communal, and familial activity.

To the right of the text stands a little girl holding an oversized fruit pit. She is dressed in a dark blue dress with red dots, a matching red bow in her curly blond hair. She wears neat shoes and socks, and her frilly pantaloons peep out from beneath her short skirt. On her back she is carrying a classic German school bag with a ruler protruding from one end. By her position and her attitude, she has just arrived at school and is proudly presenting her huge fruit pit to her teacher. The image is deliberately childlike, similar to an illustration for a children's book, but Gipkin's clever use of highlights gives it depth and movement, appealing both to adults and to children.

Gipkin's poster epitomizes the total mobilization of the civilian population for war. In fact, the majority of the posters produced during the war were aimed at the civilian population, not at soldiers. And of these, the posters aimed at household economy and saving commodities for the war effort squarely target mothers and their children. The nineteenth-century obsession with sentimental images of angelic, chubby-cheeked, blond-haired children undergoes a dark inversion in Great War propaganda. The children are still angelic in appearance, but on postcards and posters they sport uniforms and helmets and contribute eagerly to the war effort.[32] Through sentimentalized images, children are mobilized to play "war games," imitating their elders by performing appropriate activities to support the wartime economy and denigrate the enemy.[33] This poster illuminates the desperate efforts of the German government to overcome the escalating shortages of fats and other essential commodities. No one is spared mobilization—not even the chubby schoolgirl who will be much thinner by the time the war is over.

1917

HELFT UNS SIEGEN!

Fritz Erler
Germany, 1917

Fritz Erler's *Frontsoldat* (front soldier) of 1917, alert amid the barbed wire of the front, stares patiently into the distance with piercing blue eyes. The fatigue and indomitable will in his unshaven face are palpable. He is a seasoned German warrior, with his gas mask at the ready and stick grenades protruding from his pouch. His helmet proclaims his identity: he wears the *Stahlhelm*, the German steel helmet of the second half of the war, and the iconic symbol of the war experience, the *Kriegserlebnis*.

Like their French opponents who had gone to war in antiquated uniforms, German soldiers in 1914 marched in a largely useless bit of ceremonial headgear, the *Pickelhaube* (spiked helmet). Much caricatured in the West as both silly and militaristic, the real problem with the *Pickelhaube* was its failure to protect the wearer's head. Even with its canvas field cover, it was both conspicuous and ineffective. As the war of materiel ramped up, it became apparent to military authorities that a more protective helmet was needed. The *Stahlhelm* was stamped from circular sheets of 1 mm thick chromium-nickel steel. It had lug holes for ventilation and also for fitting an additional interior steel plate.[1] The helmet's distinctive shape effectively protected the head and the back of the neck. It also evoked medieval German helmets, a connection not lost on soldiers or propagandists.

The *Stahlhelm* saw its first service at Verdun, one of the two battles that defined the *Materialschlacht*, the war of materiel. English writers usually referred to this phase of the war as a war of attrition, but German writers preferred war of materiel, shifting the emphasis to the overwhelming firepower that came into play with the 1916 battles. Emerging from the stalemate of 1915, the goal of every major assault was to break through the trench lines into open country, where maneuver was possible. Part of the preparation for such an assault involved heavy bombardment of the opposing trenches. In the opening German assault at Verdun, the German crown prince Friedrich Wilhelm, tasked with the initial assault, stockpiled 2.5 million shells, enough for six days of bombardment.[2] General Sir Douglas Haig stockpiled 3 million shells for his opening bombardment on the Somme.[3] The shelling was meant to cut barbed wire, collapse enemy trenches, and stun enemy soldiers. Actual success was spotty, but nothing on the battlefield frightened soldiers as much as shelling. The utter helplessness felt by men under heavy fire produced significant battle stress and mental breakdown, the derivation of the term *shell shock*.

The physical and mental tenacity required to withstand the war of materiel led to a gradual shift in language from metaphors of iron to metaphors of steel. Men were hardened by a *Stahlbad* (bath of steel) or a *Stahlgewitter* (storm of steel). The latter term forms the title of Ernst Jünger's *In Stahlgewittern* (1922), the earliest of the major German narratives of the war experience. Jünger's men were storm troopers, formations developed in 1916 that employed tactics of rapid attack and breakthrough, bypassing strongpoints for following troops to mop up.[4] These were indeed the new "men of steel,"[5] tempered by war and marked by superhuman endurance. The German *Kriegserlebnis* (experience of war) as it emerges in the war narratives of the 1920s and 1930s is marked above all by a profound sense of comradeship, the necessity of endurance, and a belief in

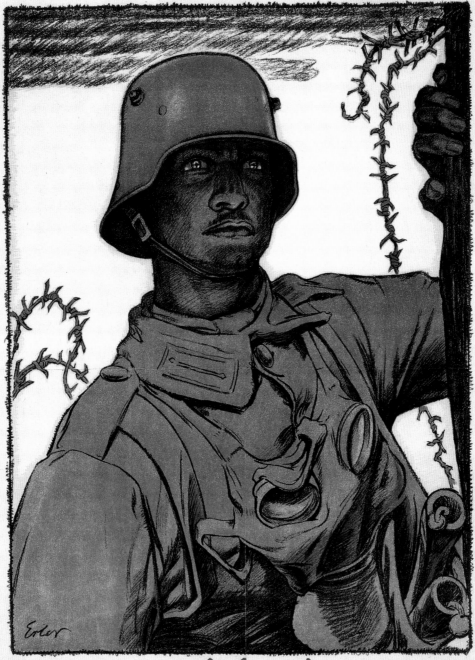

LIBRARY OF CONGRESS: LC-USZC4-11292

the ultimate rebirth of the nation out of the soldiers' suffering. The defining visual image of the German veteran and his *Kriegserlebnis* was the *Stahlhelm*.

While the designer of the *Stahlhelm*, Dr. Friedrich Schwerd,[6] was likely thinking of effective protection and practicality in use, and not of medieval precedents, the medieval "look" of the *Stahlhelm* was quickly recognized.[7] Given that nineteenth-century German nationalism was infused with medievalism, it would have been unusual for an educated German of the time *not* to make the connection. For artists trained in Germany's art academies, visual continuity with the medieval helmets depicted by Cranach and Dürer would have been apparent. Boehle's chivalric poster, for example, was directly inspired by Dürer. The conflation of the armored and helmeted medieval knight with the modern soldier, however, produced posters with fascinating compound images of medieval knights wearing the modern *Stahlhelm*.[8] Those images metamorphose the soldier of World War I into a German knight defending his land, fleshing out the comforting and ennobling continuity with the cultural past.

In the case of Erler's poster, the connection is more subtle, but also more significant because it exemplifies the qualities of spirit most needed in 1917. Behind Erler's vision of the front soldier is Dürer's magnificent 1513 engraving *Knight, Death and Devil*. In the engraving, a stern knight stares steadfastly forward as he rides through a frightening wilderness inhabited by Death and a Devil worthy of Schongauer or Grünewald. Dürer's symbolism is notoriously arcane, but the three figures are central. The Devil traditionally represents temptation, here perhaps the temptation to give in to the ugliness of fear and despair. Death, unusually, is not figured as a skeleton, but as a decaying corpse, writhing with snakes and worms, a sight all too familiar to soldiers in the trenches, where corpses were left to rot and built into the parapets. Death waves an hourglass, the conventional reminder of the brevity of life. But in spite of the lure of temptation and the threat of death, the knight in his steel helmet rides steadily forward, the embodiment of human courage in the wilderness of life. The resolution in the expression of Erler's soldier mirrors that of Dürer's knight—the courage of the warrior passing through the wasteland of war.

For significant numbers of German troops returning home at the end of 1918 to a nearly unrecognizable homeland in the throes of revolution and disintegration, the *Stahlhelm* assumed iconic significance. Fearing the loss of eastern provinces to bolshevism and the plebiscites imposed by the Treaty of Versailles, returning officers raised *Freikorps*, military units tasked with protecting the eastern borders, and encouraged veterans to join. The omnipresent image in *Freikorps* enlistment posters is the *Stahlhelm*, usually worn by a square-jawed veteran of the war. The *Stahlhelm* put in another postwar appearance as the symbol and name of the conservative nationalist war veterans' association. The organization embodied the conservative *Kriegserlebnis* and exercised significant influence in German popular thought and politics in the 1920s, before being absorbed into the Nazi veterans' organization in 1934.[9]

By the mid-1930s the *Stahlhelm* had reappeared in posters and propaganda, notably film, this time as part of the iconic image of the National Socialist soldier. It remained the helmet of German soldiers to the end of the Second World War.

DIE ZEIT IST HART

Bruno Paul
Germany, 1917

Field Marshal Paul von Beneckendorff und von Hindenburg stares steadily ahead, his close-cropped hair, squared-off head, and bull neck immediately recognizable by all Germans in 1917. This was not the case in August 1914, when the retired corps commander and member of the Great General Staff applied for reappointment to the army.[10] By late August he and his new chief of staff, Erich Ludendorff, were the victors of Tannenberg and the first German heroes of the war.

Von Schlieffen's battle plan for a two-front war was posited on the conviction that the Russian army could not mobilize and begin operations in fewer than forty days, leaving that amount of time to defeat France before turning east. Both German and Russian strategists faced geographical problems. For the Germans, the salient of East Prussia, historical homeland of the German officer corps and the Prussian monarchy, snaked eastward along the Baltic coast, vulnerable to Russian incursion despite its forests and lakes. For the Russians, the great western bulge of Russian Poland (created by the three partitions of Poland in the late eighteenth century), placed Berlin only 200 miles away from the Russian frontier, but the salient was liable to being pinched off by joint German and Austrian pincer movements.[11] Under pressure in 1914 from its ally France to attack quickly, two Russian armies, the First and Second, mounted an offensive into East Prussia. The First Army crossed the frontier in the north on August 15, followed by the Second Army in the southeast on August 20, with the Masurian Lakes separating them.

The first phase of the battle opened with a significant German defeat at Gumbinnen. The commander of the German Eighth Army, von Prittwitz, lost his nerve and decided to retreat west of the Vistula, abandoning East Prussia. Appalled by so unthinkable a betrayal, Moltke replaced Prittwitz with Hindenburg. Arriving on August 23, Hindenburg and Ludendorff implemented the plans that Prittwitz, having recovered some of his wits, had put in motion. Thanks to excellent internal rail communications, they shifted the bulk of Eighth Army south, enveloped the Russian Second Army, and annihilated it. The Germans inflicted 50,000 casualties and took 100,000 prisoners. Hindenburg and Ludendorff followed up that victory by moving troops back north, and with additional troops dispatched from the Western Front by Moltke, forced the Russian First Army out of East Prussia.[12]

Hindenburg christened the battle Tannenberg, recalling the crushing defeat of the Teutonic Order by a Polish-Lithuanian army in the same area in 1410. Tannenberg thus became legendary retribution for that earlier German defeat at the hands of the Slavs (not unlike Hitler's insistence that the surrender of France in 1940 be signed in the same railcar as the 1918 armistice). The deliberate linking of the two Tannenbergs conferred cult status on the victory and on the general. The lack of victories in the west only encouraged the glorification of Tannenberg, Hindenburg, and to a lesser degree, Ludendorff. The cult of Hindenburg grew throughout the war, spread by posters, postcards, figurines, and the German iron-nail statues—one of which was an enormous statue of Hindenburg.[13] A huge, fortress-like monument was built on the site of the battle in the late 1920s and early 1930s, and Hindenburg was buried there in 1935.[14] Hindenburg rode

©2015 ARTISTS RIGHTS SOCIETY (ARS), NEW YORK/VG BILD-KUNST, BONN; LIBRARY OF CONGRESS: LC-USZC4-11806

his popularity to the summit of power, becoming chief of the general staff in 1916, and, as noted earlier, exercising dictatorial power until the end of the war.

Bruno Paul's poster for the Fifth or Sixth War Loan (April or July 1917) emphasizes Hindenburg's legendary qualities of unshakeable certainty and imperturbable calm. Like many of the other well-known German poster designers of the First World War, Bruno Paul had cut his artistic teeth in Munich, home of *Jugendstil*, and of the Munich Secession, counterpart to the Vienna Secession. His early work earned much acclaim, and he became a major designer of furniture and interiors before the war, as well as beginning a career in residential and commercial architecture. His reform of art instruction lasted until the Nazi accession to power in 1933.[15]

In this poster, we can see Paul the draftsman and architect in the service of the nation. The monolithic profile of Hindenburg dominates the poster. The man of iron is here a man of stone, unbroken and unbreakable. The somber tones, black on tan, emphasize the seriousness of the carved letters of the message: *Die Zeit ist hart, aber der Sieg ist sicher* (the time is hard, but victory is certain). The time was indeed hard, especially for ordinary Germans. Although Germany had scored military successes in the previous years—the occupation of Belgium, northern France, and Russian Poland, as well as the defeat of Romania—Verdun and the Somme in 1916 had been costly draws for Germany. The British blockade was cutting deeply into the well-being of German civilians. Consumption of meat, butter, bread, and vegetables declined sharply over 1915 and 1916. Substitute products—ersatz—filled out the meager rations. During the Turnip Winter of 1916–17, turnips were substituted for nearly everything. Hunger was compounded by shortages of fuel and clothing, and the situation was even worse in Austria.

The second half of the message—"victory is certain"—expresses the continued German conviction, even in the middle of 1917, that they would win the war. The word for victory, *der Sieg*, has its origins in the medieval First Reich, the Holy Roman Empire, where the newly elected emperor was greeted by his nobles with *Sieg* and *Heil* (hail), also the origin of the Nazi *Sieg Heil*. So certain was the German government of victory, that when asked to lay out its terms for peace by President Wilson in December 1916, Germany made no concessions and insisted on the coming German victory.[16] The government's attitude toward peace overtures coincides with the widespread use of the verbs *durchleben* and *durchhalten* (to live through, to hold out). Both indicate a deepening level of sacrifice expected from soldiers and citizens. Subscriptions to war loans began to drop in 1917.[17] This somber poster mirrors the war-weariness of the time, and of a nation still united but growing desperate.

The Hindenburg legend survived the war intact. He lived to become president of the Weimar Republic in 1925, largely because he still represented stability and a link to the glory days of the German Empire. As president, he presided over the appointment of Adolf Hitler as chancellor in 1933, partly because of another legacy: In 1919, during an investigation of the reasons for the loss of the war, Hindenburg asserted that the German army had not been defeated in the field, but had been the victim of a "stab in the back" (*Dolchstoss*) by the home front.[18] The "stab in the back"—a reference to Siegfried's betrayal and murder by Hagen in the *Niebelungenlied*—had a long, dishonorable history between the wars, becoming a favorite slogan of the nationalist right, including the National Socialists. Hindenburg's stature only increased the credibility of the slogan and of the dogma concealed behind it—the invincibility of the German army. Ultimately, the real betrayal was not that of the army by the home front, but Hindenburg's verbal abdication of responsibility, which in turn convinced many on the right that the peace imposed upon them by the Treaty of Versailles was an unjust one that had to be undone, by force of arms if necessary.

ZEICHNET DIE SECHSTE KRIEGSANLEIHE

Maximillian Lenz
Austria, 1917

There is no avoiding Saint George in either the propaganda or commemorative art of the Great War. He stares down from commemorative stained glass windows and statues in Britain[19] and is muscularly modernized in Germany, complete with a *Stahlhelm*.[20] This poster presents an unusual opportunity for precise cross-cultural comparison. Having already examined the 1915 British recruiting poster of Saint George, we now view this 1917 Austrian war loan poster that uses Saint George in a central rondel, a scheme very similar to the British poster.

Why does Saint George "play" so well in the Great War and its immediate aftermath? One would expect Saint Michael, the warrior archangel, to be an important symbolic figure, but although he appears in commemorative settings, he is absent from the posters. In my view, Saint George's popularity is due to his humanity, and his courage against great odds. Unlike an angel, ordinary humans could project their own fears and need for courage on to him. Saint George's international success during and after the war is linked to the fundamental human need to bestow meaning upon experience, to place events and feelings within a comprehensible context. To dub the war "meaningless" (as did many of the British poets) was simply unacceptable to most citizens and soldiers. The expense of so much blood and treasure had to *mean* something. The easiest way to establish meaning was to place current events within a familiar historical and cultural value system. Two such systems readily presented themselves: the classical and the medieval.

The French, who saw themselves as the heirs of Roman classicism, chose classical imagery. French posters use Roman typefaces, classical figures, and drapery, and above all references to the French Revolution (1789) and the creation of the First Republic, seen as the heir of the Roman Republic. That cultural language provided continuity and visual support for the republican ideals of the Third Republic.

The other option was the medieval, above all the chivalric tradition. Romantic fascination with national languages and origins contributed directly to the medievalist revival of the late eighteenth and early nineteenth centuries. Aside from its aesthetic expressions, the yearning for the medieval world represented a yearning for a stable, ordered, spiritual world, even if only an imagined one. The leading exemplar for that medievalist world was the knight. The chivalric virtues were ready-made for Europeans to ennoble their soldiers in life and after death.[21] The use of chivalric images and diction on posters, and later in commemoration, asserted continuity in the face of devastation and loss.

Which brings us to Saint George, the paradigm of knightly and soldierly virtues. The medieval cult of Saint George is associated with the Crusades, and was encouraged by Richard I of England. The saint's intercession was credited with saving Richard's fleet from a storm.[22] References to the Crusades are especially widespread in Britain in the early part of the war, as is the invocation of Saint George as the patron saint of England, so his presence on a 1915 recruiting poster is hardly surprising; his appearance in the German-speaking countries requires some explanation. In Germany, as in Britain, the war was widely seen as a crusade, fitting well with the prewar German belief in Germany's

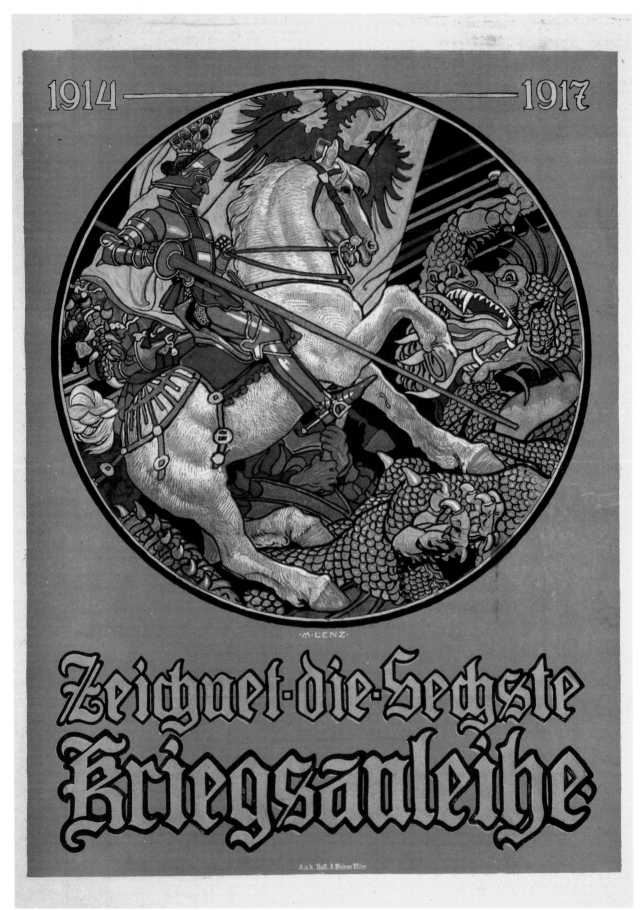

LIBRARY OF CONGRESS: LC-USZC4-12212

civilizing mission to the world. As the heroic warrior saint, whose victory over the dragon is generally regarded as a symbol of the victory of good over evil, Saint George was a logical choice for both propaganda and commemoration, particularly in the Catholic parts of Germany (Bavaria and the Rhineland) and in Catholic Austria.[23] His appeal is heightened because he is both heroic model and intercessor. In 1917, Austria-Hungary needed both.

The Dual Monarchy, plagued by competing languages and nationalities and saddled with a notoriously cumbersome bureaucracy, was pitifully unprepared for the industrialized mass warfare that began in 1914. Napoleon's famous witticism that the Habsburg forces "were always one army, one year, and one idea behind" rang true.[24] After Austria's defeat by the Prussians in 1866, Emperor Franz Joseph had reached a complex agreement with the Hungarian Magyars, resulting in three military units in the empire, with as many commands and as many languages.[25] More seriously, the army was underpinned by inadequate production and transportation systems, weaknesses that spilled over into shortages for the civilian population as well as the army.[26] The Sixth War Loan, opened in May 1917, coincided with major strikes in metal and munitions industries caused by serious shortages of food and escalating inflation.[27] By that time, the cost-of-living index in Vienna had risen by 671 percent.[28]

In those circumstances, and faced by falling war loan subscriptions due to desperately difficult living conditions, it is no surprise that the authorities, or the artist, chose to invoke the heroic Christian warrior in the form of Saint George. Maximillian Lenz was one of the founders of the Vienna Secession and one of Vienna's leading artists. Lenz designed several war loan posters, but this is the jewel of the collection. Although similar to the British poster, especially in its use of a rondel, Lenz's version of the heroic saint is visually richer and more complex. Saint George in full armor, on a rearing white horse, plunges his lance into the dragon's breast, while tongues of flame spurt from the beast's mouth. Behind the resolute warrior waves a golden banner bearing the double-headed eagle of Austria-Hungary. Unlike the solitary English Saint George, this one appears to be accompanied by a standard-bearer (his hands clutching the pole are visible below the horse's

belly) and by other troops, creating a forest of lances above the dragon's head. The rondel is set on a golden background, with the dates of the war above, and the imperative *Zeichnet die Sechste Kriegsanleihe* (Subscribe to the Sixth War Loan) in the usual familiar plural form, in black-outlined *Fraktur* below.

Lenz's palette is dictated by the gold-and-black imperial colors, but may also have been influenced by a visit he made with Gustav Klimt to see the golden mosaics of Ravenna. (Klimt's mosaic-like designs are, of course, one of the hallmarks of the secessionist style.) Furthermore, the color gold in a war loan poster is always a reference to coins. The image, as befits the subject, is filled with dynamic diagonals. Saint George's lance is paralleled by the horse's leg as it presses into the dragon's chest. The body of the rearing horse is doubled by the lances in the background. Much of the beauty of this poster is in its details, including the small touches of gold throughout: the knight's spurs, the decorations on the horse's saddle and bridle, the feathers in the plumed helmet. This is perhaps a subtle reminder to the viewer to part with some gold. But the most striking element is the dragon, a true expression of the Vienna Secession. He not only sports magnificent claws and teeth, but his perfectly drawn scales reflect the secessionist interest in the integration of surface pattern into the overall design. The dragon's horned tail appears to coil over the lances, threatening Saint George's horse, although the quantity of surface decoration makes it difficult to distinguish the actions in the design.

The Vienna Secession had peaked in production and influence in the first decade of the twentieth century. In comparison to the posters of Hohlwein and Bernhard, Lenz's effort appears rather old-fashioned and fussy. But therein lay its appeal. For Austrians of 1917, the world they knew seemed to be falling apart. Emperor Franz Joseph, after a reign of sixty-eight years, had died in 1916, succeeded by his largely unknown great-nephew Karl. With their army facing defeat, the stability of prewar life destroyed, and the very real possibility of the dismemberment of the Habsburg empire, Austrians needed proof of continuity with an older and more secure world if they were going to part with their money. Lenz provides that conviction with his image of a courageous, jewel-like Saint George, resolutely facing and slaying the embodiment of evil.

Journée de l'Armée d'Afrique et des Troupes Coloniales

Lucien Jonas
France, 1917

The war on the Western Front was not fought exclusively by white troops. Britain and France had vast colonial empires, on which they drew for resources and for men. Along with white troops from the Dominions, Britain recruited 1.5 million men from India. France already had 90,000 *troupes indigènes* (native troops) at the beginning of the war, and recruited nearly 500,000 more in North and West Africa, Madagascar, and Indochina.[29] Of these, the most important troops were the *tirailleurs sénégalais* (Senegalese riflemen), drawn from West Africa, though not entirely from Senegal.

France had good reason to call upon its colonial troops. The stagnant French birth rate and rising German population filled the French high command with trepidation over the potential disparity in troop strength. In 1910, then Lt. Col. Charles Mangin of the French Colonial Army in Africa published a book called *La Force noire* (The Black Army), in which he lobbied forcefully for a significantly larger colonial army to offset France's limited population. He maintained that West Africa could easily make up for France's troop deficit, and that black Africans were born soldiers.[30] While Mangin overstated Africa's limitless pools of manpower, the *tirailleurs sénégalais* were indeed on the Western Front by August 1914.

The performance of black African troops in combat was mixed. When thrown into combat at Dixmunde to block the German push to the Channel (October 1914), they took huge casualties but held the line and blunted the German advance. On the other hand, they suffered badly from the cold of northern France, and after undergoing a German bombardment without cover at Verdun, a battalion broke at the advance of German infantry. African troops apparently also retreated when faced with the first German gas attack of the war at Yprès in April 1915, and they were badly mauled at the beginning of the failed Chemin des Dames offensive in 1917.[31] It is difficult to make an objective assessment of the performance of the *tirailleurs sénégalais* in battle, because most of the reports came from white French and British officers, and are almost certainly marked by their own prejudices.

The use of colonial troops in propaganda, as in this poster, is shaped by sometimes contradictory racial and political ideologies. On the one hand, the French government wanted to display and acknowledge the contribution in goods and manpower made by the colonies to the motherland. This constitutes an expanded version of the common "we're all in this together" theme used to mobilize entire populations for the war effort. On the other hand, while the French government needed and wanted to mobilize colonial peoples, they were clearly not native-born citizens. They were subject peoples, and whatever their élan and contributions to the security of the French Empire, the praise is tinged with paternalism and a firm belief in the civilizing mission of (white) France.[32]

Although a tone of racial and cultural superiority operates in virtually all of the depictions of colonial troops, there are significant differences in the depictions of North and West Africans. The Arab and Berber peoples of North Africa had retained into the colonial era a degree of the European romantic fascination with the exoticism of the Islamic world. Hugo's *Les Orientales* and Delacroix's colorful paintings fed the French

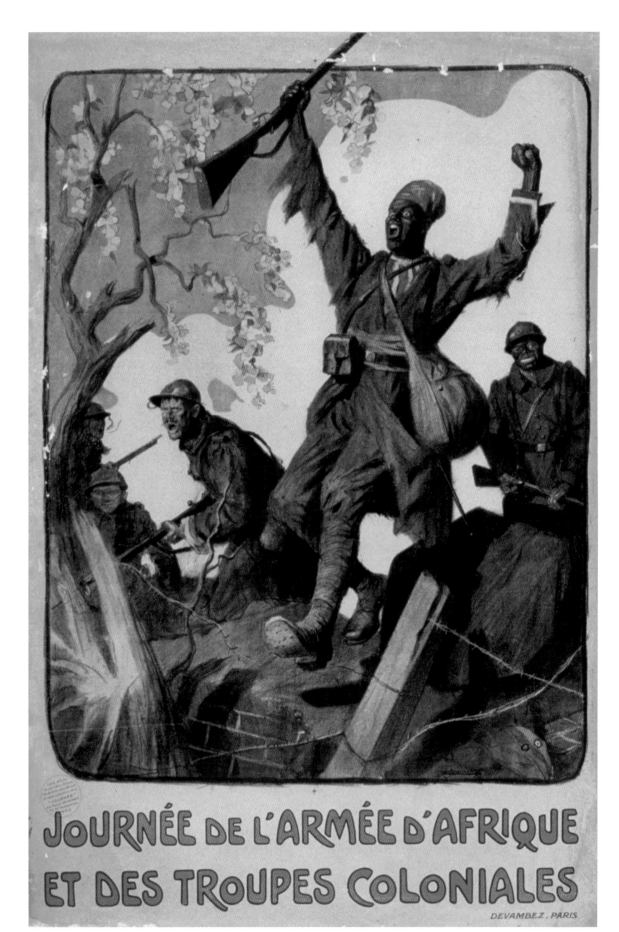

©ESTATE OF LUCIEN JONAS; LIBRARY OF CONGRESS: LC-USZC2-3949

vision of North Africa's enticing "otherness." Along with souks and veiled women, the mounted Arab warrior (a frequent Delacroix subject) embodied the warlike courage of Arab and Berber fighters, and became a preferred image for French war loan posters.[33]

The depictions of black *tirailleurs sénégalais* from West Africa differ from those of the appealingly exotic Arab horsemen, and rely on racial characteristics and personality traits attributed to them by the culturally superior French. French as well as British commanders divided subject peoples into "warlike races" (*races guerrières*) and "non-warlike races" (*races non-guerrières*), and recruited accordingly.[34] Mangin maintained that West Africans were "natural warriors" and "primitives."[35] These two components—warrior-like and primitive—coexist uneasily in the stereotypical representations of West African soldiers in texts and posters. On the one hand, they were believed to possess a limited intelligence and a childlike innocence that made them fiercely loyal to their white officers;[36] at the same time, they were ferocious and primitive warriors who could be used as shock troops.[37]

These stereotypical qualities are present in Jonas's poster. This advertising poster for the *Journée de l'Armée d'Afrique et des Troupes coloniales* (Day of the Army of Africa and Colonial Troops) is one of the best known of the posters showing indigenous troops, and it is always worth recalling that such posters were displayed in metropolitan France and intended for French audiences. It depicts African and French troops assaulting a trench. The focus of the action is the *tirailleur* in his *chéchia* (the red cap of the *tirailleurs*), eyes widened, fist clenched, mouth open in a shout, leaping into the enemy trench, the very image of savage ferocity. Even his tattered uniform contributes to the aura of wildness and uncontrolled aggression. The dynamism is enhanced by the diagonal of his rifle, which pierces the border of the image and the paper itself. The other African soldier behind him, in a conventional French

uniform, seems to be grinning broadly. His apparent joy in battle reflects the French racial assumption of the simplistic, warlike character of African troops. The white French soldier is also shouting and charging aggressively forward, but he pales beside the African's full-throated leap into battle.

The blue sky and large white cloud in the background, coupled with the blooming tree on the left, suggest spring, the season of rebirth and renewal. Although spring-blooming trees were an unlikely apparition on the battlefields of the Western Front, there are precedents.[38] The soft delicacy of the pink flowers contrasts sharply with the dullness of the uniforms and their touches of assertive red. Visually, the blossoms frame the African's rifle and reinforce the message that the *tirailleurs sénégalais* represent a renewal for the French war effort, and a promise of future victory.

Lucien Jonas's poster fulfills multiple propagandistic functions. Firstly, it reemphasizes the link between colonial possessions and the metropole, here presented as French and West African troops attacking the enemy together. France benefits from the bravery of her colonial troops. Secondly, although the white and black troops fight together, the West African troops are still men of color, and according to the racial assumptions of the period, are both different and inferior. The facial characteristics of the two Africans are stereotyped—thick lips and broad noses—and the *tirailleur* is attacking with the ferocity of a wild animal. Finally, the uneasy presentation of civilization versus barbarism lies at the heart of this poster. The carefully developed French propaganda myth of the ferocity of West African troops was deformed by German propaganda into a myth of barbarism, to the point that German soldiers were seriously frightened by their reputed savagery.[39] Behind that accusation was the German conviction that black troops should not be used against white Europeans, or perhaps another expression of German envy that they had so few African colonies.

VOUS AUSSI FAITES VOTRE DEVOIR

B. Chavannez
France, 1917

Chavannez's pastoral poster for the Third War Loan, opened in December 1917, takes us into the heart of rural France and into the soul of 1917. A *poilu* who has evidently just returned to his home farm on leave—he has doffed his jacket, but still wears helmet, horizon-blue trousers, and puttees—has taken over the plowing from his wife. A smile of pride and tenderness brightens his face. His wife, dressed for hard work in peasant *sabots* (wooden shoes) and an apron, a scarf covering her hair, holds both his rifle and their baby, possibly the fruit of an earlier leave (the French government, always concerned about the declining population, diligently encouraged soldiers on furlough to leave their wives something to remember them by). Behind them are woods and a peaceful village with a church and smoke rising from a house.

The text beneath the image, *Vous aussi faites votre devoir* (You also do your duty), elevates the woman, who has kept the farm going in her husband's absence, to a model of conduct. The text then implores, *Avec toutes vos ressources, souscrivez à l'Emprunt* (With all your resources, subscribe to the war loan). On the surface, it appears to be a fairly standard albeit attractive war loan poster. But behind image and text lie the brutal realities of 1917, the year John Keegan has called "the breaking of armies."[40] In the east, 1917 had begun with the abdication of Tsar Nicholas II (February), the gradual disintegration of the Russian army, and the October Bolshevik Revolution. By November, the Russian army had ceased to play any part in World War I. In the west, French General Robert Nivelle, who had succeeded Joffre, had a new plan to gain the longed-for

rupture (breakthrough): In early 1917, the German army had staged a withdrawal from the Somme salient into a carefully prepared defensive line, the Hindenburg Line. Nivelle's plan was to attack on what he thought was the less-protected southern flank—the heights above the Aisne River, called the Chemin des Dames because a road traversing it had been laid out in the eighteenth century for the daughters of Louis XV.[41]

The Nivelle Offensive began on April 16 in cold, wet weather. As usual, the general had overestimated the ability of his troops to advance over difficult, well-defended terrain, and the rolling artillery barrage, meant to protect the advancing infantry, quickly outstripped them. The attack bogged down like so many before it, and by the fifth day, after 130,000 casualties and 29,000 killed, it was abandoned for slight gains. There was no breakthrough, and Nivelle was relieved of command by the end of the month.[42]

Acts of "collective disobedience" or "collective indiscipline" began to occur immediately after the failure of the initial phase of the Nivelle Offensive. Those actions usually took the form of refusal to march or to return to the trenches from the rear. Soldiers never refused to defend their trenches if attacked, but were deeply unwilling to participate in new, costly offensives. They held demonstrations to air their demands, but not in the front lines. Incidents occurred in nearly half of all the divisions in the French army, involving 25,000 to 30,000 men. The movement escalated until mid-June, then began to decline.[43] Demands included peace, but focused on poor food and lack of leave.[44] The last was immensely important, because regular leaves were

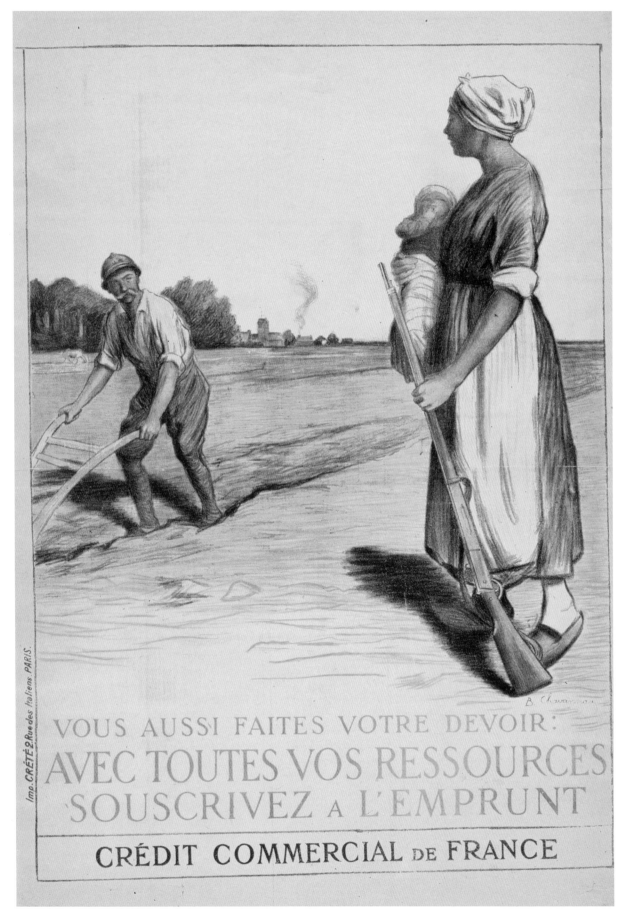

behind schedule, and men were concerned about civilian strikes, high prices at home, and general war-weariness.[45]

The new commander in chief, Philippe Pétain, who had replaced Nivelle, was a wiser man, and quickly reformed food distribution and leave policy. He also developed "defense in depth"—thinly manning the front lines to reduce casualties, while keeping most of the infantry in the second and reserve lines—and retrained his men efficiently. As the incidents of indiscipline declined, military justice, severe in France, took its course. According to the most reliable figures, 3,427 soldiers were tried for mutiny, 554 received death sentences, and 49 were shot.[46] By autumn, the situation had stabilized.

In the light of the abortive Chemin des Dames offensive and the subsequent mutinies, Chavannez's poster takes on deeper significance. Two themes come to the fore: the soldier's connection to his family and his commitment to the soil of France. Gone is the élan-inspired young soldier of Faivre's 1916 poster, replaced by an experienced veteran of the trenches. His joy at being home with his wife and baby is palpable. As the visual correlative of national virtues, this soldier embodies the will to protect what he loves most: his family and his land. Images of family became more prominent in posters and other visual sources as the war prolonged itself, as did images of fruitful farms. Soldiers, as well as the nation at large, needed to be reminded what they were fighting for, and that was almost always family and home, rather than any abstract concept of nation or military glory.[47]

While an abstract concept of the nation of France had little persuasive power, a commitment to the soil of France did. Duty pivoted on the need to hold on to French soil. A 1916 French war novel by Adrien Bertrand is called *L'Appel du sol* (The Call of the Earth). In it the narrator avers that what motivated French soldiers was the nearly mystic "call of French land" (*l'appel de la terre française*—my translation).[48] That commitment emerges in the posters with the frequent depictions of what is usually called "deep France" (*la France profonde*), which translates into images of rural France, particularly of farms and small villages. The farm is the quintessential locus, because agriculture was essential to the survival of the nation. The first thing the soldier-farmer does on his long-awaited leave is to take over the plow from his wife, symbolically reconnecting himself to his native land.

His wife stands at the edge of the field, holding the rifle that he handed to her as he took the plow. The plow and the rifle are both obvious phallic symbols. Plowing the furrows prepares the land to receive the seeds. The crops that grow from those seeds are the metaphorical equivalent of the baby in the woman's arms. By taking the plow, the soldier prepares France for the future. Because the rifle is an aggressively masculine symbol, the figurative exchange of rifle for plow might be problematic, but the conjunction of image and text suggests another significance. By transferring the rifle to the woman, Chavannez provides both an oblique reference to Delacroix's *Liberty leading the People*, in which Marianne brandishes a rifle as well as the tricolor, and a suggestion that the woman, by doing her duty, maintaining the farm, and raising the child, is also a soldier. The text implies that she does her duty (*devoir*) as the soldier does his, and it is incumbent on patriotic citizens to do theirs by subscribing to the war loan.

Another common theme exploited in this poster is that of women's war work. In the hierarchy of valuable war work for women, agricultural work was at the summit. France was a largely agricultural nation, and with men mobilized and animals requisitioned, many women, old and young, tackled the arduous task of maintaining family farms and ensuring the harvests. Unlike Germans and Austrians, the French did not starve during the war, largely due to women who kept the farms going.[49] While images of female factory workers, especially munitions workers, are common in British posters, they are rare in French posters, despite the large numbers of French women in war work. That may have much to do with traditional views on women's place in society (French women didn't get the vote until after World War II), but it likely has more to do with the elevation of agriculture to a symbol for national survival, evident not only in this poster and Chavannez's 1918 poster, but also in the image of women pulling a plow in the 1915 Canadian poster.

Despite the reverses, crises, and war-weariness of 1917, the soldiers' and civilians' commitment to victory never seriously wavered. Even during the mutinies, the striking soldiers called for peace, but not at the price of the loss of French soil, and unlike Russian soldiers, ultimately made the decision to continue fighting.[50] Chavannez's poster reflects that decision, and the unwavering belief in the French family and in French soil.

3E EMPRUNT DE LA DÉFENSE NATIONALE

Auguste Leroux
France, 1917

A soldier-father, departing for the front, tenderly embraces his daughter. In the background, barely sketched in, his wife nurses a new baby. Like Chavannez's poster for the same war loan (the Third), this poster by Auguste Leroux centers on an image of the family. But unlike Chavannez, there is no rural background—indeed, no background at all. There are only four figures, two of them lightly sketched in. Everything extraneous has been subtracted. The exclusive focus is on the family, and most importantly on the father and his daughter. Although depictions of the family occur in the posters of all the combatant nations—the protection of the family as the future of the nation is invariably a central concern—in France the images are more realistic and the concern almost obsessive.

The reason for the concern was not only the threat from the marauding Hun, but the internal threat of depopulation. French population growth, with an occasional jig up or down, had been flat since the middle of the nineteenth century. At around 40 million against Germany's 65 million and rising, France, as already noted, could not hope to match the mobilization levels of the German army. From 1871 onwards, the French general staff looked for ways to augment the size of the French army, including, as mentioned, the use of colonial troops. The defeat of 1870 energized existing pronatalist groups, organizations that encouraged a higher birth rate, into heightened activity; over fifty books on depopulation were written between 1870 and 1914.[51] Despite a persistent gap between a vocal ideological elite and reproductive behavior in the general population, the coming of the

war created an ideological convergence between the masses and the pronatalists. Depopulation, as a threat to the armies and to the survival of the nation itself, became a major propaganda theme, particularly evident in picture postcards.[52] Faced with a stagnant population and huge battlefield losses, repopulation became a patriotic duty. Even feminist opposition to such ideas wilted in the patriotic atmosphere, with one editorial in a feminist publication encouraging readers to provide "children, lots of children to fill the gaps."[53]

All of this agitation to procreate is at its most obvious and most amusing in the picture postcard industry. Constant postage-free correspondence between the front and the interior, although censored, was a lifeline for both soldiers and families, at a time when a silence of a few days might reduce a family to anguished worry. With eight million men under arms, postcards, which became immensely popular in the years before the war, were the ideal medium to maintain a steady flow of messages. To supply this need, it has been estimated that over 20,000 different designs were published during the war, each in quantities of 5,000 to 10,000 copies or more. Actual circulation numbers, unknown and unknowable, must run into the tens or even hundreds of millions.[54]

Patriotic postcards showing children as soldiers are ubiquitous in the combatant nations, but in France they show a pronatalist slant. Along with baby boys popping out of cabbages (the origin of baby boys in French popular culture), to babies hanging from rifles and bayonets (*tirer un coup*—to fire a shot—means to have sexual intercourse, providing a neat double entendre in French), a particularly popular theme was the

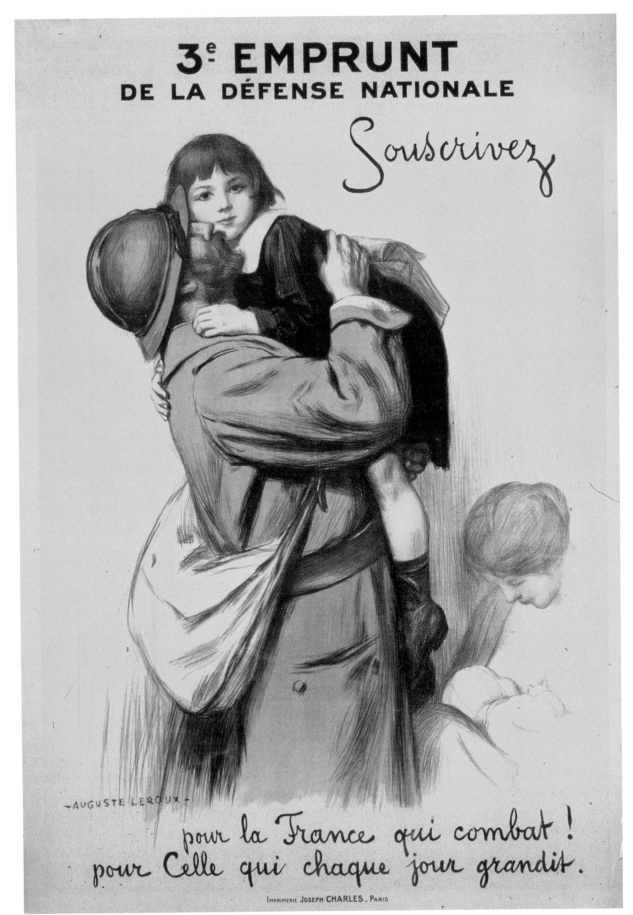

soldier on leave, *le permissionnaire*. As noted before, the term *poilu* for the French soldier of this period connotes courage and virility. A *poilu* on leave was expected to do his duty toward his wife by making her pregnant with a *petit permissionnaire*, a baby conceived during leave.[55] Many of these cards have a distinctly erotic edge that recalls the naughty "French postcards" of the Belle Époque. The high seriousness of poster advertising generally precluded the racy illustrations and double meanings so common in the postcards, but the irreducible theme of protecting and enlarging the family is equally present.

Auguste Leroux's posters are always typified by beautiful drawing, and nowhere more so than in this image of a *permissionnaire* saying farewell to his family. Leroux was an eminent Parisian artist of the traditional nineteenth-century type. He studied at the École des Beaux-Arts and at the Villa Medici in Rome, winning prizes along the way. He was a professor at the Beaux-Arts for thirty years, and died in 1954 in the same house where he had established his studio in 1908.[56] Leroux's poster represents French academic art simplified to its core value of beautiful, realistic drawing. In the center of the image, the father gives his daughter a final embrace. He wears the horizon-blue greatcoat and helmet. His canvas haversack is already thrown across his shoulders. He is seen only in profile—his bearded face the emblem of the *poilu*. The little girl wears a white-collared black dress and neatly laced and tied boots. She is dressed for school, with her schoolbag on her back. With her arms wrapped around her father's neck, she stares steadily out of the poster, inviting the viewer into the scene. To one side, the mother nurses a new baby.

This small domestic interlude represents a serious version of the pronatalist theme, and more importantly, of why and for whom the French were fighting. The appearance of the text provides an excellent example of the French use of Roman or block letters combined with handwriting. Lacking the plural familiar form present in German, which allowed German poster artists to create a communal appeal, French artists often resorted to putting the word *souscrivez*

(subscribe) in handwriting, thus making the appeal more personal, as Faivre did for "On les aura." The handwritten text beneath the image rams home the message: citizens are invited to subscribe to the war loan *pour la France qui combat!* (for France that fights) and *pour Celle qui chaque jour grandit* (for she who grows every day). Thus the text, like the image, focuses on the embodiment of fighting, the soldier, and the emblem of the nation's future, the child. The family forms the basic unit of the nation, and by fighting and procreating becomes a national model.[57]

The little girl with her schoolbag demonstrates another aspect of popular patriotism. The passage of the Jules Ferry laws (1881–82) mandated universal public elementary education. The public schools became the "school of the nation," where republican patriotic values were inculcated nationwide through the use of standard texts and curricula. One such text was the famous *Tour de France par deux enfants* (A Tour of France by Two Children), which provided a panoramic tour of France under the pretext of following two Alsatian orphans who leave the province after the defeat of 1870 to find their uncle in France. Their search allows them to discover the geography, landscape, activities, history, and people of the country, and to cultivate republican virtues and a love of the *patrie* (homeland). Such schooling turned "peasants into Frenchmen" to borrow Eugene Weber's phrase,[58] and linked French people of different generations and localities together in common patriotic attitudes that contributed to the continued will to fight.

Leroux's deceptively simple image contains within it a number of themes that resonated powerfully in the dark year of 1917: the encouragement and protection of the family as the essential social unit, the creation of a patriotic citizenry, and the unity of the nation as mirror of the family. Ernest Renan, in a famous 1882 lecture called *What is the nation?* proposed that a nation needed two elements: common memories and the will of the citizens to stay together. Renan would be content with Leroux's visual projection of his definition.

FIGHT OR BUY BONDS—THIRD LIBERTY LOAN

Howard Chandler Christy
USA, 1917

The United States declared war on the Central Powers on April 6, 1917—finally but reluctantly convinced of the need to intervene. American public opinion had been gradually shifting in favor of intervention since the sinking of the *Lusitania*. As noted earlier, legislation allowing the enlargement of the army had been passed in 1916, and officer training had begun. That gradual movement away from isolationism was encouraged by such posters as Spear's "Enlist" and others urging military training. The formal Declaration of War was triggered first by Germany's resumption of unrestricted submarine warfare in January 1917, and second by the outrage of the Zimmermann telegram, an intercepted German message offering Mexico large chunks of the American Southwest if it would join the Central Powers. The United States, with its peacetime economy, small standing army, and limited program of capital shipbuilding, entered the war ill equipped in all areas except one to prosecute a modern total war.

The one exception was the well-developed business of commercial advertising and the closely linked industries of illustrated magazines and books. The first decade of the twentieth century was the golden age of the illustrator. Literary periodicals such as *Harper's* and *Scribner's* commissioned both posters and covers from well-known illustrators, and the illustrated magazines *Collier's* and *Saturday Evening Post* enjoyed very large circulations.[59] Large-scale publishing also ensured the existence of a sizable pool of artists skilled in illustration and persuasion. After all, the same skills that sold cigarettes and face cream could also sell war bonds.

The confluence of advertising and illustration shaped the American propaganda posters. With a few exceptions, American commercial artists were largely untouched by the avant-garde movements in European art.[60] Their roots were in the American traditions of narrative and historical genre painting, which had shaped an art that was both representative and popular.[61] Americans at large tended to be downright suspicious of foreign ideas in general and foreign (modern) art in particular, as the reaction to the 1913 Armory Show of avant-garde art amply demonstrated.[62] American tradition also molded a poster style dominated by a single strong image with limited text. The mobilization of that style for the war effort was facilitated by a serendipitous collaboration.

The fortunate collaborators were George Creel, the newly appointed head of the Committee on Public Information, and Charles Dana Gibson, president of the Society of Illustrators, the highest-paid artist in America, and the creator of the fetching "Gibson Girl." On April 17, 1917, at a meeting of the Society of Illustrators to discuss how artists might contribute to the war effort, Gibson received a telegram from Creel asking him to create a committee to produce artwork for the government. Within a few days, the Division of Pictorial Publicity of the Committee on Public Information had been formed.[63] Alongside his vice chairman, Frank Casey, art manager of *Collier's*, Gibson recruited most of the best-known artists and illustrators in America. The division met every Friday night with government representatives to ascertain what was needed and to divide the work.[64] Architect Cass Gilbert

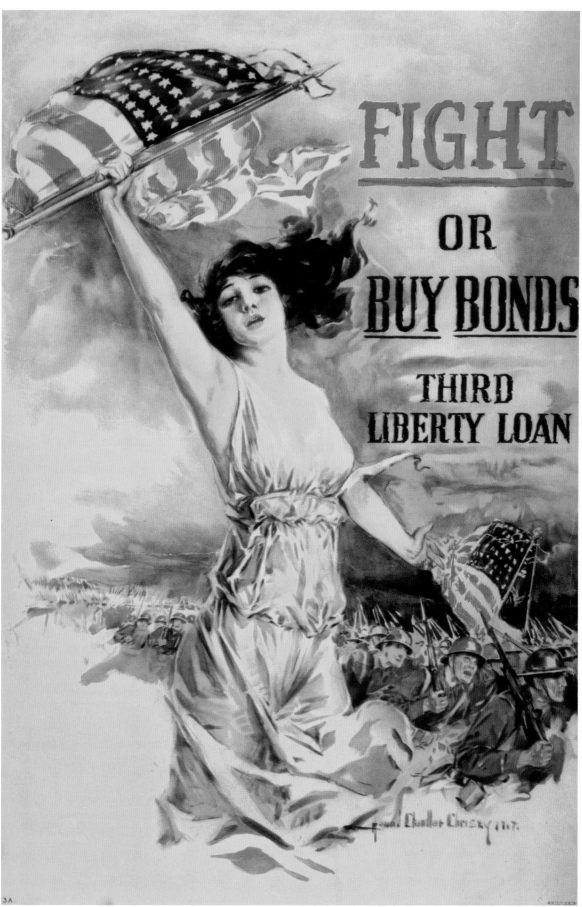

LIBRARY OF CONGRESS: LC-USZC4-9735

defined as their mission "to place upon every wall in America the call to patriotism and to service."[65] The remarkable fact is that all the artwork was donated, including work from major artists who could otherwise command hundreds or even thousands of dollars for a single sketch.[66] Over the course of American involvement in the war, the United States printed 20 million copies of 2,500 poster designs, more than all of the other combatants combined.[67]

How do you sell war loans, enlistment, and charitable contributions to Americans? The same way the ad men had been selling for a decade: communal values of hard work, patriotism, the "get it done" spirit, and, of course, sex. The sexually attractive female resonates (even with women) across a century of American advertising. Even the immensely successful Red Cross fund and membership appeals were driven by images of pretty young women, to say nothing of Howard Chandler Christy's saucy young beauties encouraging enlistment in the Navy, the Marines, and the Motor Corps of America.[68]

Gibson consistently encouraged his artists to paint ideas, not events.[69] Christy, one of the most popular illustrators in America, clearly took the advice to heart in his depiction of Lady Liberty for the Third Liberty Loan. She stands in the center of the poster beneath a stormy sky, massed formations of troops marching behind her. Her pose is dynamic, brimming with urgency, challenging the viewer with an inescapable dilemma: either fight, or buy bonds—no other courses of action are possible. And with such enticement, who could refuse?

The American posters of the First World War are heavily peopled with the allegorical figures of Liberty and her male counterpart, Uncle Sam. Artists working within Gibson's injunction to paint ideas turned easily to existing allegorical figures to embody those ideas. America abounded in classically inspired statues of justice and liberty. They were a familiar cultural vocabulary at county courthouses and state capitols across the nation, and the Statue of Liberty, unveiled in 1886, provided a preexisting symbol of American democracy.[70] But long before the Statue of Liberty, abstract virtues such as liberty, justice, and truth were embodied

as females in art because the nouns designating those abstractions were grammatically feminine in Greek and Latin. The feminine designation descended through the Romance languages, retaining the gendered idea even in languages such as English, where grammatical gender has disappeared.[71] This theory also suggests why so many of the allegorical figures in posters, and not only American ones, seem to resemble statues.

Many American posters follow the lead of the Statue of Liberty and depict Liberty as a stern, static figure, clothed in concealing Grecian draperies or the U.S. flag. But Christy gives us a different Liberty, closer to Delacroix's revolutionary Marianne than to the standard allegorical figure of the period. In the first place, she is very scantily clad for 1917. Her diaphanous draperies cling and reveal rather than flow and conceal. Her navel is visible and her skirt wraps around her thighs in a V-shape, suggesting the pubis. Although she isn't displaying the bare breast of earlier Liberties, the breasts are barely concealed and her armpit and side are quite bare. This poster probably raised a few eyebrows among the prudish, although many Americans were accustomed to seeing statues in classical dress. With her flowing dark hair and bracketed by two American flags, Liberty's slender figure and ecstatic expression are meant to entice and challenge. She is an eroticized figure designed to sell, in this case Liberty Bonds. No better example of the adage "sex sells" can be found in this period than Christy's war posters.[72]

If the goal of an advertising campaign is to sell a product, even war bonds, then the logical question is how well did it succeed? Christy's posters were by no means the only approaches to selling bonds, although perhaps the most memorable. (In another tactic, the Four-Minute Men, so called because their sales pitch lasted the four minutes it took to change the reels in a cinema, fanned out across America to encourage patriotic behavior.) Most of the leading artists created war loan posters, some using more traditional versions of Liberty or Uncle Sam. Ultimately, their success can be judged by the numbers. All four of the war loans and the 1919 Victory Loan were oversubscribed. It would appear that the combination of patriotism and sex was irresistible, at least to Americans.

DESTROY THIS MAD BRUTE

Harry R. Hopps
USA, ca. 1917

The dehumanization of the enemy is one of the most common themes in war propaganda. Allied propagandists in the First World War reveled in reducing German soldiers to rampaging animals, and the animal of choice gradually became the gorilla. The metaphor emerges out of the propaganda surrounding the so-called "rape of Belgium" in 1914, and follows a trajectory from comparison to barbarian hordes (the Huns) to premodern primates (Neanderthals) and finishes with thuggish apes. The German invasion of Belgium presented two interlocked sets of crimes: criminal actions against civilians, especially women and children, and crimes against civilization and culture.

As discussed earlier, the German progress through Belgium was marked by widespread atrocities, many of which were exaggerated by rumor and Allied propaganda. Rape is the crime most frequently used in the visual propaganda. Magazine and newspaper caricatures from 1914 and later frequently include a young woman with her skirt suggestively hiked up—an implication of rape.[73] Sometimes she or a child (invariably a girl) is being crushed beneath the German soldier's hobnailed boot. The other constant attribute of the soldier is the spiked helmet, often supplemented by blood dripping from hands or a bayonet, the latter both sexual and brutal. The women and children are depicted as murdered innocents, deflowered and savagely crushed by barbarians.

The charge of barbarism outraged the Germans, and was one that they were unable to shake off in the course of the war. German nationalist ideology maintained that Germany was the most civilized and cultured land in the world, and that their sacred mission to the rest of the world was the spread of *Kultur* (culture).[74] Germany was, after all, called *das Land der Dichter und Denker* (the land of poets and thinkers). The destruction of the European cultural heritage, especially the burning of the medieval library at Louvain and the shelling of Reims cathedral, cemented the Allied perception of German hypocrisy and the irreversible and wanton destruction of cultural treasures.[75]

The use of the word *Hun* as a derogatory epithet for "German" is generally accepted to have originated from yet another bombastic speech by Wilhelm II in 1900, speaking of the German punitive expedition against the Boxers, "[j]ust as the Huns a thousand years ago . . . so may the name of Germany become known."[76] The term had long been used to designate those engaged in singularly savage and uncivilized actions, but once the war began, it stuck relentlessly to the Germans. German behavior in Belgium represented a conflation of barbaric and uncivilized action: the disregard of "civilized" treaties, mistreatment of civilians (notably the rape of women), and the destruction of irreplaceable cultural artifacts. Just as Allied soldiers represented the values of enlightened Western civilization, the Germans were given coarsened features and expressions, in keeping with an alien and even demonic people.

By the middle of the war, the coarseness had given way to further dehumanization, with German soldiers often presented as Neanderthals. The choice of Neanderthals, who had heavy brow ridges and were reputed at the time to be of limited intellect, was scarcely accidental, as it fitted the stereotype; that the type specimen of the Neanderthal had been found in

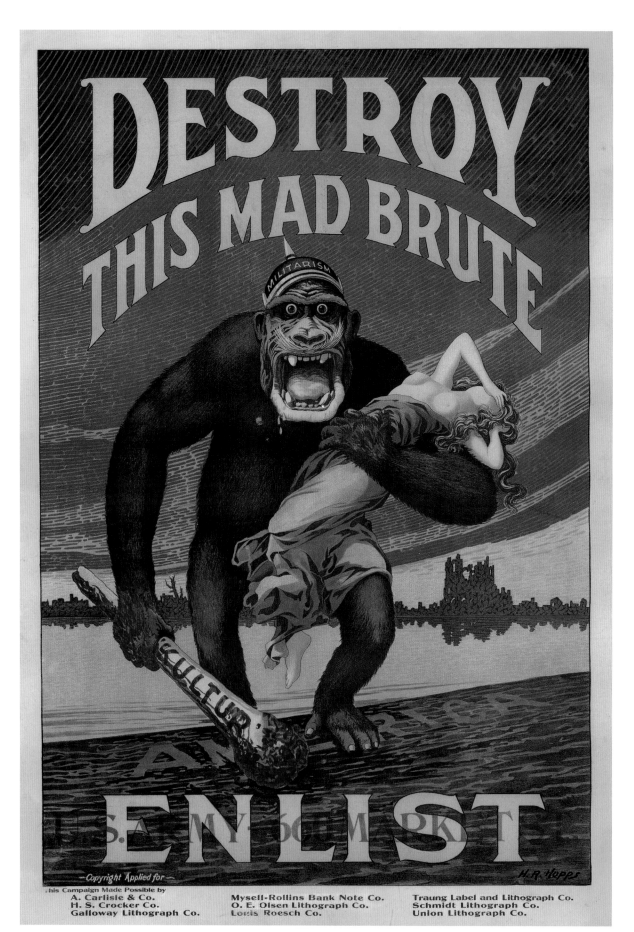

Germany, in the valley of the Neander, helped seal the connection. In a 1917 Canadian poster, for example, the German soldier with his blood-tipped bayonet and hobnailed boots has a distinctly Neanderthal profile,[77] but with Harry Hopps's circa 1917 poster, we reach the full dehumanization of the enemy.

One of the most striking of the American posters of the war, it owes much to the American taste for lurid sensationalism and to carnival posters. In the center of the image is the snarling German gorilla. Although his spiked helmet is labeled "militarism," he is unmistakably German, his identity clenched by his bristling yellow "kaiser" mustache. His huge, snarling mouth displays a full set of teeth and drips saliva, suggesting insatiable appetite. In his bloody right fist he clutches a crude club labeled "Kultur," also bloody. In the context the club is clearly phallic and indicative of rape carried out with brute force. In his other equally bloody arm, he carries a terrified woman. The woman is sexualized—her breasts are bare and she is imperiled and helpless in the grasp of the huge gorilla. Her blond hair is loose and she has thrown one hand over her eyes in horror, emphasizing her vulnerability. Without the propaganda labels, this could almost be a poster for *King Kong*, sixteen years in advance. There are some precedents for the image: Edgar Rice Burroughs's story "Tarzan and the Apes" dates from 1912, and a silent film, *Beasts of the Jungle*, opened in 1913.[78]

Sexual threats to women are a mainstay of war propaganda. There are ample examples from both world wars proclaiming the danger of "our" women being defiled by enemy soldiers. As in this case, the propaganda is directed at soldiers, or men who could become soldiers, urging them to protect women from enemies bent on rape and, if you will, the defilement of the gene pool. Hopps goes a step further. The woman represents not only American womanhood, but also Liberty herself. The flowing blue dress, one of the colors associated with Liberty, suggests the analogy, as does the gorilla's arrival on the shore of America. By enlisting, men will protect not only "our" women, but "our" liberty.

Behind the gorilla are the ruins of Europe, symbolically the ruins of Western civilization. Particularly notable on the right are the ruins of a cathedral, referring initially to the damage done to Reims, but more

deeply to the destruction of the values of Christianity. The gorilla of German militarism has crossed the ocean and now stands on the American shore. Given the chance, he will do the same here. He poses an immediate threat to the American homeland, to women, and to culture, which has been left in ruins in Europe. As is usual in posters, the message poses a false but urgent dilemma: the invader must not only be stopped, but destroyed. The yellow letters of the text, reminiscent of circus posters in style, virtually scream at the viewer. The creature to be destroyed is not human; he is a "mad brute." A "brute" is specifically one of the lower animals, as distinguished from man. The word also implies lack of human intelligence, reason, and sensitivity.[79] Additionally, this brute is "mad": not only lacking in human reason, but driven by the inversion of it. This is a creature that is, in its very essence, nonhuman, bestial, and irrational. The only possible response, within the parameters of the poster, is to enlist to fight and kill it.

The argument here is posited in much the same way as in Spear's *Lusitania* poster: the viewer is presented with an intolerable situation and exhorted to do something about it. Both this poster and Spear's partake of the American penchant for action that emerges in the First World War posters as a kind of "let's do it" mentality, an attitude that is still alive and well in American advertising, especially among home improvement chains and sports gear companies. That spirit may well be a result of the United States' brief involvement in the war (nineteen months), but the depiction of solitary endurance so evident in Europe, for example in Erler's "Helft uns siegen," is almost entirely missing from American posters, replaced by cocky self-assurance or community action. Unified action (join the service or the Red Cross, buy bonds or savings stamps) is bolstered by a strong sense of imminent success. In the world of propaganda, the worries and reservations of politicians and generals about American readiness for war are nonexistent. As events played out, the United States built, trained, and transported an army with remarkable speed. The poster vision of American success no doubt fed the myth, passed on to several generations of schoolchildren, that Americans troops won the war for the Allies.

1918

ON NE PASSE PAS
1914–1918

Maurice Neumont
France, 1918

"*On ne passe pas*" (They shall not pass) is one of the two great French rallying cries of the Great War. Oddly defensive for a nation so obsessed with the offensive, the phrase nevertheless reflects the French determination to stop the invader. It appeared almost immediately after the start of the war. *L'Illustration*, the leading French illustrated magazine, used it on the cover of its first wartime issue as the caption for a drawing by Georges Scott (who became an official French war artist) of a French soldier in the 1914 uniform, guarding the border with Alsace.[1] Although he is holding his rifle to one side, his stance prefigures the stern resistance of the soldier in this poster by Maurice Neumont. Despite setbacks, unshakeable resistance toward the German invader marks the entire course of the war. At the height of the struggle for Verdun, Gen. Robert Nivelle transformed the phrase into *"Ils ne passeront pas"*, which carries the same meaning, but shifts the verb into the future tense and thereby affirms ongoing resistance.[2]

Neumont's poster is dominated by the soldier of 1918, ragged and worn but unbroken. The lower part of his face and his neck are concealed by scarves, masking individuality and substituting the identity of representative soldier and spokesman. He is wearing a sheepskin vest for extra warmth, one of the uniform "additions" most frequently seen in photographs of French soldiers in the trenches. His gas mask is ready to hand, as are his cartridge pouches. Everything about him bespeaks a war-hardened veteran, ready for action, the rifle with its bayonet forming a visual and symbolic barrier equivalent to the *"on ne passe pas"* in the surging flames behind him. The restrained colors evident in so many French posters are here replaced by the vivid oranges and yellows of an apocalyptic battlefield.

In his ragged uniform, the soldier stands foursquare in the mud of the battlefield, surrounded by war debris—barbed wire, a broken rifle, a bullet-riddled German helmet, and an unexploded shell. His booted feet, encased in their leg wrappings, appear unnaturally large and are rooted in the very earth of France, earth he is still protecting after four years of war. Water and earth were the dominant natural elements in the world of the trenches. In the damp climate of northern France and Flanders, those two elements combined to create mud—the curse of the trench soldier. By 1918, the trenches, which had been in place since the end of 1914, formed the nexus of what was conventionally called the "horrors" of war: filth, lice, rats, stench, decomposing corpses, water, and mud.[3] In his famous war novel *Le Feu* (*Under Fire*, 1916), Henri Barbusse describes an apocalyptic flood in the trenches; when the rain finally stops, the trenches appear to have vanished under the water, but gradually mud-encrusted men begin to appear.[4] The scene, painted by Otto Dix in 1934–36 in his mature old master style, shows a drowned world with three soldiers who are almost indistinguishable from the earth around them. The hand of the middle soldier appears to be part of the roots of a tree.[5]

Neumont would almost certainly have known Barbusse's book, as it was widely read during the war. At the end of the scene described above, the men who have survived band together to proclaim that there should be no more war. The unremitting death and misery had to end and never pollute the earth again. Such apocalyptic

LIBRARY OF CONGRESS: LC-USZC2-3936

visions of destruction and redemption are not rare in the war literature. After the unprecedented levels of violence, death, and destruction, Europe was weary. But were the combatant nations weary enough to seek peace at any price? Although Neumont's poster refers visually to Barbusse's earthbound soldiers and their hope for peace, the poster's answer is an unequivocal "no." Throughout the war, various organizations and individuals attempted, and failed, to initiate peace negotiations: Henry Ford had led a "Peace Ship" to Europe in November 1915.[6] Woodrow Wilson had secretly offered himself as a mediator at the same time, as had Pope Benedict XV, and both Wilson and the pope continued to do so.[7] Clashing national war aims, especially where territory and colonies were concerned, created insurmountable barriers to peace negotiations.[8] But by 1918, after the French mutinies, the industrial strikes, and the collapse of Russia, the exhausted population was ready to entertain the possibility of a negotiated peace.[9] Any such hopes foundered on the irreplaceable investment of men and wealth and on the hardening of political positions. In France, Clemenceau and other political leaders coalesced into a group called the *jusqu'auboutistes* from the French phrase *jusqu'au bout* (to the very end), an unequivocal statement of their determination to win the war.

Neumont's poster, commissioned by the "Union of large French associations against enemy propaganda," clearly embodies the *jusqu'auboutiste* philosophy, and while not an official government poster, forcefully affirms the government position. Not only does the image represent stoic resistance to the end, the text, addressed to French civilians, states the position in uncompromising terms. The first line reads *Par deux fois j'ai tenu and vaincu sur la Marne* (Twice I have held and won on the Marne). The reference to the second Battle of the Marne, when French and American troops stopped Ludendorff's Blücher-Yorck offensive in June 1918, establishes a probable date for this poster. The line also reminds the viewer of the first Battle of the Marne, where French troops, some ferried to the front in the famous Paris taxicabs, stemmed the initial German advance (September 1914). The statement is also personal; the speaker, the soldier in the image, uses "I," presenting himself as the iconic soldier of France, whose sacrifice must be valued, and whose convictions must be respected.

The second line, *Civil, mon frère* (Civilian, my brother) cements the link between soldiers and the civilian population. The phrase echoes the opening line of François Villon's great fifteenth-century poem *La Ballade des pendus* (Ballad of the Hanged Men), which begins *"Frères humains, qui après nous vivez"* (Human brothers, who will live after us). The lines are spoken by the hanged men on the gallows, who beg that the living will pity them and absolve them of their crimes. Like the hanged men, the soldier may soon be dead, but he has a message for the living.

In the final three lines of text, the soldier states his core message. The third line *La surnoise offensive de la "paix blanche" va t'assaillir à ton tour* (The underhanded offensive of the "white peace" will assault you in your turn) raises the concept of a "white peace." The term referred to a peace settlement without annexations or reparations, a possibility inimical to the combatants, whose war aims, both stated and secret, included annexations, and whose human and material losses had to be made good.[10] In the case of France, it would mean the permanent loss of Alsace-Lorraine and possibly of northeastern France, losses that could not be borne or even entertained. This "crafty" or "underhanded" offensive will assault (note the use of military diction) the civilians in their turn. The "you" and "your" are in the familiar form, used with family and friends, reaffirming the fraternity of the soldier with his civilian "brother."

The fourth line completes the sentence: *comme moi, tu dois tenir et vaincre, sois fort et malin* (like me, you must hold and win, be strong and shrewd). Again, the soldier asserts the identity of soldier and civilian, using the same familiar form of address and the same verbs (*tenir* and *vaincre*) used in the first sentence. At the end, he moves into imperative, ordering the civilians to be strong and cunning. The final phrase, also in imperative, is *Méfie-toi de l'hypocrisie boche* (Beware of German hypocrisy), and it drives home the message: any program for peace is part of German hypocrisy, and cannot be trusted. The implication is that true peace can come only with victory. The use of the verb *méfier* (to mistrust) is significant. Its connotations of distrust and suspicion are deeply embedded in French culture. The attitude of mistrust is still visible today in a general tone of skepticism, in the care taken to avoid being cheated, and in the myriad ways of avoiding the requirements of officialdom.

The political stance embodied in this poster—the refusal to consider any peace not predicated on victory—hardened in mid-1918, following the shock of the powerful German offensives of March–August. At its most fundamental, it incorporated both a sense of enormous loss and a vindictive determination to have both vengeance and reparation for that loss. Prime Minister Clemenceau, "the tiger of France," became the incarnation of those principles, and one of the architects of the Treaty of Versailles.[11]

POUR LE SUPRÊME EFFORT

Marcel Falter
France, 1918

In 1918 French support for staying the course to victory, which had faltered during the domestic troubles and army mutinies of 1917, reasserted itself. The so-called "second mobilization" was led by Georges Clemenceau, who became prime minister at the end of 1917. Clemenceau cleverly recalled the mobilization of revolutionary France in 1792 by consciously exploiting the revolutionary cry of *la patrie en danger* (the fatherland in danger). Despite some antiwar sentiment in 1917, and talk of a negotiated peace (as referenced in Neumont's poster), few French were willing to settle for any peace that could not pass as a victory.[12]

Like Neumont's "*On ne passe pas*," Marcel Falter's poster for the Fourth War Loan illuminates government and public response to the crises of 1917. The public remobilization is visible in the subscription level of the Fourth War Loan. Subscriptions to the Third Loan had fallen, but rebounded with the Fourth, opened in October 1918. Posters for the Fourth Loan mine cultural bedrock. They appeal through images of the land of France and through symbolic figures and themes. National symbols abound in poster propaganda, ranging from female personifications of the nation such as Marianne, Germania, Britannia, and Liberty to allegorical and heraldic animals, allegorized soldiers, and national flags. With France's classical heritage and historic tendencies to allegory, symbols were a part of the French mental baggage.

Falter's poster rests on the injunction *Pour le suprême effort* (for the supreme effort) and on two symbolic figures: the French soldier and the black eagle of Germany. The emblematic struggle between the soldier

and the eagle is framed by the landscape of war. On the left, smoke rises from a burning house and an abandoned field gun sinks into the mud. On the right stands a blasted tree. In the center, a sturdy soldier resolutely chokes the eagle. Like Neumont's soldier, and unlike Faivre's offensive warrior of 1916, Falter's *poilu* exudes strength, steadiness, and resolution. His helmet, firmly strapped to his head, is tilted back slightly and his uniform has seen hard wear, but his sturdy, puttee-wrapped legs are firmly planted as he struggles with the huge bird.

Like the soldier, the eagle, one of the oldest symbols of imperial power and victory, has seen hard combat. His spiked helmet has fallen to the ground, implying his ultimate defeat. One feather is drifting to earth, and the others are ragged and bedraggled. But he is still full of fight, flapping his great wings in an attempt to escape. His claws rip at the soldier, and he has sunk his sharp beak into his adversary's wrist, drawing blood. Despite his injuries, the stalwart French soldier hangs on. The dynamism of the eagle also reflects Falter's skills as a painter of animals, a career that he took up after the war.[13]

The soldier's action in this poster has been described as strangling the eagle, but in my view he is wringing the eagle's neck, as one would a barnyard fowl. The eagle is still a formidable opponent, but symbolically the soldier is going to make one final, supreme effort and finish the job. The idea of wringing the eagle's neck reinforces the message, because it reduces the imperial eagle to a barnyard bird. The heraldic symbols of the combatant countries readily lent themselves to caricature as well as to glorified representation. The

LIBRARY OF CONGRESS: LC-USZC2-3867

caricaturing of national symbols was widespread on postcards and in magazines during the war, generally with the aim of rendering cherished symbols ridiculous. Thus Marianne turns up as a black net–stockinged tart on German postcards, and Kaiser Wilhelm as a pig, his cosseted mustaches intact, on French ones.

Falter's tattered eagle, though not caricature in the traditional sense, does serve something of the same function, because the image reeks of hatred and disdain. Falter was from Lorraine, one of the "lost provinces," which may account for the tone of this image. But it also reflects the attitudes of a remobilized French population. On March 21, 1918, Hindenburg and Ludendorff had launched their final throw of the dice—the great offensives that were designed to break the French and British lines and deliver a victory before the weight of American troops could be felt. Initially successful, the offensives penetrated some forty miles behind Allied lines, creating near collapse in some areas and frantic efforts to shore up the lines. The offensives finally ran out of steam in late July, and a surprise British tank attack on August 8 pushed German troops back.[14] Ludendorff, daunted by the demoralization of German troops (many surrendered with little resistance) and the irreversible decline in the will to fight, called it the "Black Day" of the German army.[15]

From a distance of one hundred years, it is easy to see that the German army was exhausted and the final retreat had begun; at the time, though, it would not have been apparent to the French population at large, or even to the French commanders. Hence we have Falter's still-formidable eagle—a reminder to citizens that victory had not yet been won, that lost territories had not yet been reclaimed, and that a final "supreme" effort was needed.

SOIGNONS LA BASSE COUR

G. Douanne
France, 1918

A plump black hen perches atop a small moun-
tain of pale brown eggs. Can this beguiling
image be a World War I propaganda poster?
Yes, both because it was produced during the 1914–18
conflict, and because its purpose was to further govern-
ment programs for the production and conservation of
food. Amid the reams of posters urging food conserva-
tion, this one possesses social, cultural, and aesthetic
interest, and illuminates the means used to mobilize
the civilian population, particularly children, during
the conflict.

Men, money, and raw materials for war production
were essential, but food was the most precious of
wartime commodities. With the mobilization of men
and animals by the army, and the diversion of nitrates
(used in fertilizer) for munitions, the agricultural econ-
omy was affected in all the combatant nations,
although to varying degrees.[16] Most of the continental
countries with large peasant populations suffered sig-
nificant declines in agricultural production. France,
with half its population living on the land, was the
important exception. As discussed earlier, despite losses
of man- and beast-power, the French rural population,
by mustering the young, the elderly, and women, kept
the farms producing.[17] Peasant acceptance and even
support of the war had a stabilizing influence on the
entire country.[18] So while the French may not have
eaten well during the war (the French cultural obses-
sion with food is well documented), they ate, which is
more than can be said for the populations of Germany
and Austria-Hungary, who passed the latter years of the
war in a state of quasi-famine.

For urban populations in France, particularly Paris,
there were food shortages and a significant escalation of
prices. Arms workers, whose wages kept ahead of infla-
tion, were alone in managing to maintain their standard
of living. Only in 1917 did shortages of basic com-
modities become serious, leading to the introduction of
food rationing.[19] Throughout the war, posters urging
Frenchwomen *Économisons . . .* (Let's economize . . .)
proliferated, encouraging the saving of everything from
bread and meat to coal and gas. Most were profession-
ally designed official posters. This poster, while official,
was designed by a schoolgirl, and the story behind it
clarifies French use of the public school system, chau-
vinistic since the early years of the Third Republic, to
integrate children into the war effort.

The minister of provisions, Victor Boret, had seen a
highly successful 1917 Paris exhibition called "Drawing
in the Municipal Primary Schools during the War."[20]
He was convinced that children's drawings could be
used to propagandize food conservation and improve
morale, so he initiated a government-sponsored poster
competition for schoolchildren in early 1918. Students
in Parisian schools were asked to make conservation-
themed drawings, and sixteen winning designs (from
several hundred submissions) were turned into litho-
graphs and widely distributed.[21]

Like the other posters in the group, the hen sitting
on her eggs presents a significant departure from the
standards of French Great War poster art, as typified by
Faivre's posters. Instead of beautiful academic drawing
and monochromatic or very subdued color schemes,
we have a burst of color, naïf drawing, and a design

LIBRARY OF CONGRESS: LC-USZC2-4064

that looks more like German object posters than the classically inspired official posters. The modernist style reflects the new methods of teaching drawing in Parisian primary schools, focusing on modernity and the study of everyday objects.[22]

The design by sixteen-year-old G. Douanne (signed to the right of the hen) evinces the success of those methods. Just under the image is the name of her school, *École de Filles Avenue Daumesnil* (School for Girls Avenue Daumesnil) of the city of Paris. At the top of the image is the title: *Soignons la basse cour* (Let's care for the poultry). The translation is a loose one, as the phrase *la basse cour*, traceable to the Middle Ages, refers to the enclosed courtyard of a farmhouse, where the farm wife raises chickens, ducks, and rabbits, protected from predators by walls and fences. The most famous *basse cour* in French literature is found in the twelfth-century *Roman de Renard*, a group of animal fables in verse centered on the adventures of Renard, the fox. In the tale of Renard and Chantecler, later retold by Chaucer, the fox discovers a break in the fence that protects the *basse cour* and its inhabitants: Chantecler the cock; his wife, Pinte, and the other hens. Renard at first outwits Chantecler and carries him off, but in turn is tricked himself in a typical medieval scenario.[23]

The reference here to *la basse cour* (a term still in use) is not random. It conjures centuries of French rural tradition and careful housewifery, reinforced by the image of a well-cared-for black hen with brilliant red combs. Both she and her brown eggs are outlined in blue, matching the frame of the poster. The areas of flat color show the influence of German modernist styles, but the blue outlines suggest Cézanne. The focus on everyday objects instead of abstract allegories and values not only furthered the goals of the art program, but created images to which average women, struggling with daily privations, would respond. Altogether, the style is delightfully naïf, as is the case with the other winning posters. The text at the bottom completes the message of the ensemble: *je suis une brave poule de guerre; je mange peu and produit beaucoup* (I am a fine war hen; I eat little and produce much). In the economics of the Great War, even the hens are mobilized for war production. The hen on her pile of eggs is the agricultural equivalent of a female munitions worker piling up shells.

Like the Gipkins poster urging the collection of fruit pits, this one is aimed directly at women and girls. Caring for poultry had traditionally been women's work, and with men away, it became even more so. In France, participation of women and children in the war economy protected resources and stiffened civilian resistance to the invader. Although it may seem odd for a government agency to solicit poster designs from schoolchildren, ideological mobilization of children, widespread in the combatant countries, was especially ferocious in France.[24] While participation in the contest may have been optional for the young artists, participation in the war effort was not.

EMPRUNT NATIONAL 1918
(LA DOUCE TERRE DE FRANCE)

B. Chavannez

France, 1918

Chavannez's poster for the 1918 war loan, much like his 1917 poster, leads the viewer into what is often called "*la France profonde*," deep France, the France of timeless rural landscapes, agricultural work, and peasant values. In the foreground a woman scythes wheat, while another with a rake pauses to acknowledge a little girl (her daughter?) who is trying to help by gleaning an armful of fallen grain. To the right a horse-drawn cart, led by what appears to be an old man, carries the grain toward a small village in a gentle valley. In the sunset clouds behind a stand of forest, a ghostly Marianne in her *bonnet phrygien* inspires waves of attacking French troops.

Like most French Great War posters, this one is representational, drawing on the long French tradition of academic art and artistic training. Although more colorful than many French posters, the colors are muted, and the style draws on Millet and other nineteenth-century painters of peasant life. Marianne, the symbol of revolutionary France, sports her revolutionary cap and flowing classical draperies, much as in Rude's sculpture *La Marseillaise* on the Arc de Triomphe. The woman and child in the foreground owe much to Millet, as does the depiction of the stacks of mown wheat. The softened edges and gentle colors evoke an idealized rural France, a stark contrast to urban life and to the blasted landscape of the battlefields.

In the entire poster production of the First World War, war loan posters predominate. War, after all, is expensive, and the combatant nations defrayed most of those expenses through national war loans. Many of the early war loan posters are distinctly bellicose in tone, attempting to shame or bully the citizen into parting with his money. Here, near the end of the war, image and tone coincide in a gentle exhortation to preserve what is worth preserving. The poster's emotional appeal (it is, after all, attempting to persuade) operates on several interlocking levels: the family, the land, and the nation. The women bringing in the harvest are clearly there because their men are at war. The tired, sad young woman is carrying on as best she can, doing her duty to her husband, her family, and her nation. The little girl, who represents the future of that nation, also contributes to the essential work of growing food. Without them, and the toil-bent woman behind them, the poster implies, there would be no food for the victorious army in the background.

Cereal crops, primarily wheat, had been the staple diet of France since the seventeenth century. Bread was a "merciless tyrant" for the entire population in the eighteenth century, but particularly for the peasantry, which then made up 75–80 percent of the total population.[25] The four-pound loaf was the staple diet of three quarters of the French population, and normally consumed half their income. When the price nearly doubled in the winter of 1788–89 due to devastating crop failures from extreme weather (hail in the spring, then drought, then the most severe winter since 1709), the resulting bread shortages and price inflation meant destitution and ultimately, revolution.[26] In First World War propaganda, bread was the shorthand reference for all food.

In contrast to the quiet but purposeful farmwork, the ghostly troops are charging into action, with Marianne urging them on. As the symbol of the French Republic, Marianne had specific origins in the 1789

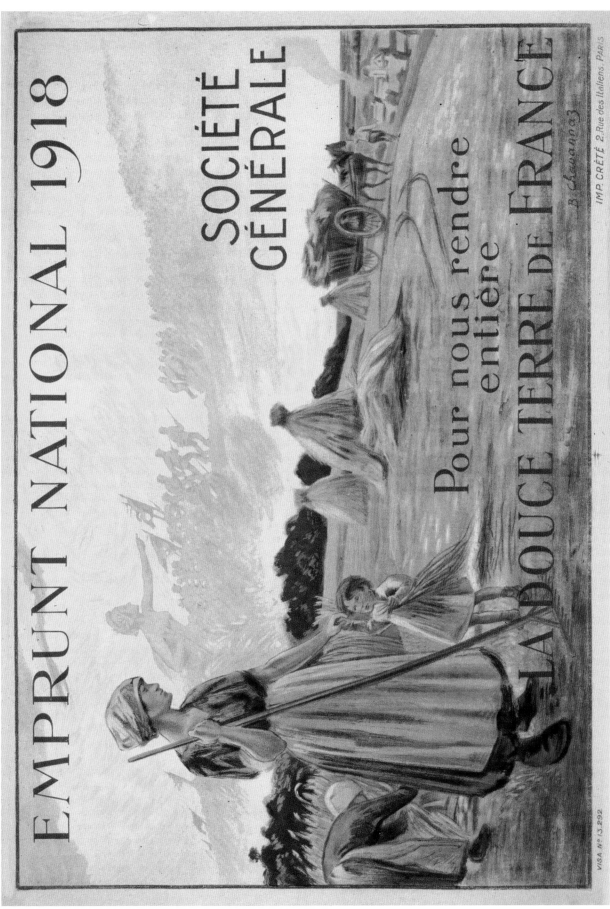

LIBRARY OF CONGRESS: LC-USZC2-3844

revolution that created the First Republic. She is always clothed in flowing classical dress, frequently with one or both breasts bared. She also wears her red Phrygian cap (*le bonnet rouge*), the symbol of the 1789 revolution.[27] The most important prototype for late-nineteenth and early-twentieth-century depictions of Marianne is Delacroix's 1830 *Liberty leading the People*, the incarnation of revolutionary spirit.[28] The troops behind her in this image embody the obsession with the offensive that characterized French military thinking from the 1880s through World War I, despite the stalemate in the trenches.[29] The maintenance of civilian morale and support for the war was fundamental to all sides. In France it was even more critical because that country, having already lost Alsace-Lorraine to Germany, had now been invaded again, and believed herself to be fighting a just war of defense against an uncivilized enemy.[30]

That brings us to the most striking feature of Chavannez's poster—its text. First, it is in Roman typeface, which visually links France to the classical heritage of Roman Gaul and to the Latin origins of the French language. It contains the standard announcement of the loan, and where one can subscribe (the *Société Générale*). But it is the text in the lower half of the poster that carries the true message: *Pour nous rendre entière la douce terre de France* (In order to return to us entirely the sweet land of France). The phrase has been variously translated, but one must start by examining the second word, *nous*. Possessive pronouns and adjectives are critically important in the "us versus them" mentality of war propaganda. In this case, *nous* is an indirect object pronoun meaning "to us," the people of France. With the verb *rendre*, which means to return or hand back, the text indicates that something that has been taken away must be returned to its rightful owners. But the weight of the phrase turns on the word *entière*. It is generally translated in a manner indicating that the entire territory of France should be returned.[31] But it means not only that the land in its entirety must be returned, but also that it must be returned *whole*, restored to its original condition. Photographs of the battle zones show that both the land and inhabitants of northern France were devastated by the years of fighting, a situation that led the French government to demand reparations in the Treaty of Versailles, and to replace war loans with a program of restoration loans lasting well into the 1920s.

The final line of text gains prominence by its larger typeface. *[L]a douce terre de France* is an oblique reference to the iconic phrase from *The Song of Roland*: "*la douce France*," a phrase that vibrates with the yearning of Charlemagne's soldiers to terminate their seven-year battle against the Saracens in Spain and return to their sweet homeland of France. Although the historical action behind *Roland* took place in the 770s, the epic dates from the period of the Crusades, circa 1140, so the reference subsumes within it the notion that the current war is a crusade to retake land from the infidel, in this case the Germans. After four years of war, the conjunction of the phrase and the image would have resonated strongly with remobilized French citizens. The land (*terre*) is France, at its sweetest, most nourishing and most profound, and it must be retaken and restored at all costs.

MORE AEROPLANES ARE NEEDED

Anonymous
Great Britain, 1918

Female labor is still a widely debated aspect of the First World War. Ongoing discussions center on women's roles in society, the kinds of work women did and did not perform, the numbers of war workers, and the pay and conditions under which they worked. Nevertheless, several points are clear. First, as men enlisted or were called up, their absence created a severe labor shortage that was at least partly alleviated by female workers. Secondly, governments, which were worried about production of war materiel, were universally in favor of females working in the war industries; trade unions, worried about skills and wages, were almost universally hostile. Propaganda offices saw female workers as proof of the unity of the nation behind the war effort. Thirdly, across industrialized western Europe, the experience of female workers differed from country to country.[32]

When war came in 1914 there were already large numbers of women engaged in agricultural work, largely in mainland European countries that had substantial peasant populations. After the men were called up, the women took over the farms, and kept them going as best they could. In Britain agriculture was more mechanized, and although the "land girls" came on the scene late in the war, they had little effect on agricultural production.[33]

Female labor was also widespread in industrial and service occupations before the war. The largest single form of female employment was domestic service, which occupied 1.6 million women in Britain. When the war began, women who were already in the workforce migrated from low-paid women's work (including domestic service) into higher-paying jobs in transport

and industry.[34] Serious recruitment of women workers, especially in the critical munitions industry, began in 1915.[35] Working conditions in the factories varied by country, but the manufacture of munitions was inherently risky. Explosions and TNT poisoning threatened lives and health. Women in those industries, the forerunners of Rosie the Riveter, still earned less than men, but more than they would have in traditional women's work.[36] In countries such as Germany and Austria-Hungary, where the food supplies seriously deteriorated (France and Britain maintained secure food supplies throughout the war), women who were exhausted from long hours of work still had to line up for food and care for their families. For them, the war was very hard indeed, and working-class women grew increasingly desperate, leading to strikes and food riots in 1917–18.[37]

As in World War II, and despite having been told for years how essential their work was, when the war ended women were dismissed wholesale from "men's jobs," particularly in the war industries. Life, they were told, needed to get back to "normal." By the early twenties, the old patterns of male and female employment in Britain had reasserted themselves.[38] In France, pronatalist forces, terrified by the losses of the war, responded by asserting that childbearing was a woman's duty to the country, and pushed through legislation forbidding information about birth control and outlawing abortion.[39] In Britain, at least, women got the vote; French women waited until 1944 for that privilege.

Of the war industries in which women worked, munitions was the most dangerous, while aviation was

©IMPERIAL WAR MUSEUMS (ART.IWM PST 5227)

the most glamorous. Still in its infancy in 1914, the use of airpower grew exponentially during the war, from simple reconnaissance to the development of airships, bombers, and fighters. The development of fighter tactics created yet another version of the chivalric theme, as fighter pilots became the "knights of the air," the embodiments of individual heroic action in an unheroic mass war.[40] High attrition in the air war, beginning in earnest in 1916, led to serious industrial mobilization in 1917 and 1918, as by that time the airplane had become indispensable over the modern battlefield.[41]

This recruitment poster (probably from May 1918) for women workers in the airplane industry uses the glamour of aviation to appeal to young women. The stock advertising techniques of bright color and a pretty girl engage the viewer. At the top, planes wheel and turn against a puffy pink and white cloud, while a large biplane occupies the top of the image, its wings reaching beyond the borders of the poster. It carries the markings of the Royal Air Force, created as a separate service in April 1918. The whole landscape is wonderfully English—blue sky, huge trees, and green fields. In the foreground a maintenance crew works on a biplane in front of a row of hangars. Inside the framed image the viewer is told in simple white block letters "More aeroplanes are needed" (British spelling). As always, a response to the situation is provided: "Women, Come and Help!" in larger text, with the inducement of free training and allowances listed below.

But the real interest lies in the figure of the young woman. She is a conventionally pretty girl of the period: blue eyes, Clara Bow mouth, blond curls peeking from beneath her cap, and the suggestion of a nice figure. Interestingly for an industrial worker, she is very clean and tidy. She wears an industrial overall belted below the bosom, sleeves rolled up to the elbows. The rolled sleeves are the standard emblem of a hard worker, appearing frequently on men in posters encouraging industrial output. The cap protecting her hair is also a regular accoutrement for female workers (there are

many examples in contemporary photographs). With her serious expression and raised arm indicating the biplane—the only dynamic line in an otherwise static composition—she encourages other young women like herself to join the war effort.

The conjunction of the female figure and the background image implies that the necessary work of building airplanes will be carried out in healthful country surroundings. It also substitutes a peaceful setting for the less-than-peaceful and far uglier realities of the front. In the case of this poster, simple commercial images convey simple messages, however deceptive. The poster is even provided with an empty space at the bottom to list a location where one can "apply at once." The urgency of the appeal mirrors that of the 1915 recruiting posters.

Aesthetically this poster, like many encouraging women to take up war work, lacks sophistication and refinement. Criticism of the artistic quality of British posters was common both before and during the war.[42] Most British posters were designed and produced by printing firms using staff artists, so they rarely reach the artistic quality of Hohlwein, Bernhard, or Faivre. That said, they are workmanlike and fulfill the persuasive purpose for which they were created. Women did respond and did go into war industries, perhaps enticed by the familiar commercial style of the posters.

Since the conditions of war work certainly weren't as appealing as depicted here, why did women go into war industries? Certainly they went for the money, whether to earn more for themselves or to maintain their families while the men were away. There was also patriotism—the desire to "do their bit," and to contribute as men were contributing at the front—the emotional bedrock on which this appeal is based. And at least for many women in Britain, it was exciting. War work not only provided good wages, but also interesting work and companionship. For some women, they were the best years of their lives.

REMEMBER!
THE FLAG OF LIBERTY

Anonymous
USA, 1918

In 1900, the United States had a population of 76 million. By 1915, that had risen to 100 million, 15 million of whom were immigrants (my paternal grandparents among them) in the "new wave" of immigration.[43] The "old immigration" in the late nineteenth century consisted primarily of people from northern and western Europe: Germans, Irish, Scots, and Scandinavians. The new immigration comprised mostly Italians and non-Germanic central and eastern Europeans—Poles, Russians, and Jews. However much they may have wanted to assimilate, most ended up in ethnic neighborhoods in big cities, New York's Lower East Side and Little Italy being only the most obvious of many examples. With the declaration of war in 1917, public pressure on immigrants to "Americanize" intensified.

Military service was one overt form of Americanization. The idea of conscription had faced significant opposition, some arguing that it was unconstitutional and others that it was "Prussian" and out of keeping with the American tradition of volunteerism.[44] Despite this, the bill passed, and Woodrow Wilson signed the new Selective Service Act in May 1917.[45] Selective Service was successfully promoted with posters and presidential proclamations asserting that it was not conscription, but a selection of volunteers, and on June 5, 1917, ten million men registered.[46] Once the Selective Service numbers were drawn, 20 percent of inductees were recent immigrants to the United States.[47]

Having sold the need for manpower, the next challenge was to convince the entire population, including immigrants, of the need for money. At the outbreak of war, Secretary of the Treasury William McAdoo turned to the records of Samuel Chase, Lincoln's treasury secretary, for guidance on how to finance a war. In 1917 the Civil War, now so distant to us, was merely fifty years in the past and still within living memory. Chase had marketed some government securities through a private firm, but McAdoo was convinced that he could expand the idea into a government-administered public program of war bond sales.[48] Prior to the issue of the First Liberty Loan in May 1917, the energetic McAdoo had spoken at war bond rallies nationwide, recruited movie stars such as Douglas Fairbanks and Mary Pickford to encourage sales, and enlisted artists to create posters.[49]

In McAdoo's mind, purchase of war bonds demonstrated support for the war. Before the issue of the loan, his greatest fear was that the "morale effect" of having millions of bonds left unpurchased "would be equal to a crushing military disaster."[50] Fortunately for McAdoo, the first and all subsequent loans were oversubscribed. Despite widespread ignorance of the functioning of high finance, estimates indicate that one-third of the U.S. population bought at least one Liberty Bond.[51] The bonds were sold through appeals to patriotism and little else, and were visually led by Uncle Sam and Liberty, who as allegorical figures enjoyed wide recognition and identification. Social pressure also encouraged purchase. Every purchaser received a Liberty Button to wear, and posters suggested that people would be "uncomfortable" without the button—visible patriotism was the only socially acceptable position for a citizen.

One group of citizens, however, turned out to be difficult to convince—the immigrants. Although eager

LIBRARY OF CONGRESS: LC-USZC4-9933

to be considered Americans, old national loyalties and grudges undermined new loyalty to the United States. Irish Catholics had no desire to aid Britain. Jews who had left the Russian Pale were less than thrilled with America's new ally. Citizens of German heritage, although they did not support the German war effort and were entirely loyal to the United States, still did not want German culture destroyed. The "Americanizers" were unsympathetic to such concerns, McAdoo having said that "[a] man who can't lend his government $1.25 per week at the rate of 4 percent interest is not entitled to be an American citizen."[52] Many no doubt agreed with him.

In order to entice immigrants, especially recent immigrants, into buying bonds, the government commissioned targeted posters, many of which were produced in multiple languages. These posters characteristically include imagery designed to remind the immigrant of his or her arrival in America. In this anonymous poster advertising the Third Liberty Loan (April 1918), a lightly sketched steamship (the only mode of arrival for Europeans) occupies the background. Although not included in this image, the Statue of Liberty, who had greeted most immigrants in New York harbor since 1886, was a favored symbol, representing hope, freedom, and a new life for millions.[53] Her "off-poster" presence may be suggested by the hopeful gaze of the immigrants, much like the moving scene in the second *Godfather* film. The rest of the background of the poster is occupied by the U.S. flag, a ubiquitous presence in most war loan posters.

In the foreground stands a group of immigrants, identified as such by their clothing and bundled belongings. Their countries of origin are uncertain, although the cap and red kerchief of the handsome, dark-haired man who occupies the middle of the image may indicate that he is Italian. The woman behind him, her head wrapped in a shawl, could be from any of the central European countries. The little boy on the left wears what may be a Russian cap. The figures are probably

not meant to be a family group, but immigrants of different ages, sexes, and origins joining the American melting pot. As such, they represent all immigrants, who are enjoined to "Remember! The Flag of Liberty," and to respect it as the man has done by removing his cap. The man and woman both wear expressions of hope and faith in the future, and are the embodiment of what was then regarded as the immigrant experience. Even more, they are urged to support the flag—the symbol of the United States—by buying war bonds.

The word *remember* takes on great significance in World War I posters, especially American ones. It evokes the battle cry of the Spanish-American War, "Remember the Maine," which slips easily into "Remember Belgium" and then into "Remember the Argonne." In the United States, the word appears more frequently on posters aimed at immigrants, as in a Second Liberty Loan poster titled "Remember your First Thrill of American Liberty," showing an immigrant ship passing the Statue of Liberty. In this case, immigrants are being asked to remember not the flag itself, but what it stands for: liberty, and the country that has given it to them.

This poster effectively combines several persuasive themes: duty, shame, and inclusion. It first suggests to immigrants that America has given them liberty, and now they have a duty to repay that great gift. The other implication is more subtle and works through the visual image: If they want to be true Americans, they must support America in every way possible. False dilemmas (if you don't buy war bonds you are a disloyal American) function on a subliminal emotional level, evoke shame in the viewer, and are very effective in propaganda. Whether overt or merely implied (as in this poster), forced choices run right through the history of propaganda. Here the hidden implication is softened by the drawing's visual appeal and the hopeful expressions. Though not one of the great posters, it is nevertheless a wonderfully subtle and persuasive one.

USA Bonds

Joseph Christian Leyendecker
United States, 1918

Weapons for Liberty—U.S.A. Bonds by Joseph Christian Leyendecker is one of the most recognized and most reproduced of American First World War posters. With its impressive composition and skilled drawing, it displays all the expected elements of a war loan poster: a statuesque Lady Liberty, draped in the American flag and holding a shield embossed with the Great Seal of the United States, reaches for a longsword offered reverently by a Boy Scout. It is excellently done, but predictable in its appeal and imagery, and so we turn the page.

But turn it back and look again. Why? Because for the early twenty-first-century viewer, this image raises questions of gender, race, sexuality, and politics. Is that a Phrygian bonnet under Lady Liberty's seven-pointed crown? Her features are rather masculine, and the arm reaching for the sword is distinctly muscular. Lady Liberty is presented as a classical figure, but the sword the Boy Scout holds is medieval in design. The boy appears reduced and even enfeebled by the mass of the sword. And what are Boy Scouts (children) doing in a war loan poster? The weighty symbolism can be charitably described as eclectic, and uncharitably as a contradictory mishmash.

In the case of Leyendecker's poster, the obvious starting point is Lady Liberty herself. At first glance, she is completely different from Christy's dynamic, eroticized Liberty. This one, first of all, is largely static and monumental. She is undoubtedly meant to be a direct reference to the Statue of Liberty, which at this point was a mere thirty years old but had already become a potent symbol, particularly for immigrants, and had largely replaced the older allegorical figure of Columbia.[54] The

majority of First World War posters that depict Liberty, with the notable exception of Christy and a few others, represent her in statuary terms—that is, upright and fairly static. She is presented as a universal icon of American liberty, using a familiar artistic language. She also wears the statue's seven-pointed crown, a reference to Helios, the sun god. The Statue of Liberty is intimately connected with the idea of light: her torch lights the way to freedom for the world, especially within the context of the early twentieth century.[55]

Leyendecker had studied at the Académie Julien in Paris, a bastion of the French academic style, and would certainly have been familiar with French representations of Marianne, including Delacroix's, so it is possible that his use of the Phrygian cap under the crown is a nod to Liberty's revolutionary forbearer. Draped in the Stars and Stripes and carrying a shield bearing the Great Seal, Leyendecker's Liberty is the symbolic embodiment of the revolutionary American idea of Liberty, relying on the vocabulary of nineteenth-century classical references.

Those classical references break down when we consider the sword. The sword depicted, bearing the emblem and motto (Be Prepared) of the Boy Scouts of America, is a long medieval broadsword, more at home with Saint George or Saint Michael than with Liberty and a Boy Scout. But the sword is connected to the title on the plinth beneath the statuesque Liberty and the kneeling Boy Scout: *Weapons for Liberty*, an easily understood double entendre. In wartime, Liberty relinquishes her lamp in favor of a sword. The medieval reference inherent in the sword is reinforced by the kneeling posture of the Boy Scout. He is offering the

LIBRARY OF CONGRESS: LC-USZC4-1127

sword as would a squire to his knight. Moreover, it is a Boy Scout sword, linking the uniformed adolescent boy to both war and chivalry. Indeed, both the uniform and the sword with its motto suggest that the scout is in training to become a soldier, as the squire is to become a knight. The boy's expression of dedication seals his readiness for service and sacrifice in the chivalric mode.

The link between scouting and chivalry reaches back to the foundation of the movement by Robert Baden-Powell in Britain in 1908. With its emphasis on duty and morality, the ideology and language of chivalry entered the movement early on.[56] When the scouting movement crossed the Atlantic in 1910, most of the ideological baggage came with it. McAdoo, recognizing the unique position of the Boy Scouts as the youthful epitome of duty, morality, and patriotism, enlisted them to help in the sale of war bonds, giving them a dedicated week and using the slogan "Every Scout to Save a soldier."[57] The slogan reaffirms the close identification of the scout with the soldier. Leyendecker's clean-cut scout, in his crisp uniform, boots, and kneesocks, would have impressed viewers of the time as the incarnation of high moral standards, patriotism, and readiness for service. In the course of the war, Boy Scouts sold over $355 million worth of war bonds and war savings stamps, as well as participating in other programs to support the war effort.

Total war involved the participation of the entire population, including children. The willingness of the Boy Scouts of America to partner with the government to further the war effort—the overall slogan was "Help Win the War"—speaks volumes about contemporary attitudes concerning proper activities for children and adolescents.[58] It is clichéd to refer to pre–First World War America as "innocent," but in its perception of the relationship between children and violence it is indeed a period and place still innocent of the horrors of the next hundred years.

With this poster, we come face to face with the problem that bedevils any historian who deals with visual images: the gap between the world in which the image was made and expressed its meaning, and the world in which it is viewed. We are looking at images from one hundred years ago, made in a world whose framework of references, values, and assumptions was quite different from our own. A careful historian, through much research and reflection, can to some extent think himself or herself back into the mentality of an earlier period—but not completely. We are all shaped by the world in which we live and our experiences of it. We have no choice but to see with our own twenty-first-century eyes.

So then, are modern interpretations of these posters—analyses based on ideologies of gender, race, politics, and economics—invalid? Not necessarily. Every generation reevaluates ideas, events, and artifacts from preceding generations. At their best, contemporary interpretations raise interesting questions about representation, purpose, and meaning. But in all cases, we are analyzing and judging artifacts by applying a set of categories, standards, and values that did not exist when the objects were made, and that do not enlighten us about how that poster persuaded its audience. Maurice Rickards has pointed out that as the First World War and its background detail fade, "each individual message gets more difficult to read; in some cases it actually may be unintelligible."[59] We will never really know exactly how these posters affected the people who saw them; there is very little direct evidence testifying to their effect.[60] But we can work backwards from the stated purpose of the poster (to encourage enlistment, to sell war bonds, etc.) to determine how it would likely have been perceived.

For the people of its time, this poster probably functioned on an almost entirely symbolic and universal level. That is why the combination of classical and medieval references that we find so jarring, particularly in a culture with neither a classical nor a medieval past, probably passed unnoticed, much like the sixteenth-century paintings of biblical scenes in which the figures are clothed in the finest Renaissance silks. Given that classical references had been deeply embedded in American culture since the founding of the republic (few important public buildings are *not* neoclassical), Liberty is less masculine and more statuary. The Boy Scout-squire is also universalized. Although metaphorically chivalric, his devotion is an Americanized dedication to Liberty as the ideal of the nation. Ultimately, whatever we choose to make of this poster, for Americans of 1918, it must have represented the universal strength of liberty and a confidence in the patriotism and duty of the next generation.

CRÉDIT LYONNAIS SOUSCRIVEZ AU 4E EMPRUNT NATIONAL

Jules-Abel Faivre

France, 1918

While classicism in the United States was largely a matter of architecture and sculpture (a stylistic choice influenced by Jefferson, among others), classicism had permeated all the arts in France for centuries, periodically going out of favor (as in the Middle Ages), but always returning. For public art, it was France's default vocabulary. That was expressly true of the Third French Republic, established in 1871 following the defeat by Germany and the civil uprising of the Commune. In their efforts to reestablish French self-esteem and patriotism, the successive governments of the Third Republic promoted patriotic education and indulged in what has been called "statuomanie," a mania for (classical) statues.[61]

As the end of the First World War approached, the use of symbolism, never entirely absent, became increasingly prevalent. Symbols became more appealing to artists because, first, they provided a means of avoiding actualities while still creating a persuasive message. In the dark days of the German offensives (March–August 1918), realistic depiction would only undermine citizen morale. Classicism, on the other hand, served as a kind of French aesthetic comfort zone, filled with familiar and predictable references to the glory of France and French arms.

This poster, one of two that Faivre created for the Fourth National Loan (October 1918), stands at the apogee of classicizing symbolism. There are only two figures: the great black eagle of Imperial Germany, and the French soldier as a classical warrior, contesting possession of the French flag. At first glance, the warrior is a classical archetype: muscular, nude but for the sword belt and helmet, heroically attacking his opponent. The

French tradition of academic figure drawing—drawing from the nude—is apparent. The musculature of the body is beautifully delineated. The figure is classical, except for the sword, which appears to be relatively modern, and the Adrian helmet, which immediately identifies the warrior as a French soldier, and conflates ancient warrior with modern soldier in a single universalizing gesture.

The warrior-soldier's opponent is a huge, glaringly malevolent black eagle. Wings outstretched, talons clawing for the warrior, its beak clings ferociously to the French flag as the warrior pulls the flag away and simultaneously plunges his sword into the eagle's body. Faivre has created a single diagonal line running from the top of the warrior's outstretched arm down through the eagle's body. Along that line, the warrior stares down the eagle from his superior position, symbolically rescuing France from Germany. The folds of the flag are behind his body as he lunges forward to kill the eagle. The image, even with its abstraction, suggests the level of French animosity toward Germany at this point in the war. The remobilized French public of 1918 was determined to gain the victory. The war is here configured as a battle to the death, which France is winning, as suggested by the plunging sword and the rising sun behind the figures. And indeed by early autumn of 1918, Frenchmen could finally believe that they were winning. The German offensives had collapsed after "the Black Day of the German army" on August 8, and German forces were in retreat. Whether belief or hope, this poster and Faivre's other poster for the same war loan exude the whiff of victory.

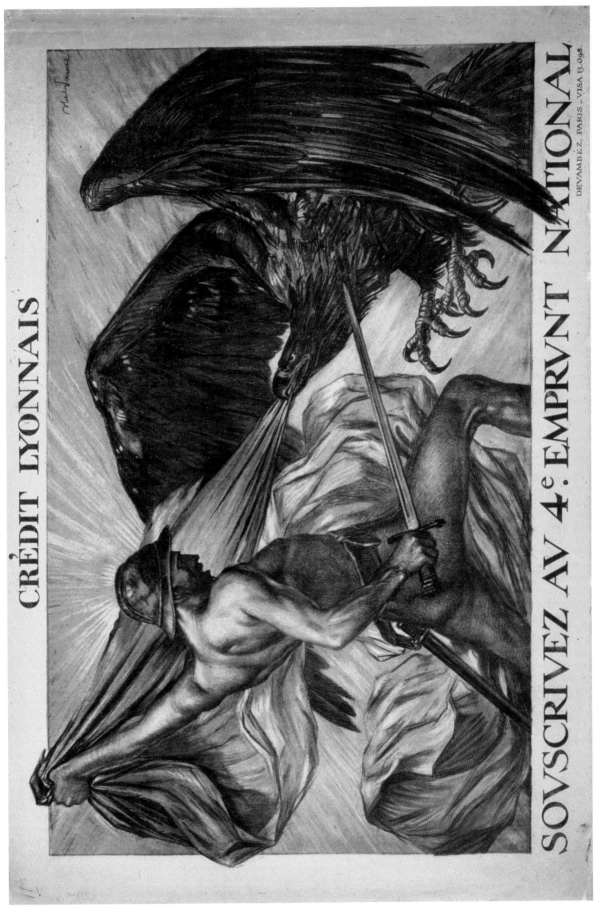

©2015 ARTISTS RIGHTS SOCIETY (ARS), NEW YORK/ADAGP, PARIS; LIBRARY OF CONGRESS: LC-USZC2-3859

In addition to the dueling warrior and eagle, there is another animated symbol: the French tricolor flag. Stretched tightly between the eagle's beak and the warrior's hand, it cascades in folds behind the warrior's body. With its origins in the Revolution of 1789, the flag adds traditional republican references to the mixture of symbols. The combination of colors in the flag originated with the Marquis de Lafayette, commander of the National Guard and the man tasked with keeping order in Paris—no mean duty in the heady revolutionary summer of 1789. As a badge of patriotic identity for the guard, he invented the revolutionary cockade. Between red and blue, the traditional colors of Paris—the epicenter of the revolution—he inserted white, the color of the Bourbon monarchy. The cockade was worn on the hats of the National Guards and swept through the population as the essential patriotic symbol.[62] It appeared everywhere: on hats, coats, dresses, Phrygian bonnets, and shoes, and even on the "trees of Liberty" planted across France.[63] A cursory overview of revolutionary prints shows how widespread the cockades were. With the reestablishment of Bastille Day (July 14) as a national holiday in 1880, and the *Marseillaise* as the national anthem, the Third Republic sealed its position as the heir to the French Revolution and simultaneously validated its legitimacy.[64]

Faivre's posters are the most "French" of the French war posters. His academic style and relatively muted colors carry on the traditions of academic classicism. Nevertheless, his drawings are never static. They are so dynamic that they threaten to explode out of their frames, and sometimes do. This dynamism, combined with his skilled exploitation of traditional national symbols (the cock, the tricolor) and his ability to embody the concept of "fighting France" transforms his posters into iconic expressions of French belief and French will.

HELFT DEN HÜTERN EURES GLÜCKES

Walter Georgi
Germany, 1918

In early 1918 the domestic and military situation for Germany worsened. American troops arrived in France in ever-increasing numbers, forcing Hindenburg and Ludendorff to make their final, desperate gamble of the war: the German offensives of March–August. As always, the offensives were designed to create a breakthrough and a German victory. Their failure signaled the inevitability of a German defeat. In spite of increasing shortages of basic commodities, and inflationary prices for those that could be found, war loan drives went on as usual. There were two German war loans in 1918, the Seventh in April and the Eighth in July.

German war posters, which invariably have a deep seriousness about them, grew ever more somber in tone as the war stretched into its fourth year. A brightly colored poster in 1918 is a rarity. Germany's technological resources for poster production had always been more limited than, for example, those of the United States, including the range of colors available. The subdued colors favored by the most important artistic movement of the period, *Jugendstil*, further ensured that Germany tended to produce posters that quietly advocated unity, endurance (*durchleben*), and cultural and historical continuity.[65] Sober German posters of 1917 and 1918 concentrated on duty and sacrifice, and were essentially inward-looking, reflecting the general deterioration of daily life and mounting human losses.[66]

Georgi's poster for one of the 1918 war loans (it is unclear which) is fairly characteristic. As the French reached back to the Revolution and its associated classical images, German artists retreated into medievalism. Whatever the reality of medieval life, the romantic medieval revival had transformed the German late Middle Ages into a mythical world of security, certainty, and German political and cultural unity. Much as classicism provided wartime France with a sense of French identity and *gloire*, medievalism provided Germans with a stable past that was both refuge and model.

Georgi's poster draws on idealized images of the German warrior and of the medieval German family. The theme of the war loan, stated in the upper right corner, is *Helft den Hütern Eures Glückes* (Help the guardian of your happiness). The phrase "your happiness" indicates that the poster is probably aimed at women, notably at mothers with children whose security depends on the strength of the father. The word *Hütern* comes from the verb *hüten*, to guard or protect. Although the word is still current in German, it has an appropriately archaic ring. As in Gipkin's poster, the request is couched in the familiar form, drawing the viewer into the familial scene, configured as a medieval image.

The image occupies almost the whole of the poster. In the foreground a mother holds her baby, who has entwined his rather muscular arms around her neck. She is presented as the archetype of the German medieval woman with her simple dark dress and kerchief, and her cascading blond hair with a braid that forms a virtual diadem. The child is as blond as she, one of the icons of the Germanic medieval vision. Whether most medieval Germans were blond or not is beside the point here; the German paradigm of the medieval woman is blond, a trait of coloring that snakes its way into racial typing in later National Socialist posters. She is fully occupied with the child, and smiles softly at him. The image is, of course, a

LIBRARY OF CONGRESS: LC-USZC4-11600

reference to the Madonna and Child, appropriate to the medievalism of the poster. Both are visibly wrapped in the security provided by the father. Although the woman and child do not appear fragile, they are dwarfed by the size and strength of the man. His facial features embody the idealized Germanic type: blue eyes, chiseled nose and cheekbones, square jaw, and stern expression. His height and masculinity are evident in his broad shoulders and the heavy broadsword grasped in his large right hand, ready to strike. The left hand, huge and protective, gently envelops his wife and child. The family group is presented as the incarnation of the German family and of traditional German values—both of which, the image implies, reach back to the Middle Ages.

At the same time, the artistic style is not expressly medieval, unlike that of Boehle's "In Deo Gratia." Georgi trained in Leipzig, Dresden, and finally Munich, becoming a part of the *Jugendstil* movement, as well as the group *Die Scholle*, which included Fritz Erler and Adolf Münzer. In keeping with the tenets of *Jugendstil*, Georgi used limited colors and simplified forms. His muscular male figures also appeared in the series of twenty-five field postcards that he designed for the baked goods company Bahlsen in 1914–15.[67] But the modernism is largely superficial, because the content of the poster, particularly the sword and the text in *Fraktur*, anchor it firmly in the traditionalist sphere. As noted earlier, *Fraktur* is the typeface of choice for most printed forms of communication in Germany in the nineteenth century and throughout the First World War. Between the wars, modernist and liberal writers and artists eschewed *Fraktur* for the simplicity of Roman type, but it remained the dominant typeface of conservative artists and groups, including the National Socialists.

The icon of the armed father protecting his family from outside dangers resonated strongly in the endangered Germany of 1918. Georgi's image emanates strength in the preservation of innocence, much like the sheltering walls of medieval German towns. Notions of blood, land, and "rootedness" in a national landscape solidified among nationalist and *völkisch* thinkers at the beginning of the twentieth century. They glorified peasants, rooted in their land and history and prepared to protect it, as the models of the true Germanic *Volk* (folk or people), an ideology apparent in this image.[68] It is but a short step to the National Socialist posters of "authentic" German peasant families.

DAS IST DER WEG ZUM FRIEDEN

Lucian Bernhard
Germany, 1918

Even more somber in style and message than Georgi's, Lucian Bernhard's war loan poster relies upon a stunningly simple image resting on complex cultural and historical associations. A mailed fist descends in a dynamic diagonal from the top right corner of the poster, nearly smashing into the text below. The wicked claw at the elbow exaggerates the implied threat of the clenched fist. It is an unambiguous symbol of strength, violence, and iron will—the embodiment of the German determination to see the war through to a German victory.

The creator of this poster, Lucian Bernhard, was one of the two most innovative German poster artists of the period (Ludwig Hohlwein was the other). After discovering the bright colors of art nouveau in his youth, he migrated to Berlin, not as "artistic" a city as Munich, but a center of industrial production and commercial activity. In 1905, with little time to prepare a design, he entered a poster contest for Priester matches. According to legend, Bernhard designed a complicated poster, then painted out everything except the word *Priester* in purple and two red matches with yellow tips on a maroon background. The judges threw it in the trash. But the leading judge, seeing nothing of interest among the entries, fished it out of the trash can and called it a work of genius.[69] Bernhard had created the *Sachplakat*, the object poster, characterized by reductive imagery and pared-down text.[70] He went on to design posters for many German businesses, and took his talents to New York in 1922, where he established long-term relationships with a number of American firms.

Bernhard's hallmark simplified design determines the composition of this poster. The mailed fist that occupies half the poster is not rendered in a painterly, realistic way, but reduced to thick black outlines and short black lines with alternating highlights. Bernhard, a master of minimalist imagery, here persuades with an armored fist of lights and shadows. The streamlined image is all the more powerful as it thrusts downward toward the *Das* of the text.

The text itself is in the familiar *Fraktur*, appropriate to the medieval imagery. The red first and last words provide the only color. In this context *Das* means "this"—a direct reference to the hovering fist, followed in black by *ist der Weg zum Frieden* (this is the way to peace). As is often the case with propaganda, the message leaves the viewer with no choice—only obedience. The second line of text, separated from the first by a dash, reads *die Feinde wollen es so!* (the enemies want it so!). The final words demand action, *darum zeichne Kriegsanleihe* (therefore subscribe to the war loan), the only response to the categorical assertion of the first line.

The image of the mailed fist has several direct precedents. The most obvious is Kaiser Wilhelm II's "mailed fist" speech of 1897, mentioned earlier, in which he threatened a ruthless response to any Chinese resistance.[71] But the more pertinent reference is to the historical, but nearly legendary, figure of *Götz von Berlichingen mit der eisernen Hand* (Götz von Berlichingen with the iron hand).[72] Götz was an imperial knight and soldier in the early sixteenth century, the period of the German Reformation, the Peasants' War, and numerous feuds, conflicts, and shifting alliances in the German lands. In 1504 he lost his right arm in battle, but continued a military career that stretched from 1497 to 1544. He had an iron prosthetic hand made

©2015 ARTISTS RIGHTS SOCIETY (ARS), NEW YORK/VG BILD-KUNST, BONN; LIBRARY OF CONGRESS: LC-USZC4-11504

for him that allowed him to fight and to write. He left a manuscript autobiography published in 1731, used by Goethe as the source of his early play *Götz von Berlichingen* (1773).[73] For nationalist historians and thinkers in the nineteenth century, Götz was an emblem of German resistance and endurance.

In Goethe's play, Götz embodies both defiance and betrayal. When imperial troops surround his castle and invite him to surrender, he leans out the window and tells the captain *"es kann mich im Arsche lecken"* (he can lick my ass). Götz's defiance ends with his betrayal by the leaders of the Peasants' War.[74] The German obsession with betrayal reaches far back into medieval literature, specifically to the *Niebelungenlied*, transformed in the late nineteenth century by Richard Wagner into a cycle of four operas generally known as the Ring Cycle. The betrayal at the heart of the legend is the treachery of Hagen, whose minions stab Siegfried in the back on a spot marked on his tunic with an *x*, the only spot where he is vulnerable. It is to that legendary betrayal, as noted earlier, that Hindenburg referred in 1919 when he stated that the German army had been stabbed in the back, displacing blame for defeat onto the civilian population and away from the army.

Bernhard's poster also shifts blame, suggesting that a continuance of the war is not the fault of Germany, but of enemies, and the only possible response is iron resolve and endurance. The text obliquely refers to the rising number of peace proposals floated in 1918. No peace is possible, it implies, because of the perfidiousness of enemies. The language suggests the many xenophobic phrases bandied about before the war, such as "encirclement" (*Einkreisung*) and "a world of enemies" (*ein Welt von Feinden*).[75] Shifting blame is a standard propaganda technique, heavily employed by Germany throughout the war. The kaiser's paranoia is well known, but much of the desire to shift blame originates with the German denial of Allied accusations of barbarianism and "Hunnish" behavior early in the war. With such consistent shifting of blame, and the delusional thinking it brought with it, the civilian government that assumed power after the abdication of the kaiser—and then negotiated the Armistice—expected far better treatment than it received. But worse was coming. After months of believing that the treaty to conclude the war, the Treaty of Versailles, would be based on Wilson's *Fourteen Points*, it is scarcely surprising that the "war guilt" clause of the Treaty of Versailles came as a terrible shock to the German delegation, and to the German population at large.[76] This poster has the same delusional tone—"we're chivalric, you aren't; we want peace, you don't." In the end the mailed fist looks like a final desperate strike—much like the last German offensives.

8. KRIEGSANLEIHE

Julius Klinger
Austria-Hungary, 1918

Within the European context, a witty war loan poster would seem to be an oxymoron. But amid the reams of deadly serious war loan appeals (many already examined), wit occasionally rears its dragon head. It did so in May 1918, a time of shattered hopes and rising insecurity for Austrian civilians, in the form of Julius Klinger's poster for the Eighth War Loan. Franz Joseph, the only emperor most Austrians had ever known, died in 1916 and was succeeded by his little-known great-nephew Karl. Faced with rising nationalist claims in the empire and a deteriorating situation in the cities and on the battlefield, Karl made a secret peace proposal to France in 1917. France and Britain, though tempted, were unwilling to abandon Italian claims in the South Tyrol, and Karl was equally unwilling to abandon Germany, so the offer, like so many before it, came to nothing.[77]

Austrian war loan posters, as one critic has pointed out, had little to do with a world in which millions of men were slaughtered in an industrialized mass war, but rather existed in a "mythical knightly kingdom," a "harmless world of saga and fairy tale."[78] The posters by Puchinger and Lenz, examined earlier, bear out that judgement. While the irony is inescapable in hindsight, gory realistic images of death and destruction do not instill hope, and do not persuade citizens to part with their money. If there is a universal paradigm in war loan posters, it is a message of hope: if you give, we will win the war. The unspoken subtext implies that if citizens don't give money for the war effort, the war will be lost, a prospect that no patriotic citizen would wish to contemplate. Hence the almost universal traditionalism of war loan posters: They are peopled by comforting images of noble knights, women and children in peril, and dutiful soldiers protecting hearth and home. They speak to the deep human need for stability and continuity.

Although it appears to break the traditional mold, Klinger's poster, despite its reductive modernism, still evokes an archaic world of dragons and archery. The iconography is as conventional as other appeals using chivalry (Puchinger) and Saint George (Lenz), but couched in a minimalist style that relies on visual wit. The text is reduced to a single line in an attenuated, elegant type: *Kriegsanleihe* (war loan). The figure eight (the number of the war loan) is not a part of the text, but an integral part of the design itself. Only three elements compose the image: the dragon's head and neck, eight arrows, and the figure eight. The palette is equally limited: black, dark green, and red on a tan background. Rising from the base of the image, the dragon's neck protrudes through the upper loop of the eight, which visually chokes it. The head has been pierced by seven arrows bearing small red numbers on their tails. The eighth arrow pierces the neck below the spines. Although the baleful red eye still glows, the head is drooping from the deadly blow of the eighth arrow, and blood drips from the mouth.

For all its simplicity, the message is clear. The dragon, representing the enemies of Austria-Hungary, has been badly wounded by the previous seven war loans (arrows), and the eighth will kill it. This is yet another version of the familiar theme of "one more effort for victory." The stylistic form employed for this theme is generally symbolic, as in Falter's visualization of a French soldier choking a German eagle. As the war

LIBRARY OF CONGRESS: LC-USZC4-12214

moved into its final stages, the European posters in general move increasingly toward visual symbolism to carry their messages to a war-weary audience. Abel Faivre's two posters for the Fourth War Loan are cases in point.

Originally from Vienna, Klinger lived and worked in Berlin before the war and absorbed the aesthetics of Lucian Bernhard and the object poster.[79] He became an established poster artist in Germany, particularly known for his wit.[80] He returned to Austria in 1915, when he was called up for service, and worked in the military press headquarters for the rest of the war.[81] He continued to create stylish modern posters after the war, and was active until 1938, when he was arrested and deported to Minsk by the Nazis due to his Jewish ancestry. He died there shortly afterwards.

This poster skillfully displays Klinger's gifts of elegant composition and visual wit deployed in a minimum of elements. It plays out as a duel between disorder and order, evil versus good, with color and form as the weapons. The dark colors and irregular coils of the dragon's neck represent disorder. The bright red and orderly curves of the figure eight stand for order—order that is choking the dragon. The composition is placed slightly off-center in the space, balanced by the red blood dripping from the dragon's mouth, and the large red dot at the bottom right. The dot is a superb example of the incorporation of text into

design: in German, a period after a numeral indicates that the number is ordinal and not cardinal—equivalent to the English *th* on most numbers—but here it ingeniously balances the composition. In Klinger's clever poster the enemy is not defeated by soldiers, coins, or Saint George; he is defeated by the number of the war loan itself.

Was this a "successful" war loan poster? Did it contribute to raising the needed funds? The question is essentially unanswerable, because it is impossible to quantify an exact correlation between propaganda and action. Did some hungry Viennese see the poster and rush to the bank to subscribe? Some may have done so; most probably did not. That likely had little to do with the aesthetics or persuasiveness of the poster, and everything to do with individual economic status and sentiments of duty and patriotism. On the other hand, in the age before radio, posters were the essential form of communication and persuasion, because they were seen by virtually everyone and appealed even to the illiterate or marginally literate, something that newspapers couldn't do. Even if they didn't subscribe to the Eighth War Loan, worn and hungry Austrians, wishing for peace, plenty, and the stability of the vanished world of Franz Joseph, may have looked at Klinger's poster and smiled, or even chuckled at its wit. And that, in 1918, is also success.

AND THEY THOUGHT WE COULDN'T FIGHT

Victor Clyde Forsythe
United States, ca. 1918

The entrance of the United States into the war in April 1917 raised hopes and doubts on both sides of the Atlantic. French and British leaders hoped fresh American manpower would give them the margin of victory they sought, but doubted that the United States could enlarge and mobilize its tiny standing army soon enough to be of any use, and further doubted the fighting caliber of its troops, especially newly recruited ones. Many Americans still doubted the wisdom of "foreign entanglements," but patriotically hoped that the boys, with their American "can-do" spirit, would give a good account of themselves. The German high command, which had long feared American manpower, believed that the Allies would be forced to capitulate before American might could be felt, especially with the resumption of unlimited submarine warfare and its effect on Atlantic shipping.

Doubts about the expansion and mobilization of the army were largely unfounded. The National Defense Act, allowing the army to more than triple in size from its prewar numbers, had already been passed in 1916.[82] Selective Service was introduced in May 1917, and a full division of the American Expeditionary Force (AEF) embarked for France within two months of the declaration of war.[83] That did not, of course, mean that the troops were trained and battle-ready. The more worrisome questions involved the disposition and use of American troops in Europe. French and British commanders, eager for fresh manpower, advocated amalgamating American units of regiment or division size into existing Allied formations, under French and British command and maintained by their logistical systems.[84] The U.S. government firmly rejected such plans as an insult to national pride, as it also rejected the idea of American troops being used in any theater other than the Western Front.[85] President Wilson, partly influenced by political considerations in the postwar world, had determined to create a huge, independent American army, commanded by its own officers, supplied by its own logistical system, and fighting under its own colors, even if it would not be capable of operations before 1919.[86] His point man in Europe, Gen. John J. Pershing, rigid and self-righteous, maintained the independence and identity of the U.S. forces at all costs.[87]

As things turned out, neither Allied nor American commanders won that battle. While the majority of American troops in France were training in rear areas, Pershing had been persuaded by Ferdinand Foch, the supreme commander of the Allied Armies, to put small American units into the line under Allied command. The first blooding of American troops in October 1917 had made a bad impression on Allied commanders, with the Americans showing poor preparation and even unwillingness to fight.[88] Things went better when U.S. Marines helped block the German advance to the Marne in May–June 1918. Eventually the U.S. First Army was formed and allowed to conduct independent operations in September 1918.[89] American offensives in September reduced the Saint Mihiel salient, which had existed since 1914, in six days. The Meuse-Argonne offensive began in late September and forced the Germans away from the Aisne and back to the Meuse, clearing much of the plain between the two rivers. It was still in progress when the Armistice was declared on November 11.[90]

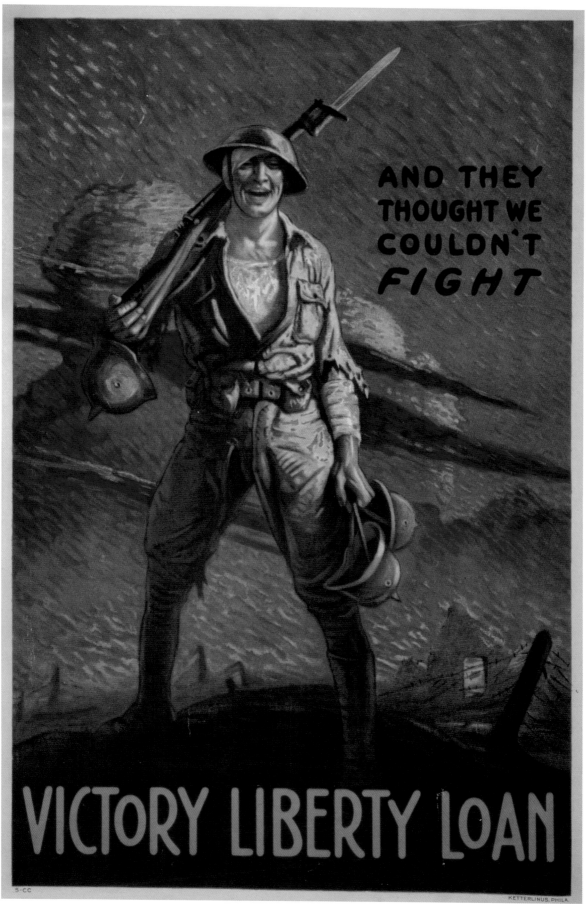

LIBRARY OF CONGRESS: LC-USZC4-10221

On May 30, 1918, the leading elements of Ludendorff's third offensive had reached the Marne, the corridor to Paris. With the Allied commanders desperate for troops, Pershing agreed to release the Second Infantry Division, composed of U.S. Marines, to French command. They were trucked to the front by French Indochinese drivers and finally reached French general Degoutte's retreating headquarters. In an incident that remains a part of Marine Corps legend, a young Marine officer, Capt. Lloyd Williams, rushed in to receive his final orders, which were to withdraw. Appalled and confused, the young man blurted out "Retreat? . . . Hell! We just got here."[91] That exchange provides a verbal equivalent to Victor Clyde Forsythe's poster for the Victory Liberty Loan. The loan was floated in May 1919, though the artwork was most likely done in 1918, as its cocky assurance embodies the success of American arms in the autumn of 1918.

Forsythe came from Southern California to New York in the early years of the century, and became a well-known illustrator and cartoonist. He produced a number of posters for the Division of Pictorial Publicity, of which this is the best known. Against a background of barbed wire and ruined houses, and beneath a dark blue sky enlivened by drifting clouds and smoke, a grinning, almost laughing American soldier stands with his feet planted solidly on French soil. His shirt is unbuttoned and the left sleeve shredded, indicative of hard fighting. Both his arm and head are bandaged, and blood stains his undershirt. His helmet is set at a jaunty angle over the bandage, and he has shouldered his rifle (with bayonet) in order to carry his trophies: three German spiked helmets. Never mind that the German army had been using the *Stahlhelm* since 1916—in propaganda the spiked helmet remained the symbol of German militarism. Here, those trophy helmets, each marked by a bullet hole, symbolize the victory of American manhood and the vindication of American fighting spirit.

The textual style reinforces the image. The caption at the bottom, *Victory Liberty Loan*, is rendered in red in a casual, cheery style: the *o*'s are smaller than the other letters, and the arm of the *y* in Liberty has been clipped to allow for the crossbar of the *t*. Likewise, the text of the title, framed by the rifle and the helmets, encapsulates the attitude of the moment, "and they

thought we couldn't fight," with the word *fight* in larger, widely spaced block letters.

This poster typifies the clash between "Old Europe" and "New America" on several levels. Like the incident cited above, it reveals negative European attitudes about American soldiers, including questions of their ability and willingness to fight. The European military elite by and large knew very little of the American Civil War, although it was the largest war of the nineteenth century, and knew even less of the Spanish-American War and of actions against Mexico and Native American tribes. Their standard was European warfare (although there had been no war in Europe in the forty years before 1914). They deprecated volunteer armies for military and political reasons, and they suspected that American troops were not up the standard of European troops.[92] "They" in the text refers most obviously to the Germans (hence the helmets), but more broadly to the "Old" Europeans who had misjudged American fighting spirit and dedication to action. There is little doubt that American propagandists played on America's traditional isolationism and suspicion of Europe, and emphasized European disdain in order to codify the perceived American values of independence, action, and outright cockiness about their own capabilities. The same spirit drives Irving Berlin's *Over There*, where the "Yanks are coming" to sort out Europe's problems.

On another level, this is the most American of posters in style and tone. The style of the image is typical of American magazine illustration in the first decade of the century. It isn't subtle, arcane, or avant-garde, but on the contrary straightforward and familiar in its design and its message. Readers of *Collier's* and *The Saturday Evening Post* would have been right at home with it and recognized it as a part of their own culture. It is also, unlike European war loan posters, humorous. There are a few British posters that use humor. Bert Thomas's "Arf a mo', Kaiser" comes immediately to mind, but that's a poster for tobacco, not something as serious as a war loan. This isn't the subtle visual wit of Faivre or Klinger. This was meant to elicit a chuckle of agreement, if not an outright laugh, from a viewer. Imagine a solid American citizen of the time, an office or factory worker, standing before this poster and chuckling "That's right—we showed them," and then going off to buy his Victory Bond.

THE TIDAL WAVE

Joseph Clement Coll
United States, 1918

"New America" on its way to save corrupt "Old Europe" from itself is equally the message of Coll's poster *The Tidal Wave*. In one of the most dynamic posters of the war, the arrival of American ships, troops, and armaments is configured as a tidal wave, an irresistible force of nature carrying all opposition before it. Nationalist writing of the period is filled with organic metaphors of power, projecting military might as a raging tempest, or as here, a tidal wave sweeping away everything in its path.

With its garish colors, Coll's poster embodies the dynamism of American military might in a single image. Led by an attacking eagle, wings outstretched and talons thrust forward, a line of ships fronts the great wave. In a confused mass behind the ships are troops, armaments, and planes. The peak of the wave is occupied by Teddy Roosevelt, charging up San Juan Hill, immediately recognizable to Americans of the time by the many popular illustrations of the battle. To the left of the image, more cavalrymen, the heroes of the opening of the American West, rear and plunge through the wave in front of a large artillery piece. On the right, above more heavy guns, troops are assaulting a hill (part of the wave) behind a flag. Above them, against an orange sky (the rising sun of the New World?), airplanes burst out of the wave. In its dynamism, the image itself bursts out of its frame, the wave lapping behind the top title and more waves, along with the eagle's wings, reaching down to the bottom of the poster. It's as if the energy of American arms cannot be contained or limited.

Coll's energetic illustrative style emerged from his background as an illustrator of thrilling adventure sto-

ries and fantastic tales. By the time of his death from appendicitis in 1921, aged forty-one, he had created a body of work that defined what adventure illustration should be. He was also a master of the pen-and-ink drawing, using fine lines to create shading and texture, a technique apparent in the horses and soldiers in the wave. The rearing and plunging mounts testify to a long career of illustrating adventure stories filled with galloping horses.[93] Coll's taste for pen and ink also explains the limited palette of the poster. Other than the emphatic orange, the poster largely relies on line rather than color.

The immediate occasion commemorated by the poster is the launching of ninety-five new ships on July, 4, 1918. The choice of Independence Day connects present with past. More significant is the obvious pride in American industrial achievement represented by the number of ships and the speed with which they were constructed.

The United States did not enter the war without ships. The U.S. Navy had embarked in 1916 on a vast building program to create a fleet capable of mastery of the seas according to the influential theories of Alfred Thayer Mahan[94], and the United States had the second-largest fleet of modern battleships after Britain.[95] But the sudden imperative need for cargo, transport, and antisubmarine vessels led to the abandonment of capital shipbuilding in favor of merchant ships. The Emergency Fleet Corporation (EFC) was created by the U.S. Shipping Board on April 16, 1917, shortly after the declaration of war, to build, acquire, maintain, and operate a merchant fleet for the U.S. government. The EFC began by requisitioning more than 400 ships

LIBRARY OF CONGRESS: LC-USZC4-9734

currently under construction for foreign companies in American yards. It went on to build three major shipyards, the most important of which was Hog Island near Philadelphia.[96] To speed construction, the shipbuilding industry applied innovations that Henry Ford had already brought to automobile construction: the use of prefabricated parts and standardized designs.[97] Hog Island became the prototype for the mass production of ships.[98]

In October 1918 over 3,000 ships were in the construction program, but by the end of the month only 378 ships had entered service. So it is highly unlikely that any of the 95 ships whose launch Coll's poster so proudly proclaims saw active service during the war. In fact, the EFC's major problem after the Armistice was how to shut down the program and get rid of the ships it had produced. A severe postwar slump in the shipping industry made selling the ships difficult, and many of the cargo ships were eventually sold for scrap.[99]

Although the EFC can scarcely be regarded as a successful enterprise, due largely to the brevity of American involvement in the war, it laid the groundwork for future developments. First, it created a template for industrial expansion in a national emergency, a prototype using standardized parts and assembly that could be applied to many types of armaments manufacturing. That foundation allowed the United States, even before its own entry into World War II, to become what President Franklin Roosevelt called the "Arsenal of Democracy."[100] Second, although the slow startup of industrial conversion to war production meant that American industries had little effect at the front, war industries made rapid progress on a large scale.[101] American industrial expansion in World War I also set the pattern of government and industry cooperation that would later come to be called the military-industrial complex. Finally, World War I firmly cemented in the minds of Americans and foreigners alike a belief in the insuperable industrial might of the United States. Even with its symbolic bald eagle, Coll's poster evokes the real union of industrial and military in visual form. The tidal wave isn't just ships, but men and armaments carried in those ships. Although the overt message is about ships, the subtext is "Watch out! The Yanks are coming!"

4E EMPRUNT DE LA DÉFENSE NATIONALE

Jules-Abel Faivre
France, 1918

This is Abel Faivre's second poster for the Fourth National Defense Loan (October 1918). The previous one depicts a classicized French soldier plunging a sword into the heart of the German black eagle, with whom he is disputing possession of a French tricolor flag. That poster, even with its abstract symbolism, is all about continuing the struggle. Despite a presumably mortal blow, the eagle is not yet defeated. This poster, be it wishful thinking or a presage of the coming Armistice, stands as a symbolic summation and justification of the Allied, and more importantly, the French war effort.

As is usually the case with Faivre's work, this poster is all about diagonals. On the bottom left, Kaiser Wilhelm II kneels in defeat. He wears the gray German army cloak in which he was frequently photographed and the inevitable spiked helmet. He still has his characteristic and widely caricatured bristling mustache, but is otherwise depicted as a broken old man. His bloodstained sword, pointing directly at the massed flags, is shattered. In their forward thrust, the weight of the flags presses down on the bowed shoulders of the defeated enemy. Above the kaiser and behind the flags a rather baroque storm cloud hovers, adding its weight to the thrusting flags.

The French wartime poster style, reliant on academic drawing and monochromatic color schemes, appears in the grayed-out figure of the defeated kaiser, but the anticipated French victory comes in an exuberant explosion of color. The massed flags of the Allied nations, their colorful fabric swirling around the poles, almost explode off the paper. They do explode out of the frame of the drawing, the finials of the poles piercing the frame and the finial of the French flag, the highest, even going off the edge of the paper. The static gray figure of the kaiser is imprisoned in his corner by dynamic line and color.

The flags themselves, which occupy the majority of the image, are a dazzling tour de force of academic artistic skill, an opportunity for an artist to display his mastery of drapery. Although difficult to see amid the whorls of fabric, the flags are on poles carried by human hands, a reminder that wars are won by men. Pride of place in the composition goes to the flags of the nations that would come to be called the "Big Four": the United States, then in order to its left France, Great Britain, and Italy. The prominence of the American flag is probably due to the stunning focal point created by the cascading red and white stripes, but it may also be a bow to the knowledge on all sides that the Doughboys were in France and millions more were coming, effectively eliminating any German hope of victory.

The other flags are less visible and somewhat obscured by the eddies of fabric. To the right of the American flag is first the black, gold, and red of Belgium; then, nearly concealed, is a flag that is probably that of Serbia, the first nation to have war declared against it in the cascading declarations of 1914. To the right of that are (possibly) Japan and Greece. The three flags closest to the kaiser are almost indecipherable, although the left one may be Portugal and the middle one Montenegro. The third flag in that group could be the flag of Imperial Russia. As Russia and its army tumbled headlong into revolution and then into civil war in 1917, the Bolshevik inheritors of tsarist Russia had been forced to accept German territorial gains and

©2015 ARTISTS RIGHTS SOCIETY (ARS), NEW YORK/ADAGP, PARIS; LIBRARY OF CONGRESS: LC-USZC2-3857

conclude a demeaning peace with Germany at Brest-Litovsk in March 1918. That treaty had enabled Ludendorff to transfer from the Eastern Front the troops that would power the massive German offensives of early 1918. Fortunately for the infant Soviet state, the treaty was nullified by the German defeat a few months later.

At eleven o'clock in the morning on November 11, 1918—the eleventh hour of the eleventh day of the eleventh month—the fighting ended with an armistice. Field Marshal Ferdinand Foch supervised the German signing in a railcar at Rethondes in the forest of Compiègne. The political and military disintegration of Germany, along with Allied military pressure on the front, had forced the kaiser into abdication and exile, and the provisional German government to seek terms to end the fighting. An armistice is precisely that: an agreement to stop fighting. The terms were designed to make it impossible for Germany to resume hostilities, and included the immediate military evacuation of northern France, Alsace-Lorraine, Belgium, and both banks of the Rhine, the last of which was to be an Allied occupation zone. As the German army marched home to revolution and economic chaos, their humiliation was cloaked in the rhetoric of betrayal: the German army, unbeaten in the field, had returned home in good order, having been betrayed at home. That "betrayal" would haunt Europe until 1945.

The problem with the Armistice was that it was not a surrender, and therefore not an unambiguous victory. The French nevertheless treated it as one, as did the British and the Americans. In France, people rushed into the streets in a great outpouring of national joy and pride. People wept, kissed, and sang the *Marseillaise*. Fifty thousand people are said to have crowded into the Place de l'Opéra. In the Place de la Concorde, Parisians ripped off the mourning that had draped the statue of Strasbourg since 1871.[102] One observer wrote that even the parents of the dead got caught up in the celebration.[103]

The flags of Faivre's poster are reminiscent in spirit, if not in style, of another painting of celebratory flags. Monet's 1878 painting of the Rue Montorgueil, decked with tricolors for the celebration of the Universal Exposition, exudes much the same aura of victory. But while Monet's painting is all color and joy, there is sobriety to Faivre's poster. It seems to remind the viewer that although victory is at hand, the effort and cost have been incalculable. The November 16 issue of *L'Illustration* includes a poignant drawing by L. Sabattier. It depicts a victorious, beaming French *poilu* being kissed on the cheek by Marianne. In the caption she says *Merci!* (Thank you!), but she is draped in a black mourning veil.

POSTWAR

EMPRUNT NATIONAL—
BANQUE L. DUPONT ET CIE.

Lucien Jonas
France, 1920

Like Marianne, all France was in mourning. France had lost between 1.3 and 1.4 million dead, nearly 17 percent of the men who had been mobilized.[1] Novelist Jean Giono said that out of his 1914 company (around 120 men), he and his captain were nearly the only ones left alive at the end of the war.[2] In addition, there were over one million men who were physically or mentally incapacitated to some degree (300,000 completely disabled), along with 600,000 widows and 760,000 orphans.[3] Such staggering losses created interlocking circles of mourning.[4] The first circle was formed of the dead man's comrades, who, despite the omnipresence of death at the front, made every effort to honor their dead. The second circle was the man's immediate family: parents, grandparents, siblings, wives, children. The third circle included more distant relatives: aunts, uncles, cousins. The fourth circle was formed of male and female friends, coworkers, and colleagues. These circles do not hierarchize grief; a friend can be as deeply touched by death as a relative. Nearly everyone in France was emotionally touched by the death of a soldier.[5]

Faced with such catastrophic loss and suffering, the pressing human question was "why?" To say that the war was meaningless was intolerable to those who mourned, and that was almost everyone. A war must be endowed with significance and the men who fought and died honored for their sacrifice. (I will discuss commemoration of the dead in the final essay on page 132). For France, the answer to "why" centered on a narrative of sacrifice, endurance, justice, and, ultimately, victory and vengeance. Commemoration of the dead partially fulfilled that need. The national vision of the war was

of a just war against invasion and barbarism, a war for national survival. Three elements were fundamental to that vision: the justification of loss and suffering, the assignment of culpability, and the security of France. Those elements coalesced into the French requirements for the Treaty of Versailles.

The Treaty of Versailles has been much maligned by historians, and its long- and short-term effects are still widely debated.[6] French prime minister Clemenceau, the Tiger of France, has been castigated as a vengeful old man who bullied the other delegates (specifically British prime minister Lloyd George and U.S. president Wilson) into writing a punitive treaty. With the other delegates from the victorious powers, he excluded the Germans from the negotiations. When the German delegation was summoned to see the treaty on May 7, 1919 (the anniversary of the sinking of the *Lusitania*), it was essentially a fait accompli that they had to accept or reject. Rejection would bring a renewal of hostilities.[7] Clemenceau certainly took personal charge of the arrangements for the signing in the Hall of Mirrors at Versailles (where the German Empire had been proclaimed in 1871) on June 28, 1919, five years to the day after the assassination of the Archduke Franz Ferdinand and his wife in Sarajevo. That sort of tit-for-tat statesmanship was repeated when Hitler insisted the surrender of France in 1940 be signed in the same railway carriage in which the Armistice had been signed twenty-two years earlier.

To do him justice, Clemenceau was faced with a difficult problem. In order to justify the French struggle, he had to ensure that Germany was identified as the guilty party in starting the war, that Germany paid for

©ESTATE OF LUCIEN JONAS; LIBRARY OF CONGRESS: LC-USZC2-3872

her actions, and that the country was prevented from ever attacking France again.[8] The first requirement was met by Article 231 of the treaty, the so-called war guilt clause. It stated that Germany accepted responsibility for herself and her allies for "causing all the loss and damage" of a war initiated by "the aggression of Germany."[9] The acceptance of guilt meant the payment of reparations, outlined in Article 232, in which Germany undertook to make compensation "for all damage done to the civilian population . . . and to their property."[10] These two clauses permitted France to demand enormous reparations for rebuilding, but those could only be paid if Germany emerged from the chaos of revolution with a viable economy. However—and this is the essential contradiction in Clemenceau's position—a productive German economy would also provide Germany with the strength to attack France again. The security of France was settled, however temporarily, by the occupation of the Rhineland and stringent limitations on the German army.

Problems with reparations lingered for over a decade, as Germany's economy was ravaged first by the 1923 hyperinflation and a few years later by the Great Depression. The sums were repeatedly renegotiated. But it was money that France desperately needed for rebuilding. After nearly four and a half years of war, northeastern France was devastated. In the zone of the armies, entire villages had been pulverized, and in the occupied zone, living conditions had been harsh, with requisitions, levies, reprisals, and forced labor.[11] This poster by Lucien Jonas combines regeneration and revenge in a single image. It is for one of the national recovery and rebuilding loans that continued well into the 1920s. Although the text is partly obscured by the flag, the words *Emprunt* (loan) and *souscrivez* (subscribe) would leave no French citizen in doubt of its message. The lovely city that occupies the background is Strasbourg, German since 1870 and now returned to France. The sun-drenched old quarter of the town is shown in loving detail. Behind the old city on the left, smoke billows from factories that now produce goods for France. In the far distance lies the Rhine, the border with a defeated Germany, barely a smudge on the horizon.

The three figures in the foreground represent the rebirth of France and revenge on the *Boche*. On scaffolding surrounding the pinnacle of the spire of Strasbourg cathedral three men are working. (The church, called *la cathédrale rose* for the pink sandstone of its fabric, was a powerful symbol of the lost province in the years after 1870, appearing in textbooks and on postcards.) All the men are veterans, *anciens combattants*. The man on the right still has his boots, puttees, and uniform trousers, and still wears an army shirt, as do the other two. The kneeling man on the left is wearing his army cap. He is working with hammer and chisel to repair the pinnacle of the spire, symbolically and literally repairing the cultural fabric of France and restoring her heritage. The other two men complete the symbolic work of renewal and revenge by raising the French flag from the highest point of the city. As the flag unfurls, the man on the right steadies it, while the other fastens it to the pole. The three figures form a triangle with the French tricolor at its apex. The flag unfurling over Strasbourg and Alsace signals victory, embodied in the flag's position—it takes precedence over the text by covering part of it, and cascades out of the edge of the frame.

Finally, the work of the three men shows the way to the future. They are working soberly and steadily together, as they did in the army to gain the victory, and now to gain the peace. The recovery of France must be a communal effort, an extension of the *union sacrée* of 1914. The viewer is quietly invited to contribute and to be a part of the new French community, which is once more, in the words of Chavannez's poster, "the sweet land of France."

STURMBATAILLON SCHMIDT

Leo Impekoven
Germany, 1919

Victory is self-explanatory; defeat requires explanation and ultimately, justification. The French construed the Armistice as a victory, the only outcome that could vindicate the loss and devastation of the war. After the early autumn of 1918, when it became apparent to German soldiers that the war was lost, they faced the opposite problem: How could they accept defeat without rendering their experience of the war meaningless? After the loss of 1.7 million men, is not defeat the very definition of meaninglessness?

The response of the returning troops was partly dictated by the astounding speed with which the German Empire collapsed in the autumn of 1918. A little more than six weeks passed between Ludendorff's admission to the government that the Western Front might not hold (September 27) and the signing of the Armistice. During that period a new government was formed (led first by Prince Max of Baden, then by Social Democrat Friedrich Ebert), negotiations for an armistice were undertaken, soldiers' councils sprang up, sailors of the High Seas Fleet at Kiel mutinied, and the kaiser and crown prince abdicated. Soldiers and civilians could be excused for feeling that the world they had known was coming down around them. By the time the troops marched or drifted home after the Armistice, Germany was in full revolution.[12]

Some of the last troops to march home (in good order) were the storm troop units, who had been covering the retreat of the army.[13] Formed experimentally in 1916, the German *Stosstruppen* (storm troops) were physically fit, heavily armed, and highly mobile elite units trained to breach enemy lines, allowing regular assault troops to follow.[14] Their successes fed the myth

of the "new man," steeled by the combat experience. The storm troop units were also marked by strong ties of comradeship and devotion to their officers, characteristics that formed the ideological core of the volunteer units of 1919.

Many of the troops, including storm troops, who marched back to Germany in the bleak November of 1918 found it impossible to accept defeat. They had held the line until the Armistice, and had marched home in good order. Their years of duty, suffering, and comradeship, their *Kriegserlebnis*, had to have significance. Angry and unwilling to demobilize when they reached their garrisons, they began, largely led by storm troop officers, to form volunteer corps known as *Freikorps*.[15] The first was created by Gen. Georg von Maercker in December 1918, modeled on a storm troop battalion. Through word of mouth, and recruiting posters such as this one, the ranks of the *Freikorps* swelled by summer 1919 to around 400,000 soldiers (three times the number the Treaty of Versailles would allow to the Weimar Republic) in roughly 120 named organizations.[16] The units bore the names of their commanders—another legacy of the storm troops— and exemplified the cult of the dynamic, charismatic combat leader. The *Freikorps* commanders were paid by the new German government to defend the eastern frontiers against the Slavs (Russia and Poland) and to protect the shaky republican government from uprisings, be they from the left or the right.[17]

This recruiting poster from early 1919 by Leo Impekoven encourages enlistment in one of the most important of the *Freikorps*, the *Sturmbataillon Schmidt* of the Guard, Cavalry and Protective Division. The

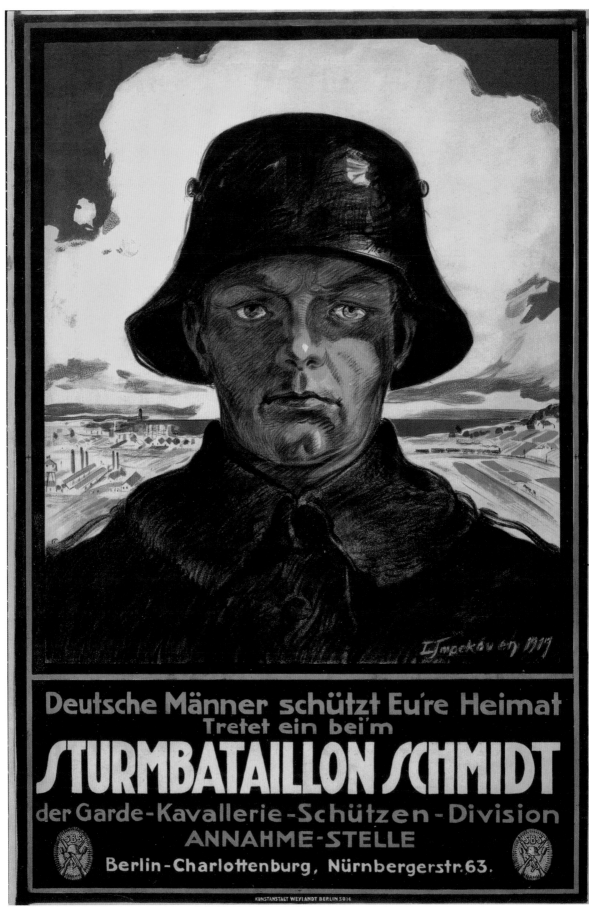

LIBRARY OF CONGRESS: LC-USZC4-11633

image utilizes the iconic symbol of the storm troopers and the *Frontsoldat* (front soldier)—the *Stahlhelm*. As in Erler's 1917 poster, the soldier's helmet dominates the image, as it does in most of the *Freikorps* recruiting posters. There are few *Freikorps* posters that do not feature the *Stahlhelm*, either in a realistic (as here) or stylized image. Here the soldier, a former storm trooper by his uniform, stares straight at the viewer with steely gray eyes. As is also characteristic of *Freikorps* posters, he exhibits a square jaw, firm mouth, and unyielding resolve. His helmet is silhouetted against a white cloud, with blue sky behind. The landscape is meant to represent East Prussia, indicated by the sea and lighthouse in the distance. Busy factories occupy the left side, while peaceful, prosperous farms form the right, linked by a speeding train. The image suggests a modern, productive Germany that will be destroyed by Slavic hordes if the volunteers don't protect it.

The message is completed by the text, echoing the landscape in green and white. The top line, *Deutsche Männer schützt Eu're Heimat* (German men, protect your homeland) reflects the *Freikorps* (and soldierly) values of manliness and German identity, along with the wartime cliché of protecting the homeland. But here the call is specifically to protect "your" homeland, the word *Eu're* in its informal abbreviated form. As with most of the German posters, the appeal is also formed in the familiar plural, creating comradeship and community. The way to protect the homeland is to enlist in the *Sturmbataillon Schmidt*—a clear reference to the *Freikorps* antecedents in the storm troop units—with the location of the enlistment office provided.

The homeland that needed protection was the former Eastern Front, specifically the Baltic region, threatened by Polish irregulars and the advancing Red Army. Due to Allied fear of the Bolshevik threat, and the German high command's desire to take the Baltic countries and use them as a bargaining chip in the treaty negotiations, German *Freikorps* forces were per-

mitted to engage the Red Army in February 1919, and captured Riga, Latvia, in May. That constituted the peak of *Freikorps* military success in the Baltic region. The action also provided a symbolic parallel to the thirteenth-century conquests of the Teutonic Knights and their defeat of the Slavs in the same area. The fighting lingered on into late summer, but the *Freikorps* victory collapsed when the Allies, fearing a resurgent German army, forced the evacuation of Riga, seen by the *Freikorps* troops as a second stab in the back.[18]

It was, however, the government's use of *Freikorps* units to suppress internal dissent that contributed most to the legend and legacy of the *Freikorps*. The first military action of the 40,000-man division named in this poster was the suppression of the Spartacist revolt in Berlin in January of 1919, including the murder of its leaders, Karl Liebknecht and Rosa Luxemburg. Essentially conservative and opposed to Ebert's socialist government, one of the best-known *Freikorps*, the Ehrhardt Brigade, led the Kapp putsch of March 1920, which quickly failed due to a leftist-led general strike. The *Freikorps* then turned back and brutally suppressed the communist Ruhr uprising.[19]

When the provisions of the Treaty of Versailles took effect in the spring of 1920, the *Freikorps* were disbanded. A few were absorbed into the Weimar Republic's *Reichswehr* of 100,000 men. Most went back to civilian life, embittered by the "Diktat" of Versailles, the loss of the war, and the betrayal of their war experience. These ideals would later be glorified by the National Socialists, and historians have long regarded the *Freikorps* as fascist antecedents. It would be more accurate to say that the myth of the *Freikorps*, a prolongation of the war experience with its values of endurance, comradeship, and loyalty, was coopted by the Nazis for their own purposes. Nevertheless, 1919 brought into being the specter of paramilitary violence that would haunt Germany for the next twenty-five years.

TERRE DE FRANCE

Jules-Abel Faivre

France, 1920

In a moment of rural tranquility, a young farmer plows his field behind a team of oxen. The sky is streaked with rosy clouds. On the other side of a water-filled ditch stands a rose-covered wooden cross decorated with a tricolor cockade. As the farmer passes, he lifts his hat in recognition and reverence for the sacrifice of the soldier buried there. This is *Terre de France*—a land bought with blood.

The human losses of the Great War, the "butcher's bill," still have the power to astonish. Although lacking the enormous civilian casualties of the Second World War, the military deaths and woundings still stagger us. Land can be reclaimed and buildings rebuilt, but human loss is permanent. The losses and the mourning they begat haunt the entire century. If we want to grasp the Great War, even in the smallest way, we must start with the pervasive sense of loss.

In 1920 virtually all of Europe was in mourning and searching for ways to assuage that pain with commemorative acts.[20] In addition to France's 1.4 million dead, Germany had lost nearly 1.8 million, Austria-Hungary 1.1 million, Russia 1.8 million, and the British Empire 900,000, to list only the great powers.[21] Moreover, half of those dead had no marked grave.[22] They had been blown to bits, buried in shell holes and cave-ins, or built into the walls of trenches, the fragments of their bodies forever scattered. In the absence of a grave, how does one mourn? The answer to that question leads to the French *monuments aux morts*, the British war memorials, and the most lasting invention of Great War commemoration, the Unknown Soldier.

I began this book with a description of the *monument aux morts* in Limeuil. There are 36,000 such monuments in France, one in each commune.[23] They vary widely in size and style. Most are traditional in design, ranging from simple obelisks to elaborate classical structures. There are a few modern monuments, usually art deco in style. Many include figures of soldiers, or Marianne, or a triumphant *coq gaulois*. But almost all bear the names of the dead, incised in stone or bronze, in alphabetical order, sometimes with an indication of rank, often not. The names are found not only on the official monuments, but also on parish memorials in churches and cathedrals. Many shrines also have walls of plaques donated to thank god and the virgin for the safe return of a soldier. Most carry only one word, *merci*, and the date. The largest *monument aux morts* in France is the ossuary at Verdun. It contains the unidentified bones of perhaps as many as 130,000 dead (some scholars argue more or fewer), whose names line the walls.[24]

The naming of the dead was fundamental to the process of mourning. Names are central to the myriad town and village memorials across Germany (often decorated with a *Stahlhelm* and clusters of oak leaves)[25] and to the memorials found in virtually every village in Britain. The British monument on the Somme at Thiepval records the names of 70,000 missing men,[26] and the Menin Gate at Ypres lists the names of almost 55,000 men who died in the Ypres Salient.[27] Americans seem to have discovered the importance of naming the dead only with the building of the Vietnam Memorial, whose distinguishing characteristic is, quite simply, the names.

However important the naming of the dead was, a name could not replace a tomb, far less a body. Both

©2015 ARTISTS RIGHTS SOCIETY (ARS), NEW YORK/ADAGP, PARIS; LIBRARY OF CONGRESS: LC-USZC2-3861

the British and French governments made an early decision to bury the dead where they had fallen. The French government, which had forbidden removing bodies from battlefield cemeteries, eventually changed its position, as French families were clandestinely, under cover of darkness, exhuming their dead for reburial in family plots.[28] In the end, most of the dead of the Western Front lie in war cemeteries along the former trench lines.

Out of anonymous mass death emerged the cult of the Unknown Soldier, commonplace today, but one of the many legacies of the Great War. War memorials, especially in France, became the locus of commemorative ceremonies on November 11, uniting the deceased with veterans, the bereaved, officials, and schoolchildren in a civic religious ceremony.[29] The ritual honoring of the dead reached its zenith with the burial of the Unknown Soldier, first in France and Britain on November 11, 1920, and followed by the United States in 1921, with most of the belligerent nations following suit.[30] The processions and ceremonies were elaborate and laden with symbolism. But what made the cult of the Unknown so powerful was the simultaneous anonymity and democracy. The Unknown could be of any rank from any battlefield, and thus represented the fallen of all ranks and all battlefields. The democratization of mass warfare had brought with it democratization in death. In an odd extension of propaganda technique, the Unknown Soldier becomes the ideal fallen soldier of the national community.

France may have construed the Armistice and the Treaty of Versailles as a victory, but death permeated society. Even the great victory parade of July 14, 1919 (shortly after the signing of the Treaty), was preceded by a vigil at the cenotaph (the Greek word means empty tomb), and the parade was led by a thousand disabled veterans.[31] So although the victory was celebrated in Paris and in London (July 19), the burden of the losses took precedence in a profoundly ambivalent Pyrrhic victory.

Faivre's poster is deeply marked by that ambivalence. It is yet another national loan poster, in this case for the rebuilding effort, but the banal *souscrivez* (subscribe) is missing. It isn't needed; the image and caption carry the message. The ambiguity begins with the lovely pink-tinged clouds. Is it sunrise or sunset? In the conventional symbolic vocabulary, one would expect

sunrise—a new day, a new beginning. But what is implied if it's sunset? Is it simply the end of a peaceful day, or is there a shadow of darkness? The image gives us no hint.

With his plowing, the farmer appears to be reclaiming field from battlefield. The flatness of the landscape and the ditch suggest the waterlogged fields of northern France. The image also pays homage to one of the quintessential French paintings of rural life, realist Rosa Bonheur's 1848 *Ploughing in Nevers*, a painting that Faivre would surely have known, and that links this poster to the tradition of rural painting. But this is not an untroubled rural scene. As he passes the grave the farmer, probably a survivor of the war, raises his hat in salute. The grave he honors, however, is as equivocal as the time of day. Wooden crosses were used to mark French graves during the fighting. But the French word, *croix de bois*, is both a simple description and an ironic reference to the *croix de guerre*, the French medal for valor. The cross is covered with white roses, symbols of purity and renewal. Both literally and symbolically the soldier's death makes the rebirth possible, forming the indissoluble union that Barrès called "*la terre et les morts*," (the land and the dead). Although the land of France may renew itself, death and loss are in the very soil and in the spirit of the people.

Faivre created yet another image that carries the same ambivalent message. In the same issue of *L'Illustration* as Sabattier's veiled Marianne, Faivre published a haunting cartoon. In a ruined village a weeping widow kneels beside her husband's grave. Their little girl asks her mother "Does Papa know that we won"? (*Papa sait-il qu'on est vainqueurs?*)[32] The child's question pierces to the heart of the French, and indeed the European war experience—an experience more of loss than of victory. The graves are always there.

And so the French, and the other combatants, moved into an ambivalent peace, haunted by death, loss, and mutilation. Britain, also badly scarred by loss, commemorated its dead and moved toward pacifism. The United States, minimally touched by the experience, retreated into isolationism, refusing to ratify the Treaty of Versailles and its peacekeeping component, the League of Nations. And Germany mourned its dead, distrustfully created a republic, ricocheted from one crisis to the next, nursed its grievances, and yearned for the rebirth of the nation from the ashes of war.

NOTES

I n order not to clog the text with notes, I have restricted the documentation in the following manner. The notes are of three types: First, as required by honest scholarship, they credit any scholars whose ideas and words I have used. Second, for material that exists in an enormous range of sources, primarily military, political, and social history, I have chosen two or three reliable sources that can be easily obtained in bookstores and libraries. Finally, there are notes that provide additional information that is tangential to the main argument. Although I have tried to provide mostly English-language sources, some essential texts are available only in French and German.

INTRODUCTION

1. John Keegan, *The First World War* (New York: Knopf, 1999), 426.
2. See James Aulich, *War Posters: Weapons of Mass Communication* (New York: Thames and Hudson, 2007); Jim Aulich and John Hewitt, *Seduction or Instruction? First World War Posters in Britain and Europe* (Manchester: Manchester University Press, 2007); Walton H. Rawls, *Wake Up, America!* (New York: Abbeville Press, 1988); Maurice Rickards, *Posters of the First World War* (New York: Walker and Company, 1968).
3. Philip M. Taylor, *Munitions of the Mind: A History of Propaganda from the Ancient World to the Present Day* (Manchester: Manchester University Press, 1995), 6–7.
4. Peter Paret, Beth Irwin Lewis, and Paul Paret, *Persuasive Images: Posters of War and Revolution from the Hoover Institution Archives* (Princeton, NJ: Princeton University Press, 1992), viii–ix. Michael Robinson, *Art Nouveau Posters* (London: Flame Tree Publishing, 2012), 23, 34–35.
5. Aulich, *War Posters*, 8.
6. Wilfred Owen, "Strange Meeting," in *The Penguin Book of First World War Poetry*, ed. Jon Silkin, 2nd ed. (London: Penguin Books, 1981), 206–8.
7. Marcel Proust, *Remembrance of Things Past*, trans. C. K. Scott Moncrieff (New York: Random House, 1934), 1: 325. The French text may be found in Marcel Proust, *À la Recherche du temps perdu* (Paris: Bibliothèque de la Pléiade, 1954), 1: 427.

1914–1915

1. Christopher Clark, *The Sleepwalkers: How Europe Went to War in 1914* (New York: HarperCollins Publishers, 2013), 555–62.
2. Ibid., 506–54.
3. Kaiser Wilhelm II, Order to the Army, August 19, 1914, accessed June 8, 2015, http://firstworldwar.com/source/kaiser contemptible/htm. See also "Old Contemptibles," in Spencer

C. Tucker, ed., *World War I: The Definitive Encyclopedia and Document Collection* (Santa Barbara, CA: ABC-CLIO, 2014), 4: 1756.
4. Allan Mitchell, *Victors and Vanquished: The German Influence on Army and Church in France after 1870* (Chapel Hill: University of North Carolina Press, 1984), 29–49; 71–82.
5. In 1914 France's population was around 40 million and stagnant. Germany's was around 65 million and growing.
6. Peter Simkins, "Voluntary Recruiting in Britain, 1914–1915," British Library, accessed July 9, 2014, www.bl.uk/world-war-one/articles/voluntary-recruiting.
7. Aulich and Hewitt, *Seduction*, 36.
8. Ibid.
9. The Parliamentary Recruiting Committee quoted in Aulich and Hewitt, *Seduction*, 37.
10. Aulich and Hewitt, *Seduction*, 53. Simpkins, "Voluntary Recruiting."
11. Imperial War Museum, accessed July 8, 2014, http://iwm.org.uk/collections/item/object/17053.
12. Quoted in John Simkin, "Savile Lumley," Spartacus Educational, accessed July 9, 2014, http://spartacus-educational.com/ARTlumley.htm.
13. *Patton*, 1970.
14. Aulich and Hewitt, *Seduction*, 45.
15. Jay Winter, "Imaginings of War: Posters and the Shadow of the Lost Generation," in *Picture This: World War I Posters and Visual Culture*, ed. Pearl James (Lincoln: University of Nebraska Press, 2009), 41.
16. Philip Larkin, "MCMXIV," in *The Oxford Book of War Poetry*, ed. Jon Stallworthy (Oxford: Oxford University Press, 1984), 222.
17. See Ben Shephard, *A War of Nerves: Soldiers and Psychiatrists 1914–1944* (London: Jonathan Cape, 2000), for a detailed analysis.

18. Peter Doyle, *World War I in 100 Objects* (New York: Plume, 2014), 58–59. See also the definition in the *Oxford English Dictionary*, s.v. "khaki."
19. Ann P. Linder, *Princes of the Trenches: Narrating the German Experience of the First World War* (Columbia, NC: Camden House, 1996), 74–85.
20. John Keegan, *The Face of Battle* (New York: Viking, 1976), 215–25.
21. Niall Ferguson, *The Pity of War* (New York: Basic Books, 1999), 198–99; 205–7.
22. Keegan, *First World War*, 135.
23. Ibid., 97–102. The French army had taken the heaviest losses: 27,000 dead on August 22 alone, 40,000 in total August 20–23. See Bruno Cabanes, *Août 14: La France entre en guerre* (Paris: Gallimard, 2014), 126.
24. Keegan, *First World War*, 130–33.
25. Ibid., 198–203.
26. Allen J. Frantzen, *Bloody Good: Chivalry, Sacrifice, and the Great War* (Chicago: University of Chicago Press, 2004), 18.
27. Shakespeare, *Henry V*, Act III, Scene 1, line 34.
28. Stefan Goebel, "Chivalrous Knights versus Iron Warriors: Representations of the Battle of *Matériel* and Slaughter in Britain and Germany, 1914–1940," in *Picture This: World War I Posters and Visual Culture*, ed. Pearl James (Lincoln: University of Nebraska Press, 2009), 96.
29. David T. Zabecki, "Medals and Decorations," in *Encyclopedia of World War I: A Political, Social and Military History*, eds. Spencer C. Tucker and Priscilla Mary Roberts (Santa Barbara: ABC-CLIO, 2005), 765–69.
30. Goebel, "Chivalrous Knights," 97.
31. Frantzen, *Bloody Good*, 121; Goebel, "Chivalrous Knights," 96.
32. Goebel, "Chivalrous Knights," 96.
33. Paul Fussell, *The Great War and Modern Memory* (New York and London: Oxford University Press, 1975), 21–23. Fussell's catalogue of elevated, essentially feudal language is worth perusing.
34. Jay Winter, *Remembering War: The Great War between Memory and History in the Twentieth Century* (New Haven, CT: Yale University Press, 2006), 32.
35. David Crane, *Empires of the Dead: How One Man's Vision Led to the Creation of WWI's Graves* (London: William Collins, 2013), Kindle Edition, ch. 8; Jay Winter, *Sites of Memory, Sites of Mourning* (Cambridge: Cambridge University Press, 1995), 220–21; George L. Mosse, *Fallen Soldiers; Reshaping the Memory of the World Wars* (Oxford: Oxford University Press, 1990), 82–84; *Wikipedia*, "Rudyard Kipling," last modified June 27, 2015, https://en.wikipedia.org/wiki/Rudyard_Kipling#First_World_War_.281914.E2.80.9318.29.
36. Serge Durflinger, "French Canada and Recruitment during the First World War," Canadian War Museum, accessed December 12, 2014, www.warmuseum.ca/education/online-educational-resources/dispatches/french-canada-and-recruitment-during-the-first-world-war. This article provides an excellent overview of the history.
37. See other examples in the Canadian War Museum exhibit "Les Purs Canayens," at www.warmuseum.ca/cwm/exhibitions/purscan/purineng/shtml.
38. I am indebted to Dr. Mélanie Morin-Pelletier of the Canadian War Museum for her insight and assistance with this poster.
39. Durflinger, "French Canada."
40. Quoted in Ferguson, *Pity*, 319.
41. Leonard V. Smith, Stéphane Audoin-Rouzeau, and Annette Becker, *France and the Great War, 1914–1918*, trans. Helen McPhail (Cambridge: Cambridge University Press, 2003), 30–36.
42. Ferguson, *Pity*, 248.
43. Ibid., 322–26.
44. "Erwin Puchinger," *Österreichisches Biographisches Lexicon 1815–1950*, Band 8 (Lfg. 39, 1982), 322, California Search, accessed December 27, 2014, http://ca.search.studyroom.us/Erwin+Puchinger.
45. Smith, Audoin-Rouzeau, and Becker, *France*, 29.
46. Ibid., 44.
47. Benoît Majerus, "Occupation," in *Dictionnaire de la Grande Guerre*, ed. Jean-Yves Le Naour (Paris: Larousse, 2014), 334.
48. Smith, Audoin-Rouzeau, and Becker, *France*, 57. The word *boche* for a German was in common usage in both world wars. Its origin is uncertain, but may come from the colloquial *cabochard*, meaning stubborn.
49. Mark Levitch, "Young Blood: Parisian Schoolgirls' Transformation of France's Great War Poster Aesthetic," in *Picture This: World War I and Visual Culture*, ed. Pearl James (Lincoln: University of Nebraska Press, 2009), 150–51.
50. Michel Pastoureau, "Le Coq gaulois," in *Les Lieux de mémoire*, ed. Pierre Nora (Paris: Gallimard, 1992), vol. 3, part 3, 508.
51. Ibid., 516–19.
52. Ibid., 521. My translation.
53. Ibid., 532.
54. Ibid., 520.
55. Smith, Audoin-Rouzeau, and Becker, *France*, 66.
56. Ferguson, *Pity*, 251–52.
57. Smith, Audoin-Rouzeau, and Becker, *France*, 61.
58. Quoted in Durflinger, "French Canada."
59. Smith, Audoin-Rouzeau, and Becker, *France*, 37. Thomas Weber, *Hitler's First War* (Oxford: Oxford University Press, 2010), 35–37.
60. Aulich and Hewitt, *Seduction*, 73.
61. Rawls, *Wake Up*, 44–45.
62. "From the battle of Solferino to the eve of the First World War," International Committee of the Red Cross, posted December 28, 2004, accessed August 1, 2015, https://www.icrc.org/eng/resources/documents/misc/57jnvt.htm.
63. Siegfried Sassoon, *The War Poems*, ed. Rupert Hart-Davis (London: Faber and Faber, 1983), 100.
64. "Ludwig Hohlwein," Iconofgraphics, accessed December 26, 2014, www.iconofgraphics.com/ludwig-hohlwein. Hoardings were wooden fences to which posters were affixed.
65. Frantzen, *Bloody Good*, 121–37.
66. Walter Laqueur, *Young Germany: A History of the German Youth Movement* (London: Routledge, 1962), 3–6.
67. "Fritz Boehle," in *Allgemeines Lexicon der Bildenden Künstler von der Antike bis zür Gegenwart*, ed. Hans Vollmer (Leipzig: E. A. Seemann Verlag, 1908), 4: 189–90. Boehle's gravestone in Frankfurt depicts Saint Martin on a horse conspicuously similar to the horse in the poster. A photograph of the tombstone is at https://www.flickr.com/photos/33784579@N05/5496465646/in/photostream.
68. Frantzen, *Bloody Good*, 14–15; 17–18.
69. Keegan, *First World War*, 135–36.
70. Smith, Audoin-Rouzeau, and Becker, *France*, 69.
71. Keegan, *First World War*, 28–36; 40–41. This provides an excellent analysis of the Schlieffen plan and its execution.

72. Keegan, *First World War*, 132–33. Weber, *Hitler's First War*, 44.

73. See Weber, *Hitler's First War*, 43–45 for a detailed analysis of the legend.

74. Keegan, *First World War*, 135.

75. Franz Menges and Edith Schmidt, "Adolf Münzer," in *Neue Deutsche Biographie*, 18 (1997), 555 [online] accessed December 26, 2014, http://deutsche-biographie.de/ppn119430282.html.

76. For an account of one German regiment's experience, see Weber, *Hitler's First War*, 60–67.

77. Quoted in Rawls, *Wake Up*, 14.

78. B. J. C. McKercher, "Economic Warfare," in *The Oxford Illustrated History of the First World War*, ed. Hew Strachan (Oxford: Oxford University Press, 1998), 120.

79. Ibid., 122.

80. Ibid.

81. Ibid., 124–25.

82. Ibid., 126.

83. Keegan, *First World War*, 265; 351. John Keegan, *The Price of Admiralty: The Evolution of Naval Warfare* (New York: Viking, 1989), 217.

84. Doyle, *100 Objects*, 291–92.

85. Keegan, *First World War*, 265.

86. Doyle, *100 Objects*, 293.

87. Quoted in Rawls, *Wake Up*, 81.

88. McKercher, "Economic Warfare," 128.

89. Rawls, *Wake Up*, 83.

90. Ibid., 106.

1916

1. *Allgemeines Lexion*, "Julius Diez," 9: 280–81.

2. "Thor's Hammer," Norse Mythology for Smart People, accessed February 11, 2015, http://norse-mythology.org/symbols/thors-hammer. Christine E. Fell, "Gods and Heroes of the Northern World," in *The Northern World: The History and Heritage of Northern Europe, AD 400–ll00*, ed. David M. Wilson (New York: Abrams, 1980), 34–36; 38–39.

3. Peter Watson, *The German Genius: Europe's Third Renaissance, the Second Scientific Revolution and the Twentieth Century* (New York: Harper Collins, 2010), 213–14; Doyle, *100 Objects*, 318–19.

4. Koppel S. Pinson, *Modern Germany: Its History and Civilization* (New York: MacMillan, 1954), 128–29; Steven Ozment, *A Mighty Fortress: A New History of the German People* (New York: Harper Collins, 2004), 208.

5. Stefan Goebel, *The Great War and Medieval Memory: War, Remembrance and Medievalism in Britain and Germany 1914–1940* (Cambridge: Cambridge University Press, 2007), 156–57.

6. Goebel, "Chivalrous Knights," 83–85; Winter, *Sites*, 82–85; Susanne Brandt, "Nagelfiguren: Nailing Patriotism in Germany 1914–1918," in *Matters of Conflict: Material culture, memory and The First World War*, ed. Nicholas J. Saunders (London: Routledge, 2004), 62–64.

7. Smith, Audoin-Rouzeau, and Becker, *France*, 16–18.

8. Ibid., 19.

9. Jean Norton Cru, *Témoins* (Paris: Les Étincelles, 1929), 29.

10. Keegan, *First World War*, 90–93. Smith, Audoin-Rouzeau, and Becker, *France*, 32–34.

11. Doyle, *100 Objects*, 28–29; See also Cabanes, *Août 14*, 97–98 for a description of soldiers receiving their uniforms and equipment.

12. Doyle, *100 Objects*, 89–91.

13. Doyle, *100 Objects*, 64–65; On French uniforms and equipment, see also Ian Sumner, "French Poilu," in *War on the Western Front: In the Trenches of World War I*, ed. Gary Sheffield (Botley, UK: Osprey Publishing, 2007), 61–69.

14. Jean-Yves Le Naour, "Poilu," in *Dictionnaire de la Grande Guerre*, 367–68.

15. *Wikipedia*, "Ça Ira," last modified January 31, 2015, accessed February 6, 2015, http://en.wikipedia.org/wiki/Ça_Ira.

16. "Bienvenue chez Oncle Hansi," www.chez.com/hansi, has copious illustrations; *Wikipedia*, "Jean-Jacques Waltz," accessed February 8, 2015, http://en.wikipedia.org/siki/Jean-Jacques_Waltz, provides a brief summary of his life and work.

17. Quoted in Ian Ousby, *The Road to Verdun* (London: Pimlico, 2003), 40.

18. Keegan, *First World War*, 279.

19. Antoine Prost, "Verdun," in *Dictionnaire de la Grande Guerre*, 456–60.

20. Doyle, *100 Objects*, 62.

21. I am indebted to Rémy Mauduit for sharing his linguistic insight with me.

22. Jean-Noël Grandhomme, "Alsacien-Lorrain," in *Dictionnaire de la Grande Guerre*, 77–78.

23. McKercher, "Economic Warfare," 120.

24. Ibid., 119.

25. Ibid., 121–22.

26. Ibid., 122–24.

27. Ibid., 124.

28. Ibid., 125; Gail Braybon, "Women, War and Work," in *The Oxford Illustrated History of the First World War*, ed. Hew Strachan (Oxford: Oxford University Press, 1998), 157–58.

29. Linder, *Princes*, 62–63.

30. Christopher Clark, *Iron Kingdom: The Rise and Downfall of Prussia, 1600–1947* (Cambridge, MA: Belknap, 2006), 610–11.

31. Steven Heller, "The Future of German Advertising Past," *Print* (blog), November 26, 2013, www.printmag.com/daily-heller/the-future-of-german-advertising-past-julius-gipkens.

32. Many postcards depicting children can be found in Brigitte Hamann, *Die Erste Weltkrieg: Wahrheit und Lüge in Bildern und Texten* (Munich: Piper, 2013), 41; 55; 124; 135; 258.

33. See Celia Malone Kingsbury, *For Home and Country: World War I Propaganda on the Home Front* (Lincoln: University of Nebraska Press, 2010), 169–216, for a detailed analysis with images.

1917

1. Doyle, *100 Objects*, 251–52; Stephen Bull, "The Somme and Beyond," in *War on the Western Front: In the Trenches of World War I*, ed. Garry Sheffield (Botley, UK: Osprey Publishing, 2007), 226–27.

2. Ousby, *Verdun*, 51.

3. Keegan, *First World War*, 291.

4. Holgar H. Herwig, "The German Victories, 1917–1918," in *The Oxford Illustrated History of the First World War*, ed. Hew Strachan (Oxford: Oxford University Press, 1998), 254–55; see Ian Drury, "German Stormtrooper," in *War on the Western Front: In the Trenches of World War I*, ed. Garry Sheffield (Botley, UK: Osprey Publishing, 2007), 10–53 for a detailed analysis.

5. See Goebel, *Medieval Memory*, 164–68 for a detailed analysis; see also Linder, Princes, 47–48.

6. Bull, "Somme and Beyond," 227.

7. Goebel, *Medieval Memory*, 164.

8. See, for example, Imperial War Museum Art.PST 3213; see also Goebel, *Medieval Memory*, 244, for a photo of the Weingarten Saint George.

9. Burkhard Asmuss, "Der Stahlhelm, Bund der Frontsoldaten," Deutsches Historisches Museum, last revised June 8, 2011, https://www.dhm.de/lemo/kapitel/weimarer-republik/innen politik/stahlhelm-bund-der-frontsoldaten.html.

10. Keegan, *First World War*, 146.

11. Ibid., 138–39.

12. Ibid., 144–50; for a fictionalized account, see Alexander Solzhenitsyn, *August 1914*, trans. Michael Glenny (New York: Farrar, Straus and Giroux, 1971).

13. Susanne Brandt, "Nagelfiguren: Nailing Patriotism in Germany 1914–1918," 64–66; Goebel, "Chivalrous Knights," 83–84.

14. See Goebel, *Medieval Memory*, 127–45 for a superb analysis.

15. "Bruno Paul," in *Allgemeines Lexicon*, 26: 280–81; "Bruno Paul," Art Directory, accessed February 18, 2015, www.bruno-paul.com.

16. Keegan, *First World War*, 319; Rod Paschall, *The Defeat of Imperial Germany, 1917–1918* (Chapel Hill: Algonquin Books, 1989), 13–14.

17. Richard Bessel, "Mobilizing German Society for War," in *Great War, Total War: Combat and Mobilization on the Western Front, 1914–1918*, eds. Roger Chickering and Stig Förster (Cambridge: Cambridge University Press, 2000), 448–49.

18. Clark, *Iron Kingdom*, 653–54.

19. Goebel, *Medieval Memory*, figs. 7, 17, 40, 42, 51.

20. Ibid., fig. 49.

21. Although my argument is somewhat different, I am indebted to Stefan Goebel for his excellent exposition. See *Medieval Memory*, especially chapters 3 and 4.

22. Goebel, *Medieval Memory*, 90.

23. Ibid., 242–46.

24. Holgar H. Herwig, *The First World War: Germany and Austria-Hungary, 1914–1918* (London: Arnold, 1997), 12.

25. Ibid., 13.

26. Ibid., 238–42.

27. Ibid., 283.

28. Ferguson, *Pity*, 331.

29. Santanu Das, "World War I Experiences of colonial troops," British Library, accessed March 6, 2015, www.bl.uk/world-war-one/articles/colonial-troops.

30. Myron Echenberg, *Colonial Conscripts: The Tirailleurs Sénégalais in French West Africa, 1857–1960* (London: Heinemann/James Curry, 1991), 28–29, 43.

31. Echenberg, *Colonial Conscripts*, 32–38.

32. Richard S. Fogarty, "Race and Empire in French Posters of the Great War," in *Picture This, First World War Posters and Visual Culture*, ed. Pearl James (Lincoln: University of Nebraska Press, 2009), 184–86.

33. Fogarty, "Race and Empire," 190–92.

34. Das, "Colonial Troops."

35. Quoted in Das, "Colonial Troops."

36. Fogarty, "Race and Empire," 194.

37. Ibid., 194, 197–98; Echenberg, *Colonial Conscripts*, 32–33.

38. See Joachim von der Goltz, *Der Baum von Cléry* (Berlin: Büchergilde Gutenberg, 1934), 269. The passage describes a blasted apple tree in full bloom, a sight that gives the narrator fresh hope.

39. Echenberg, *Colonial Conscripts*, 37–38.

40. Keegan, *First World War*, 309.

41. Ibid., 126, 323–24.

42. Ibid., 327–29; Smith, Audoin-Rouzeau, and Becker, *France*, 120–21.

43. Keegan, *First World War*, 330; Smith, Audoin-Rouzeau, and Becker, *France*, 122.

44. Keegan, *First World War*, 329–31; Smith, Audoin-Rouzeau and Becker, *France*, 121–25; André Loez, "Mutinerie," in *Dictionnaire de la Grande Guerre*, 316–22.

45. Keegan, *First World War*, 330; Smith, Audoin-Rouzeau, and Becker, *France*, 131–38.

46. Guy Pedroncini, *Les Mutineries de 1917* (Paris: Presses Universitaires de France, 1967), 194, 215.

47. Smith, Audoin-Rouzeau and Becker, *France*, 108–9; David Lowenthal, "European and English Landscapes as National Symbols," in *Geography and National Identity*, ed. David Hooson (Oxford: Blackwell, 1994), 19.

48. Adrien Bertrand, *L'Appel du sol* (Paris: Calmann-Lévy, 1916), 245.

49. Smith, Audoin-Rouzeau, and Becker, *France*, 61, 66; Braybon, "Women, War and Work," 156–57.

50. Smith, Audoin-Rouzeau and Becker, *France*, 117, 126–27.

51. Marie-Monique Huss, "Pronatalism," in Richard Wall and Jay Winter, *The Upheaval of War: Family, Work and Welfare in Europe, 1914–1918* (Cambridge: Cambridge University Press, 1988), 330.

52. Huss, "Pronatalism," 331. The author provides an excellent examination of this aspect of wartime propaganda.

53. Ibid., 330.

54. Ibid., 333, 359, Appendix 12.1.

55. Ibid., 339, 342–43.

56. "Auguste Leroux," Artfinding, accessed August 5, 2015, www.artfinding.com/36510/Biography/Leroux-Auguste?LANG=fr.

57. Smith, Audoin-Rouzeau, and Becker, *France*, 59, 109.

58. Alain Saustier, "Le Tour de France par deux enfants," La Maison d'École, accessed June 16, 2007, http://aspage.chez-alice.fr/tour2fr.htm; Eugen Weber, *Peasants into Frenchmen: The Modernization of Rural France, 1870–1914* (Stanford, CA: Stanford University Press, 1976).

59. Rawls, *Wake Up*, 19.

60. Ibid., 20–21.

61. Ibid., 23–24.

62. Ibid., 21; Judith Zilczer, *"The Noble Buyer:" John Quinn, Patron of the Avant-Garde* (Washington DC: Smithsonian Institution Press, 1978), 25–27.

63. Rawls, *Wake Up*, 149–50.

64. Ibid., 150; 153; 156.

65. Quoted in Rawls, *Wake Up*, 150.

66. Ibid., 167.

67. Ibid., 12.

68. See a wealth of examples in Rawls, *Wake Up*, 61; 78; 80; 125–27; 217; 223 and 232.

69. Ibid., 157.

70. Marina Warner, *Monuments and Maidens: The Allegory of the Female Form* (New York: Atheneum, 1985), 6–8.

71. Ibid., 63–70.

72. Pearl James, "Images of Femininity in American World War I Posters," in *Picture This: World War I Posters and Visual Culture*, ed. Pearl James (Lincoln: University of Nebraska Press, 2009), 288–91.

73. See Georges Scott, "Leur Façon de faire la guerre," *L'Illustration*, 29 August 1914 (165).

74. See Werner Sombart, *Händler und Helden: Patriotische Besinnungen* (Munich: Duncker und Humbolt, 1915) for the classic statement of these ideas.

75. Nicoletta F. Gullace, "Barbaric Anti-Modernism:Representations of the 'Hun' in Britain, North America, Australia and Beyond," in *Picture This: World War I Posters and Visual Culture*, ed. Pearl James (Lincoln: University of Nebraska Press, 2009), 61–67.

76. Quoted in Gullace, "Barbaric Anti-Modernism," 61. *Oxford English Dictionary*, Supplement, v.s. "Hun."

77. See the British-made French-language Canadian poster, "Souvenez-vous de la Belgique," in the Canadian War Museum collection at www.canadaatwar.ca/forums/showthread.php?p=7837.

78. Gerald Peary, "Missing Links: The Jungle Origins of King Kong," *Gerald Peary* (blog), 2004, accessed August 8, 2015, www.geraldpeary.com/essays/jkl/kingkong-1.html.

79. *Oxford English Dictionary*, s. v. "brute." Note also the related words "brutal," "brutality," etc.

1918

1. Cover, *L'Illustration*, August 8, 1914.

2. The phrase has sometimes been credited to Gen. Ferdinand Foch, but most historians agree that it originated with Nivelle.

3. Jacques Meyer, *La Vie quotidienne des soldats pendant la grande guerre* (Paris: Hachette, 1966), 105–14.

4. See Winter's discussion of the scene in *Sites*, 178–86; for the French text, see Henri Barbusse, *Le Feu: Journal d'une escouade* (1916; Paris: Flammarion, 1965), 266–86.

5. Matthias Eberle, *World War I and the Weimar Artists: Dix, Grosz, Beckmann, Schlemmer* (New Haven: Yale University Press, 1985), 33; 52.

6. Rawls, *Wake Up*, 56–67.

7. Ibid., 57–58.

8. David Stevenson, "War Aims and Peace Negotiations," in *The Oxford Illustrated History of the First World War*, ed. Hew Strachan (Oxford: Oxford University Press, 1998), 208–9.

9. André Loez, "Paix," in *Dictionnaire de la Grande Guerre*, 348–54.

10. Ibid., 352.

11. Margaret MacMillan, *Paris, 1919: Six Months that Changed the World* (New York: Random House, 2003), 198–203.

12. Smith, Audoin-Rouzeau, and Becker, *France*, 138–39; 143–45.

13. "Marcel Falter," in *Dictionnaire critique et documentaire des peintres*, 5: 284.

14. See Anthony Livesey, *The Historical Atlas of World War I* (New York: Holt and Company, 1994), 150–53; 158–59 and 166–67 have a detailed account of the offensives with excellent maps.

15. Livesey, *Atlas of World War I*, 166.

16. Steven Broadberry and Mark Harrison, "The Economics of World War I: An Overview," in *The Economics of World War I*, eds. Steven Broadberry and Mark Harrison (Cambridge: Cambridge University Press, 2005), 18–22.

17. Smith, Audoin-Rouzeau, and Becker, *France*, 61.

18. Ibid., 66–67.

19. Levitch, "Young Blood," 168n2.

20. Ibid., 147–49.

21. Ibid., 149.

22. Ibid., 152–155.

23. *Le Roman de Renard*, Branche II.

24. Kingsbury, *Home and Country*, 169–217; Smith, Audoin-Rouzeau, and Becker, *France*, 59.

25. Brian Fagan, *The Little Ice Age: How Climate Made History, 1300–1850* (New York: Basic Books, 2000), 154–66.

26. Simon Schama, *Citizens: A Chronicle of the French Revolution* (New York: Vintage, 1989), 305–8.

27. See the exhaustive analysis of the origins of the Phrygian cap in Warner, *Monuments*, 273–77.

28. Warner, *Monuments*, 270–73.

29. John Horne, "Soldiers, Civilians and the Warfare of Attrition: Representations of Combat in France, 1914–1918," in *Authority, Identity and the Social History of the Great War*, eds. Frans Coetzee and Marilyn Shevin-Coetzee (Providence, RI: Berghahn Books, 1995), 224–25.

30. Smith, Audoin-Rouzeau and Becker, *France*, 57–58; see also Antoine Prost, *Si nous vivions en 1913* (Paris: Grasset and France Inter, 2014), 127–29 for an example of French pride at being a republic, and therefore an exception among European nations.

31. In addition to the invasion of the northeast, the loss of Alsace-Lorraine to Germany in 1870 weighed heavily on the French consciousness.

32. Braybon, "Women, War and Work," 149.

33. Ibid., 151; 156–57.

34. Ibid., 152–54.

35. Ibid., 153.

36. Ibid., 152.

37. Ibid., 154; 157–58; Herwig, *First World War*, 272–83; 289–92; 294–96.

38. Braybon, "Women, War and Work," 161–62.

39. Braybon, "Women, War and Work," 161; Catherine Valenti, "Femmes," *Dictionnaire de la Grande Guerre*, 225–31.

40. Goebel, *Medieval Memory*, 223–29.

41. John H. Morrow Jr., "The War in the Air," in *The Oxford Illustrated History of the First World War*, ed. Hew Strachan (Oxford: Oxford University Press, 1998), 270–72.

42. Aulich and Hewitt, *Seduction*, 7–9.

43. United States Census Bureau, Population Division, Population Estimates Program, revised July 28, 2000, accessed April 8, 2015, https://www.census.gov/popest/data/national/totals/pre-1980/tables/popclockest.txt.

44. Rawls, *Wake Up*, 111.

45. Ibid.

46. Ibid., 112.

47. Ibid.

48. Hugh Rockoff, "Until it's over, over there: the US economy in World War I," in *The Economics of World War I*, eds. Steven Broadberry and Mark Harrison (Cambridge: Cambridge University Press, 2005), 322.

49. Ibid., 322.

50. Quoted in Ibid., 326.

51. Rawls, *Wake Up*, 196.

52. Quoted in Ibid., 203.

53. Warner, *Monuments*, 3–17.

54. Ibid., 13; Rawls, *Wake Up*, 208.

55. Warner, *Monuments*, 11.

56. Frantzen, *Bloody Good*, 150–51.

57. Rockoff, "Until it's over," 322.

58. "History of the Boy Scouts of America Highlights," Boy Scouts of America, 1917–1918, accessed April 13, 2015, www.scouting.org/About/FactSheets/BSA_History.aspx.

59. Maurice Rickards, foreword to *Wake Up, America!* by Rawls, 9.

60. In *Mein Kampf*, Adolf Hitler maintains that Allied propaganda was more effective than German efforts because it understood psychology and presented the Germans as Huns and barbarians. See Adolf Hitler, *Mein Kampf* (New York: Stackpole Sons, 1939), 177–82.

61. Warner, *Monuments*, 264.

62. Schama, *Citizens*, 452–55.

63. Ibid., 491–92.

64. Frederick Brown, *For the Soul of France: Culture Wars in the Age of Dreyfus* (New York: Knopf, 2010), 57–58.

65. Jakub Kazecki and Jason Lieblang, "Regression versus Progression: Fundamental Differences in German and American Posters of the First World War," in *Picture This: World War I Posters and Visual Culture*, ed. Pearl James (Lincoln: University of Nebraska Press, 2009), 112–13.

66. Bessel, "Mobilizing German Society," 448–51.

67. *Wikipedia*, "Walter Georgi," last modified December 14, 2014, http://de.wikipedia.org/wiki/Walter_Georgi; "Walter Georgi," in Dictionnaire critique, 6: 26.

68. *Völkisch* ideology emphasized the organic link between a people and their specific landscape, in which they are rooted and can trace their history into the remote past. See George Mosse, *The Crisis of German Ideology* (New York: Grosset, 1964) for the classic explication.

69. Steven Heller, "Lucien Bernhard," American Institute of Graphic Arts, 1998, accessed January 15, 2015, www.aiga.org.medalist-lucianbernhard.

70. Ibid.

71. Goebel, *Medieval Memory*, 156–57.

72. *Wikipedia*, "Götz von Berlichingen," last modified February 22, 2015, accessed April 17, 2015, http://en.wikipedia.org/wiki/Götz_von_Berlichingen.

73. "Götz von Berlichingen," German Literature, accessed April 17, 2015, http://sites.google.com/site/germanliterature/18th-century/goethe/goetz-von-berlichingen.

74. Ibid.

75. Clark, *Sleepwalkers*, 178–83.

76. MacMillan, *Paris, 1919*, 460–67.

77. Stevenson, "War Aims," 209–10.

78. Bernhard Denscher, "'Überall vor den Plakaten bildeten sich Ansammlungen. . .': Das Plakat als Kommunikationsmedium im Wien des Ersten Weltkriegs," Austrian Posters, accessed April 26, 2015, www.austrianposters.at/pages/themen/denscher_weltkrieg1_de.html. My translation.

79. Ibid.; Anita Kühnel, "Julius Klinger-Poster Artist and Draftsman," Austrian Posters, accessed April 26, 2015, www.austrianposters.at/pages/grafiker/kuehnel_julius_klinger_en.html.

80. Kühnel, "Julius Klinger."

81. Denscher, "Überall vor den Plakaten."

82. Rawls, *Wake Up*, 106.

83. Ibid., 111.

84. David Trask, "The Entry of the USA into the War and its Effects," in *The Oxford Illustrated History of the First World War*, ed. Hew Strachan (Oxford: Oxford University Press, 1998), 243.

85. Ibid., 243.

86. Ibid., 244–45.

87. Ibid., 244.

88. Paschall, *Defeat*, 120.

89. Trask, "Entry of the USA," 247.

90. Livesey, *Atlas*, 168–69.

91. Paschall, *Defeat*, 126; Keegan, *First World War*, 407.

92. John Keegan, *The American Civil War: A Military History* (New York: Knopf, 2009), 358–59.

93. Jim Vandeboncoeur Jr., "Joseph Clement Coll," Illustrators, accessed May 23, 2015, www.bpib.com/illustrat/coll.htm.

94. Trask, "Entry of the USA," 242.

95. Keegan, *First World War*, 352.

96. Frank A. Southard Jr., "Emergency Fleet Corporation," *Dictionary of American History*, 2003, encyclopedia.com, accessed May 23, 2015, www.encyclopedia.com/doc/1G2-3401801360.html.

97. Ibid.

98. John W. Lawrence, "Hog Island," *Encyclopedia of Greater Philadelphia*, 2014, accessed August 10, 2015, http://philadelphiaencyclopedia.org/archive/hog-island.

99. Southard, "Emergency Fleet."

100. Warren Kimball, "Lend-Lease," in *Oxford Companion to World War II*, ed. I. C. B. Dear (Oxford: Oxford University Press, 1995), 677–83.

101. Rawls, *Wake Up*, 185.

102. Nicholas Best, *The Greatest Day in History: How, on the Eleventh Hour of the Eleventh Day of the Eleventh Month, the First World War Finally Came to an End* (New York: Public Affairs, 2008), 205–6. See also the photograph of the statue of Strasbourg in Peter and Oriel Caine, *Paris Then and Now* (San Diego: Thunder Bay Press, 2003), 12.

103. Smith, Audoin-Rouzeau and Becker, *France*, 158.

POSTWAR

1. Casualty figures still differ among scholars. These seem to be the most reliable modern figures. See Ferguson, *Pity*, table 32, p. 295.

2. Jean Giono, "Refus d'obéissance," *Récits et essais* (Paris: Gallimard, 1989), 261.

3. Smith, Audoin-Rouzeau, and Becker, *France*, 70, 96.

4. Stéphane Audoin-Rouzeau and Annette Becker, *14–18: Understanding the Great War*, trans. Catherine Temerson (New York: Hill and Wang, 2002), 204–12. The idea of circles of mourning originates with Jay Winter's notion of "communities in mourning." See Winter, *Sites*, 29–53.

5. I have chosen France as the example, as this is a French poster, but to varying degrees the situation was the same in the other combatant countries—the United States excepted, as its brief involvement limited deaths to 114,000. That is not to suggest that mourning was less bitter in America, simply that less of the population was involved. See Audoin-Rouzeau and Becker, *14–18*, 209–12 for their discussion and figures.

6. McMillan, *Paris*, provides the best overall analysis of the treaty.

7. McMillan, *Paris*, 463–74.

8. Ibid. The Allies were in general agreement on those principles. See McMillan, *Paris*, 161–62.

9. *Treaty of Versailles*, Article 231, First World War, "Primary Documents," accessed June 15, 2015, www.firstworldwar.com/source/versailles/htm.

10. *Treaty of Versailles*, Article 232.

11. Smith, Audoin-Rouzeau, and Becker, *France*, 43–52.

12. Pinson, *Modern Germany*, 339–49; 350–91.

13. Ben Scott, "The Origins of the Freikorps: A Reevaluation," *University of Sussex Journal of Contemporary History*, 1 (2000), n.p., accessed June 29, 2015, https://www.sussex.ac.uk/webteam/gateway/file.php?name=1-scott-the-origins-of-the-freikorps&site=15.

14. See Ian Drury, "German Stormtrooper," 10–53 for a detailed history of the storm troops.

15. Scott, "Origins of the Freikorps."

16. Arnulf Scriba, "Freikorps," Deutsches Historisches Museum, modified September 1, 2014, accessed June 29, 2015, https://www.dhm.de/lemo/kapitel/weimarer-republik/revolution-191819/freikorps.html.

17. Scott, "Origins of the Freikorps."

18. Ibid.; Scriba, "Freikorps."

20. Scott, "Origins of the Freikorps."; Scriba, "Freikorps"; *Pinson, Modern Germany*, 378–90. On links between the *Freikorps* and the National Socialists, see Nigel H. Jones, *Hitler's Heralds: The Story of the Freikorps, 1918–1923* (London: John Murray, 1987).

20. The literature on commemoration and mourning is extensive. I especially recommend Audoin-Rouzeau and Becker, 14–18, Part III; Winter, *Sites of Memory*; Mosse, *Fallen Soldiers*; Antoine Prost, *Les Anciens combattants et la société française, 1914–1939* (Paris: Presses de la Fondation Nationale des Sciences politiques, 1977), vol. 3, 35–70.

21. Ferguson, *Pity*, table 32, p.295.

22. Keegan, *First World War*, 421–22.

23. Audoin-Rouzeau and Becker, *14–18*, 166.

24. Ousby, *Verdun*, 268.

25. The chaos of defeat and revolution, followed by the political polarization of the Weimar Republic prevented the rapid creation of a national monument to the dead. See Mosse, *Fallen Soldiers*, 85–89.

26. Keegan, *First World War*, 422.

27. Doyle, *100 Objects*, 344.

28. Audoin-Rouzeau and Becker, *14–18*, 215–17.

29. Ibid., 186. For a detailed description of the ceremonies, see Prost, *Anciens combattants*, vol. 3, 52–70.

30. Audoin-Rouzeau and Becker, *14–18*, 196–200; Mosse, *Fallen Soldiers*, 94–98.

31. Audoin-Rouzeau and Becker, *14–18*, 194–95.

32. *L'Illustration*, November 16, 1918 (486).

BIBLIOGRAPHY

Asmuss, Burkhard. "Der Stahlhelm, Bund der Frontsoldaten." Deutsches Historisches Museum, June 8, 2011, https://www.dhm.de/lemo/kapitel/weimarer-republik/innen-politik/stahlhelm-bund-der-frontsoldaten.html.

Audoin-Rouzeau, Stéphane, and Annette Becker. *14–18: Understanding the Great War*, translated by Catherine Temerson. New York: Hill and Wang, 2002.

Aulich, James. *War Posters: Weapons of Mass Communication*. New York: Thames and Hudson, 2007.

Aulich, Jim, and John Hewitt. *Seduction or Instruction? First World War Posters in Britain and Europe*. Manchester: Manchester University Press, 2007.

Bénézit. *Dictionnaire critique et documentaire des peintres, sculpteurs, dessinateurs et graveurs de tous les temps et de tous les pays*. 14 vols. Paris: Gründ, 1999.

Bertrand, Adrien. *L'Appel du sol*. Paris: Calmann-Lévy, 1916.

Bessel, Richard. "Mobilizing German Society for War." In *Great War, Total War: Combat and Mobilization on the Western Front, 1914–1918*, edited by Roger Chickering and Stig Förster, 437–451. Cambridge: Cambridge University Press, 2000.

Best, Nicholas. *The Greatest Day in History: How, on the Eleventh Hour of the Eleventh Day of the Eleventh Month, the First World War Finally Came to an End*. New York: Public Affairs, 2008.

Bohrmann, Hans, ed. *Politische Plakate*. Dortmund: Harenberg, 1984.

Brandt, Susanne. "Nailing Patriotism in Germany 1914–1918." In *Matters of Conflict: Material culture, memory and the First World War*, edited by Nicholas J. Saunders, 62–71. London: Routledge, 2004.

Braybon, Gail. "Women, War and Work." In *The Oxford Illustrated History of the First World War*, edited by Hew Strachan, 149–162. Oxford: Oxford University Press, 1998.

Broadberry, Steven, and Mark Harrison. "The Economics of World War I: An Overview." In *The Economics of World War I*, edited by Steven Broadberry and Mark Harrison, 3–40. Cambridge: Cambridge University Press, 2005.

Brown, Frederick. *For the Soul of France: Culture Wars in the Age of Dreyfus*. New York: Knopf, 2010.

Bruno, G. [Augustine Fouillée]. *Le Tour de la France par deux enfants*. Paris: Belin Frères, 1913.

Bull, Stephen. "The Somme and Beyond." In *War on the Western Front: In the Trenches of World War I*, edited by Garry Sheffield, 218–63. Botley, UK: Osprey Publishing, 2007.

Cabanes, Bruno. *Août 14: La France entre en guerre*. Paris: Gallimard, 2014.

Caine, Peter, and Oriel Caine. *Paris Then and Now*. San Diego: Thunder Bay Press, 2003.

Ciment, James, ed. *The Home Front Encyclopedia: The United States, Britain and Canada in World Wars I and II*. 3 vols. Santa Barbara, CA: ABC-CLIO, 2007.

Clark, Christopher. *Iron Kingdom: The Rise and Downfall of Prussia, 1600–1947*. Cambridge, MA: Belknap, 2006.

———. *The Sleepwalkers: How Europe Went to War in 1914*. New York: Harper Collins, 2013.

Crane, David. *Empires of the Dead: How One Man's Vision Led to the Creation of WWI's Graves*. London: William Collins, 2013. Kindle Edition.

Cru, Jean Norton. *Témoins*. Paris: Les Étincelles, 1929.

Das, Santanu. "World War I: Experiences of colonial troops." British Library, www.bl.uk/world-war-one/articles/colonial-troops (accessed March 6, 2015).

Denscher, Bernhard. "'Überall vor den Plakaten bildeten sich Ansammlungen . . .': Das Plakat als Kommunicationsmedium im Wien des Ersten Weltkriegs." Austrian Posters, www.austrianposters.at/pages/themen/denscher_weltkrieg1_de.html (accessed April 26, 2015).

Doyle, Peter. *World War I in 100 Objects*. New York: Plume, 2014.

Drury, Ian. "German Stormtrooper." In *War on the Western Front: In the Trenches of World War I*, edited by Garry Sheffield, 10–53. Botley, UK: Osprey Publishing, 2007.

Durflinger, Serge. "French Canada and Recruitment during The First World War." Canadian War Museum, www.warmuseum.ca/education/online-educational-resources/dispatches/french-canada-and-recruitment-during-the-first-world-war/ (accessed December 12, 2014).

Eberle, Matthias. *World War I and the Weimar Artists: Dix, Grosz, Beckmann, Schlemmer*. New Haven: Yale University Press, 1985.

Echenberg, Myron. *Colonial Conscripts: The Tirailleurs Sénégalais in French West Africa, 1857–1960*. London: Heinemann/James Curry, 1991.

Fagan, Brian. *The Little Ice Age: How Climate Made History, 1300–1850*. New York: Basic Books, 2000.

Fell, Christine E. "Gods and Heroes of the Northern World." In *The Northern World: The History and Heritage of Northern Europe, AD 400–ll00*, edited by David M. Wilson, 33–46. New York: Abrams, 1980.

Ferguson, Niall. *The Pity of War*. New York: Basic Books, 1999.

Fogarty, Richard S. "Race and Empire in French Posters of the Great War." In *Picture This: World War I Posters and Visual Culture*, edited by Pearl James, 172–206. Lincoln: University of Nebraska Press, 2009.

Frantzen, Allen J. *Bloody Good: Chivalry, Sacrifice, and the Great War*. Chicago: University of Chicago Press, 2004.

Fussell, Paul. *The Great War and Modern Memory*. New York and London: Oxford University Press, 1975.

Gallo, Max. *The Poster in History*. Translated by Alfred and Bruni Mayor. New York: American Heritage, 1972.

Gilbert, Martin. *The Somme: Heroism and Horror in the First World War*. New York: Holt and Company, 2006.

Giono, Jean. "Refus d'obéissance." In *Récits et essais*. Paris: Gallimard, 1989.

Goebel, Stefan. "Chivalrous Knights versus Iron Warriors: Representations of the Battle of *Matériel* and Slaughter in Britain and Germany, 1914–1940." In *Picture This: World War I Posters and Visual Culture*, edited by Pearl James, 79–110. Lincoln: University of Nebraska Press, 2009.

———. *The Great War and Medieval Memory: War, Remembrance and Medievalism in Britain and Germany 1914–1940*. Cambridge: Cambridge University Press, 2007.

Goltz, Joachim von der. *Der Baum von Cléry*. Berlin: Büchergilde Gutenberg, 1934.

Gullace, Nicoletta F. "Barbaric Anti-Modernism: Representations of the 'Hun' in Britain, North America, Australia and Beyond." In *Picture This: World War I Posters and Visual Culture*, edited by Pearl James, 61–78. Lincoln: University of Nebraska Press, 2009.

Hamann, Brigitte. *Die Erste Weltkrieg: Wahrheit und Lüge in Bildern und Texten*. Munich: Piper, 2013.

Heller, Steven. "The Future of German Advertising Past." *Print*, November 26, 2013, www.printmag.com/daily-heller/the-future-of-german-advertising-past-julius-gipkens/

Herwig, Holgar H. *The First World War: Germany and Austria-Hungary, 1914–1918*. London: Arnold, 1997.

———. "The German Victories, 1917–1918." In *The Oxford Illustrated History of the First World War*, edited by Hew Strachan, 253–64. Oxford: Oxford University Press, 1998.

Hitler, Adolf. *Mein Kampf*. New York: Stackpole Sons, 1939.

Horne, Alistair. *The French Army and Politics, 1870–1970*. London: Macmillan, 1984.

Horne, John. "Soldiers, Civilians and the Warfare of Attrition: Representations of Combat in France, 1914–1918." In *Authority, Identity and the Social History of the Great War*, edited by Frans Coetzee and Marilyn Shevin-Coetzee, 224–43. Providence, RI: Berghahn Books, 1995.

Huss, Marie-Monique. "Pronatalism." In Richard Wall and Jay Winter, *The Upheaval of War: Family, Work and Welfare in Europe, 1914–1918*, 329–67. Cambridge: Cambridge University Press, 1988.

Ille, Gerhard, and Günter Köhler. *Der Wandervogel. Es begann in Steglitz*. Berlin: Stapp, 1987.

James, Pearl. "Images of Femininity in American World War I Posters." In *Picture This: World War I Posters and Visual Culture*, edited by Pearl James, 273–311. Lincoln: University of Nebraska Press, 2009.

Jones, Nigel H. *Hitler's Heralds: The Story of the Freikorps, 1918–1923*. London: John Murray, 1987.

Kazecki, Jakub, and Jason Lieblang. "Regression versus Progression: Fundamental Differences in German and American Posters of the First World War." In *Picture This: World War I Posters and Visual Culture*, edited by Pearl James, 111–41. Lincoln: University of Nebraska Press, 2009.

Keegan, John. *The American Civil War: A Military History*. New York: Knopf, 2009.

———. *The Face of Battle*. New York: Viking, 1976.

———. *The First World War*. New York: Knopf, 1999.

———. *The Price of Admiralty: The Evolution of Naval Warfare*. New York: Viking, 1989.

Kimball, Warren. "Lend-Lease." In *The Oxford Companion to World War II*, edited by I. C. B. Dear, 677–83. Oxford: Oxford University Press, 1995.

Kingsbury, Celia Malone. *For Home and Country: World War I Propaganda on the Home Front*. Lincoln: University of Nebraska Press, 2010.

Kühnel, Anita. "Julius Klinger—Poster Artist and Draftsman." Austrian Posters, www.austrianposters.at/pages/grafiker/kuehnel_julius_klinger_en.html (accessed April 26, 2015).

Laqueur, Walter. *Young Germany: A History of the German Youth Movement*. London: Routledge, 1962.

Larkin, Philip. "MCMXIV." In *The Oxford Book of War Poetry*, edited by Jon Stallworthy, 222. Oxford: Oxford University Press, 1984.

Lasswell, Harold D. *Propaganda Technique in the World War*. 1927. Reprint, New York: Peter Smith, 1938.

Lawrence, John W. "Hog Island." *Encyclopedia of Greater Philadelphia*, 2014, http://philadelphiaencyclopedia.org/archive/hog-island (accessed August 10, 2015).

Le Naour, Jean-Yves, ed. *Dictionnaire de la Grande Guerre*. Paris: Larousse, 2014.

———. "Poilu." In *Dictionnaire de la Grande Guerre*. Edited by Jean-Yves Le Naour. Paris: Larousse, 2014.

Levitch, Mark. "Young Blood: Parisian Schoolgirls' Transformation of France's Great War Poster Aesthetic." In *Picture This: World War I Posters and Visual Culture*, edited by Pearl James, 145–71. Lincoln: University of Nebraska Press, 2009.

Linder, Ann P. *Princes of the Trenches: Narrating the German Experience of the First World War*. Columbia, SC: Camden House, 1996.

Livesey, Anthony. *The Historical Atlas of World War I*. New York: Holt and Company, 1994.

Loez, André. "Mutinerie." In *Dictionnaire de la Grande Guerre*, edited by Jean-Yves Le Naour, 316–22. Paris: Larousse, 2014.

———. "Paix." In *Dictionnaire de la Grande Guerre*, edited by Jean-Yves Le Naour, 348–54. Paris: Larousse, 2014.

Lowenthal, David. "European and English Landscapes as National Symbols." In *Geography and National Identity*, edited by David Hooson, 15–38. Oxford: Blackwell, 1994.

MacMillan, Margaret. *Paris, 1919: Six Months that Changed the World*. New York: Random House, 2003.

McCoy, Dan. "Thor's Hammer." Norse Mythology for Smart People, http://norse-mythology.org/symbols/thors-hammer/ (accessed February 11, 2015).

McKercher, B. J. C. "Economic Warfare." In *The Oxford Illustrated History of the First World War*, edited by Hew Strachan, 119–33. Oxford: Oxford University Press, 1998.

Menges, Franz and Edith Schmidt, "Adolf Münzer." In *Neue Deutsche Biographie*, 1997.

http://deutsche-biographie.de/ppn119430282.html (accessed December 26, 2014).

Meyer, Jacques. *La Vie quotidienne des soldats pendant la grande guerre*. Paris: Hachette, 1966.

Mitchell, Allan. *Victors and Vanquished: The German Influence on Army and Church in France after 1870*. Chapel Hill: University of North Carolina Press, 1984.

Morrow, John H. Jr. "The War in the Air." In *The Oxford Illustrated History of the First World War*, edited by Hew Strachan, 265–77. Oxford: Oxford University Press, 1998.

Mosse, George L. *The Crisis of German Ideology*. New York: Grosset, 1964.

———. *Fallen Soldiers: Reshaping the Memory of the World Wars*. Oxford: Oxford University Press, 1990.

Ousby, Ian. *The Road to Verdun*. London: Pimlico, 2003.

Ozment, Steven. *A Mighty Fortress: A New History of the German People*. New York: Harper Collins, 2004.

Owen, Wilfred. "Strange Meeting." In *The Penguin Book of First World War Poetry*, edited by Jon Silkin, 206–8. 2nd ed. London: Penguin Books, 1981.

Pastoureau, Michel. "Le Coq gaulois," in *Les Lieux de mémoire*, edited by Pierre Nora, vol. 3, part 3, 507–39. Paris: Gallimard, 1992.

Paret, Peter, Beth Irwin Lewis, and Paul Paret. *Persuasive Images: Posters of War and Revolution from the Hoover Institution Archives*. Princeton, NJ: Princeton University Press, 1992.

Paschall, Rod. *The Defeat of Imperial Germany, 1917–1918*. Chapel Hill, NC: Algonquin Books, 1989.

Peary, Gerald. "Missing Links: The Jungle Origins of King Kong." *Gerald Peary* (blog), 2004, www.geraldpeary.com/essays/jkl/kingkong-1.html (accessed August 8, 2015).

Pedroncini, Guy. *Les Mutineries de 1917*. Paris: Presses Universitaires de France, 1967.

Pinson, Koppel S. *Modern Germany: Its History and Civilization*. New York: MacMillan, 1954.

Prost, Antoine. *Les Anciens combattants et la société française, 1914–1939*. 3 vols. Paris: Presses de la Fondation Nationale des Sciences politiques, 1977.

———. *Si nous vivions en 1913*. Paris: Grasset and France Inter, 2014.

———. "Verdun." In *Dictionnaire de la Grande Guerre*. Edited by Jean-Yves Le Naour, 456–59. Paris: Larousse, 2014.

Proust, Marcel. *À la Recherche du temps perdu*. 3 vols. Paris: Bibliothèque de la Pléiade, 1954.

Proust, Marcel. *Remembrance of Things Past*. Translated by C. K. Scott Moncrieff. 2 vols. New York: Random House, 1934.

Rawls, Walton H. *Wake Up, America!* New York: Abbeville Press, 1988.

Rickards, Maurice. *Posters of the First World War*. New York: Walker and Company, 1968.

———. Foreword to *Wake Up, America!*, by Walton H. Rawls. New York: Abbeville Press, 1988.

Robinson, Michael. *Art Nouveau Posters*. London: Flame Tree Publishing, 2012.

Rockoff, Hugh. "Until it's over, over there: the US economy in World War I." In *The Economics of World War I*, edited by Steven Broadberry and Mark Harrison, 310–43. Cambridge: Cambridge University Press, 2005.

Sassoon, Siegfried. *The War Poems*, edited by Rupert Hart-Davis. London: Faber and Faber, 1983.

Saustier, Alain. "Le Tour de France par deux enfants." La Maison d'École, http://aspage.chez-alice.fr/tour2fr.htm (accessed June 16, 2007).

Schama, Simon. *Citizens: A Chronicle of the French Revolution*. New York: Vintage, 1989.

Scott, Ben. "The Origins of the Freikorps: A Reevaluation." *University of Sussex Journal of Contemporary History* 1 (2000). https://www.sussex.ac.uk/webteam/gateway/file.php?name=1-scott-the-origins-of-the-freikorps&site=15 (Accessed June 29, 2015).

Scriba, Arnulf. "Freikorps." Deutsches Historisches Museum. Last modified September 1, 2014.

https://www.dhm.de/lemo/kapitel/weimarer-republik/revolution-191819/freikorps.html. (Accessed June 29, 2015).

Shephard, Ben. *A War of Nerves: Soldiers and Psychiatrists 1914–1944*. London: Jonathan Cape, 2000.

Silkin, Jon, ed. *The Penguin Book of First World War Poetry*. 2nd ed. London: Penguin Books, 1981.

Simkin, John. "Savile Lumley." Spartacus Educational, http://spartacus-educational.com/ARTlumley.htm (Accessed July 9, 2014).

Simkins, Peter. "Voluntary Recruiting in Britain, 1914–1915." British Library, www.bl.uk/world-war-one/articles/voluntary-recruiting (Accessed July 9, 2014).

Smith, Leonard V., Stéphane Audoin-Rouzeau, and Annette Becker. *France and the Great War, 1914–1918*, translated by Helen McPhail. Cambridge: Cambridge University Press, 2003.

Solzhenitsyn, Alexander. *August 1914*. Translated by Michael Glenny. New York: Farrar, Straus and Giroux, 1971.

Sombart, Werner. *Händler und Helden: Patriotische Besinnungen*. Munich: Duncker und Humbolt, 1915.

Southard, Frank A. Jr. "Emergency Fleet Corporation." *Dictionary of American History*, 2003, www.encyclopedia.com/doc/1G2-3401801360.html (Accessed May 23, 2015).

Stallworthy, Jon, ed. *The Oxford Book of War Poetry*. Oxford: Oxford University Press, 1984.

Stevenson, David. "War Aims and Peace Negotiations." In *The Oxford Illustrated History of the First World War*, edited by Hew Strachan, 204–15. Oxford: Oxford University Press, 1998.

Sumner, Ian. "French Poilu." In *War on the Western Front: In the Trenches of World War I*, edited by Gary Sheffield, 54–91. Botley, UK: Osprey Publishing, 2007.

Taylor, Philip M. *Munitions of the Mind: A History of Propaganda from the Ancient World to the Present Day*. Manchester: Manchester University Press, 1995.

Trask, David. "The Entry of the USA into the War and its Effects." In *The Oxford Illustrated History of the First World War*, edited by Hew Strachan, 239–52. Oxford: Oxford University Press, 1998.

Tucker, Spencer C., ed. *World War I: The Definitive Encyclopedia and Document Collection*. 5 vols. Santa Barbara, CA: ABC-CLIO, 2014.

Vandeboncoeur, Jim Jr. "Joseph Clement Coll." Illustrators, www.bpib.com/illustrat/coll.htm (Accessed May 23, 2015).

Vollmer, Hans, ed. *Allgemeines Lexicon der Bildenden Künstler von der Antike bis zür Gegenwart*. 37 vols. Leipzig: E. A. Seemann Verlag, 1908.

United States Census Bureau. Population Division, Population Estimates Program, 2000. https://www.census.gov/popest/data/national/totals/pre-1980/tables/popclockest.txt (Accessed April 8, 2015).

Warner, Marina. *Monuments and Maidens: The Allegory of the Female Form*. New York: Atheneum, 1985.

Watson, Peter. *The German Genius: Europe's Third Renaissance, the Second Scientific Revolution and the Twentieth Century*. New York: Harper Collins, 2010.

Weber, Eugen. *Peasants into Frenchmen: The Modernization of Rural France, 1870–1914*. Stanford: Stanford University Press, 1976.

Weber, Thomas. *Hitler's First War*. Oxford: Oxford University Press, 2010.

Weill, Alan. *The Poster: A Worldwide Survey and History*. Boston: G. K. Hall, 1985.

Wilhelm II. "Order to the Army, August 19, 1914." http://firstworldwar.com/source/kaisercontemptible/htm. (Accessed June 8, 2025).

Winter, Jay. "Imaginings of War: Posters and the Shadow of the Lost Generation." In *Picture This: World War I Posters and Visual Culture*, edited by Pearl James, 37–58. Lincoln: University of Nebraska Press, 2009.

———. "Propaganda and the Mobilization of Consent." In *The Oxford Illustrated History of the First World War*, edited by Hew Strachan, 216–26. Oxford: Oxford University Press, 1998.

———. *Remembering War: The Great War between Memory and History in the Twentieth Century*. New Haven: Yale University Press, 2006.

———. *Sites of Memory, Sites of Mourning*. Cambridge: Cambridge University Press, 1995.

Winter, Jay and Emmanuel Sivan, eds. *War and Remembrance in the Twentieth Century*. Cambridge: Cambridge University Press, 1999.

Zabecki, David T. "Medals and Decorations." In *Encyclopedia of World War I: A Political, Social and Military History*, edited by Spencer C. Tucker and Priscilla Mary Roberts, 3: 765–9. Santa Barbara, CA: ABC-CLIO, 2005.

Zilczer, Judith. *"The Noble Buyer:" John Quinn, Patron of the Avant-Garde*. Washington DC: Smithsonian Institution Press, 1978.

ACKNOWLEDGMENTS

Many people have contributed to the making of this book. I thank the Library of Congress, the Imperial War Museum, and the Hoover Institution for making their collections of posters available to scholars online. The VADS collection from the Imperial War Museum was also very valuable. I have been studying these posters for many years, and I am grateful to the generations of students whose response to the posters and their place in the experience of the First World War convinced me that a book was a possibility.

I was aided in navigating the frustrating labyrinth of copyright claims on hundred-year-old posters by Hannah Rhadigan of the Artists Rights Society, Neera Puttapipat of the Imperial War Museum, and Virginie Frelin-Cartigny of the Musée des Beaux-Arts, Valenciennes. My thanks to the granddaughters of Lucien Jonas for permission to publish their grandfather's posters. Every effort has been made to locate copyright holders.

I am also indebted to the staff of the Canadian War Museum, and especially to Dr. Mélanie Morin-Pelletier for her valuable insights into the two Canadian posters. My friends Rémy and Marie-France Mauduit contributed their native knowledge of French culture to my studies, and Almut Haboeck lent her art historian's eye to the project. My thanks to Amy Johnson, librarian of the Montgomery Museum of Fine Arts, for her assistance in locating biographical information on some of the artists. To all my friends and colleagues over the years who have listened, looked, considered, and commented, thank you. Thank you also to my mother, whose support and interest have never failed.

Finally, I am profoundly grateful to my husband, Steve. His digital photography skills were invaluable in the preparation of the images, and his knowledgeable criticism has greatly improved the manuscript. I can never repay the love, support, and encouragement he has provided over forty-three years of marriage.